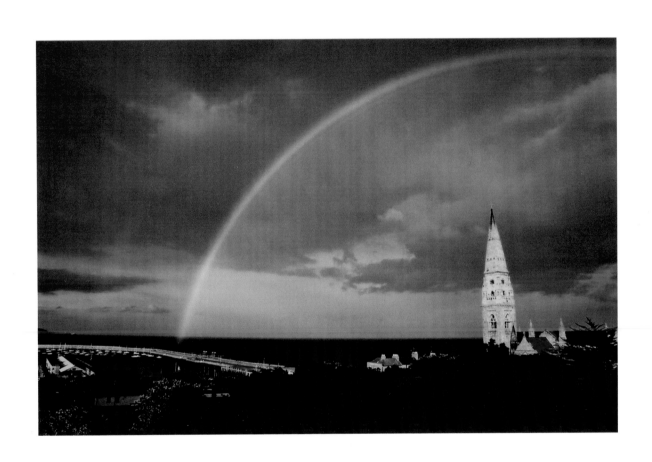

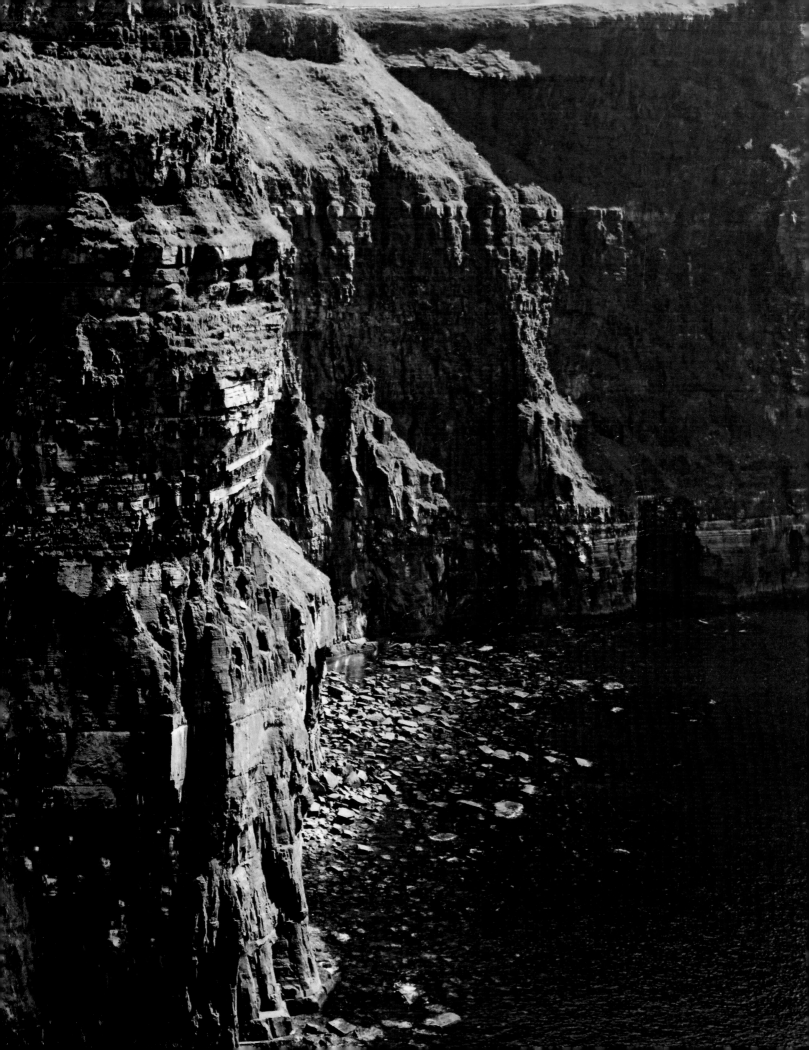

Ireland

One Island, No Borders

Photographs by Elizabeth Billups

Text by Elizabeth Billups
and Gerry Adams

George F. Thompson Publishing

To
Adrienne &
Drew!

It's an honor and
pleasure to know you!
Love
Elizabeth
xoxo

Contents

Colorful doors are a striking feature of downtown Dublin.

Roses thrive in the mists of Ireland, as do these in County Louth.

Introduction
Getting to Know Ireland

BY ELIZABETH BILLUPS

"Let the world change you . . .
and you can change the world."[1]
—Ernesto "ché" Guevara, from *The Motorcyle Diaries*

I ALWAYS KNEW I had to go to Ireland. Like many other Irish-Americans, in my imagination, I had wrapped it in magical, mystical fairy dust. This was confirmed on my first trip in May 1996, during a stopover in Belfast in the north, en route to Shannon in the south, when the plane emerged from the fog and below me I saw a patchwork of green fields that was breathtaking and surreal in its beauty. Then, as we taxied to the terminal, I saw a dozen huge, fluffy bunnies hopping through the tall, green grass that was rippling in the breeze. I thought I had found utopia.

After landing in Shannon, as we drove out of the airport, I looked up at the large trees and cried, feeling like I was seeing old friends after a very long time. I was reminded of something Ché Guevara said of his motorcycle adventures in South America: "How can I feel nostalgia for a world I never knew?"[2] (Later, I learned that Ché was part Irish.) I feel like my soul lives in Ireland, and I need to visit it as often as possible.

Ireland is a rich, many-layered culture full of texture and, yes, magic. It is easy to get caught up in the mythical and historical aspects of this island, and you can almost feel and hear the old stories as you walk on the ancient ground. At first, I photographed the striking landscape, but I quickly learned that, like every country, Ireland

9

has environmental problems—and serious political and social issues. I soon became immersed in the struggle for a united Ireland, and my photographs increasingly became a visual record and reflection of the contradictions and paradoxes contained on such a small island divided by the imposed British border.

I read the poetry and essays of Bobby Sands, who was a member of the Irish Republican Army (IRA) and who died in 1981 while on hunger strike in the infamous H blocks of Long Kesh Prison, aka Maze Jail. He was part of a group of ten hunger strikers who were trying to pressure the British government to classify them as political prisoners instead of criminals. The then-Prime Minister of Britain, Margaret Thatcher, refused, and Sands and the others died. Sands was twenty-seven years old. During his hunger strike and imprisonment and as part of his strategy, he successfully ran for office as a member of the British Parliament for Fermanagh and South Tyrone, in Northern Ireland. He was elected with 30,000 votes, but he was never able to serve.

I was also drawn to the writings and speeches of Gerry Adams, the well-known leader of Sinn Féin ("We Ourselves" or "Ourselves Alone"), the Irish Republican party. His inclusive attitude and untiring dedication to his country inspired me to study the multi-partisan, historic Good Friday Agreement of 1998, of which he was a primary architect. While key elements of the Good Friday Agreement and subsequent agreements, including the Bill of Rights, the Civic Forum, and Acht na Gaeilge (the Irish Language Act), have still not been implemented, nonetheless the Agreement has brought about significant and positive change. At its core, the Good Friday Agreement is an accommodation between those who want to end the union with Britain and create a United Ireland and those citizens who want to retain the union with Britain. Gerry provides the background and context for this remarkable achievement in his conclusion.

When I first heard Gerry speak in public, I was impressed with his calm, clear voice, and I admired how inclusive he was of all members of the community. I could hear the ring of truth in his voice. Apparently, the British government agreed. In October 1988, the British Prime Minister Margaret Thatcher had introduced a Broadcasting Ban censoring the voices of any Sinn Féin representatives, including elected officials. Gerry Adams, who was a Member of the British Parliament, was one of those whose voice could not be heard on any British broadcast outlet. In order to circumvent this, some broadcasters used actors voices to replace the voices of Adams and others. On one occasion a documentary so carefully synced the actors' with Gerry's that it made a nonsense of the ban. In retaliation the British government instructed broadcasters that they were no longer allowed to lip sync interviews. All this made me understand how afraid the British must have been of the political message of Gerry and Sinn Féin.

On my second trip, in 1999, I had the immense fortune to be able to join an Irish Northern Aid tour. It was a great education. We started in Dublin, then traveled north to Derry, South Armagh, and Portadown, ending in Belfast at the Felons Club. In Ulster, we stayed with Catholic Republican families who welcomed us into their homes and shared with us deeply moving stories of what they had suffered during "the Troubles," the roughly three decades of violence that occurred there from the mid-1960s to 1998, when the Good Friday Agreement was signed. Most of our hosts were women, as their men had died or were imprisoned. Many cried and thanked us for taking our vacations to be with them and to let them tell us their stories. I was deeply affected by this experience. Realizing that these Irish women felt so unheard solidified my determination to spread their stories, in my own way, through my photographs.

I first met Gerry during that INA tour at the Felons Club on Prisoners' Day. The Felons was a unique social club founded by former IRA political prisoners. To be a member you had to have done time. (Nelson Mandela was an honorary member.) On Prisoners' Day, those who had been in jail spoke of the hardship they had endured and the clever ways they had conjured to outsmart their captors. The crowd was huge, making it hard to move. I spotted Gerry across the room and wanted very much to meet him. He had once sent an email thanking me for sending banned books to him, so I felt we had a connection. But he left before I could get through the crowd, and I thought, "Oh no, Elvis has left the building!"

I made my way out and saw Gerry talking with a man in a courtyard next door. I pondered briefly whether to bother him or not and decided that I didn't fly across the Atlantic Ocean to miss my chance to meet him, so I went up and introduced myself. Gerry was delightful and warmly welcomed me to Ireland. That was the start of a great friendship. Paul Doris, the head of the INA, was the man he was speaking with. It was wonderful to meet him as well.

On that same INA tour I met Joe Cahill, who encouraged all of us on the tour to tell the world what we had seen, heard, and learned. Joe himself was a former IRA political prisoner sentenced to death in 1941. This sentence was commuted to life due to American pressure. I took this responsibility very seriously, and went home and had several photographic exhibitions accompanied by lectures, in which I explained the reality of the political and social situation in Ireland. I was on a mission: I went into high schools with murals of my photos. Those of the North/South borders, with their clear evidence of heavy military presence, amazed the students—they couldn't believe it was Ireland. And I talked about the beauty and promise of the Good Friday Agreement.

In the ensuing years, the peace process has changed the atmosphere of the entire country for the better. The North is a different place. The border areas no longer have

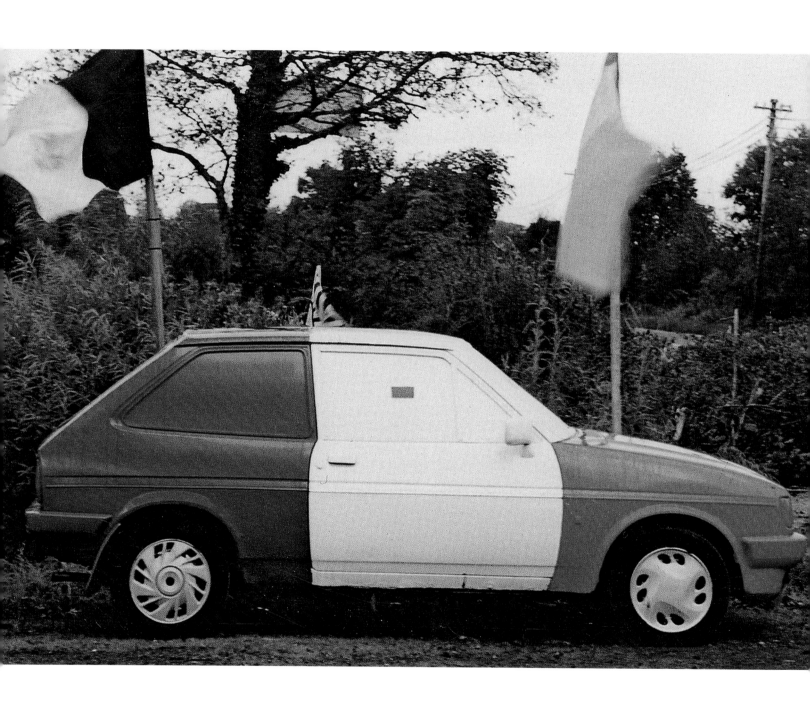

A car is painted to resemble the flag of Ireland, known as the "Irish tricolor."

spy towers blighting the beautiful countryside, and Gerry himself is now an elected member of the Irish Parliament, the Dail, from Louth in the South (although he is a native of Belfast). But the country is still not completely united; this is a dream that still needs to be realized. As Gerry would say, "It's unfinished business."

This book, first and foremost, is a photographic work whose images are meant to convey a sense of place about Ireland. And many of the places that are featured are some of Gerry's and my favorite places on this uniquely beautiful island. To these we add our own recollections and observations that are meant to layer information onto the photographs.

Our intent is not to provide an in-depth or definitive history of the country but rather an introduction that mixes some history and geography with personal reminiscences of places in both the South and the North, which usually gets short shrift in books on Ireland. For our purposes, the country of Ireland to which we refer throughout the book comprises the entirety of the island.

I asked Gerry to be involved with the book, because, as I learned, in Ireland the personal cannot be separated from the political. I wanted him to share his perspective on Ireland's complex history and to give the world a glimpse of the man behind the headlines, of his passion for his country, and his dedication to peace and justice for all its citizens.

The book is organized into four parts, representing Ireland's four provinces. Each part is introduced by me, and then Gerry (GA) and I (EB) provide our respective stories. Most people only know Gerry for his political writings, but now they can read about his love and passion for his native land.

We sincerely hope that this book whets your appetite to visit and learn about this compelling and enchanting place and to gain an appreciation for what its people—all of them, in the North and in the South—have endured and achieved. May it inspire you.

Notes

1. As quoted in "The Motorcycle Diaries," a screenplay (2002) by José Rivera for the film *Diarios de Motocicleta* (2004), directed by Walter Salles, 33.

2. Ibid, 47.

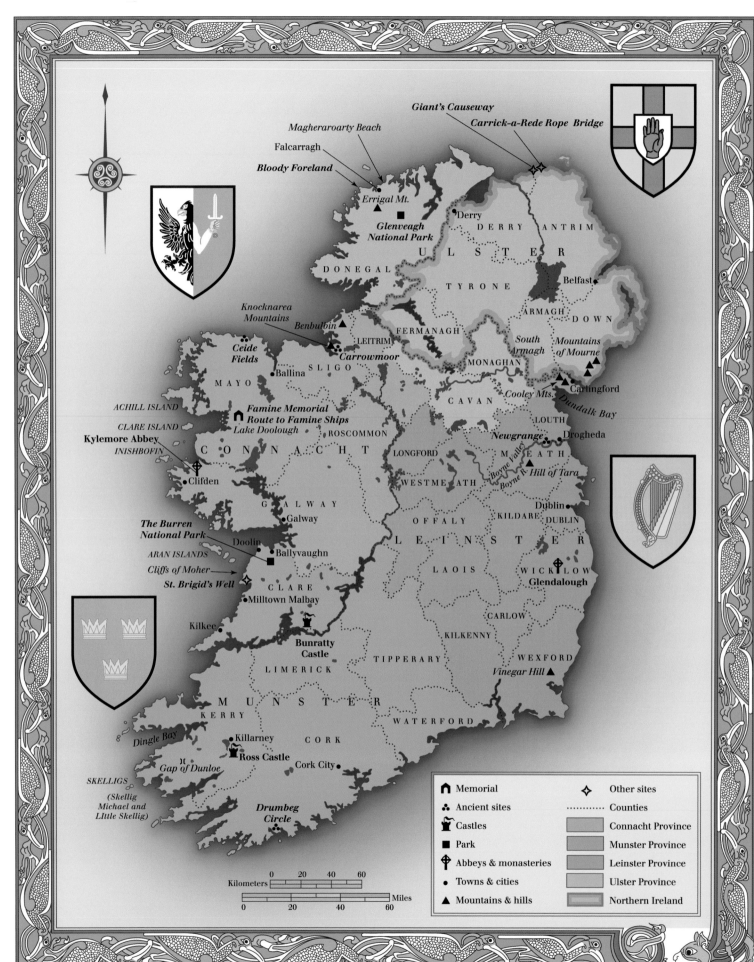

Giant's Causeway
Carrick-a-Rede Rope Bridge
Magheraroarty Beach
Falcarragh
Bloody Foreland
Errigal Mt.
Derry
DERRY
ANTRIM
Glenveagh
National Park
ULSTER
DONEGAL
TYRONE
Belfast
ARMAGH
DOWN
FERMANAGH
Knocknarea
Mountains
Benbulbin
LEITRIM
South
Armagh
Mountains
of Mourne
Ceide
Fields
Carrowmoor
SLIGO
MONAGHAN
Carlingford
Ballina
MAYO
CAVAN
Cooley Mts.
Dundalk Bay
ACHILL ISLAND
Famine Memorial
Route to Famine Ships
Lake Doolough
Newgrange
LOUTH
Drogheda
CLARE ISLAND
CONNACHT
ROSCOMMON
Boyne Valley
M EATH
Hill of Tara
Kylemore Abbey
LONGFORD
Boyne R.
INISHBOFIN
Clifden
WESTMEATH
GALWAY
Dublin
DUBLIN
Galway
OFFALY
KILDARE
The Burren
National Park
LEINSTER
Doolin
ARAN ISLANDS
Ballyvaughn
LAOIS
Glendalough
Cliffs of Moher
WICKLOW
St. Brigid's Well
CLARE
CARLOW
Milltown Malbay
KILKENNY
Kilkee
TIPPERARY
WEXFORD
Bunratty
Castle
WATERFORD
Vinegar Hill
LIMERICK
MUNSTER
KERRY
CORK
Dingle Bay
Killarney
Ross Castle
Cork City
Gap of Dunloe
SKELLIGS
(Skellig
Michael and
LIttle Skellig)
Drumbeg
Circle

Legend	
Memorial	Other sites
Ancient sites	Counties
Castles	Connacht Province
Park	Munster Province
Abbeys & monasteries	Leinster Province
Towns & cities	Ulster Province
Mountains & hills	Northern Ireland

Kilometers
0 20 40 60
Miles
0 20 40 60

© 2014 Deborah Reade

The Four Provinces
in Photographs and Stories

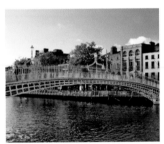
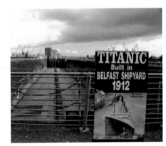

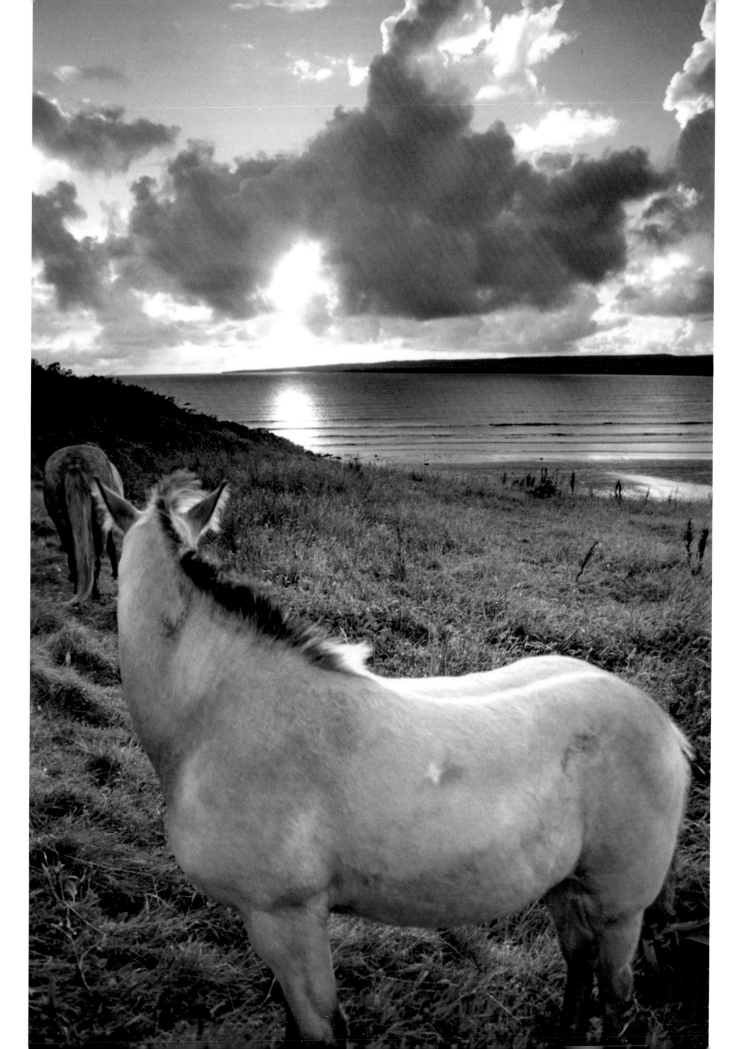

Munster

OUR JOURNEY BEGINS IN MUNSTER, the southernmost province of Ireland. Munster is comprised of the counties of Clare, Cork, Limerick, Tipperary, and Waterford, and the main cities are Cork, Limerick, and Waterford. Shannon Airport, where most people arrive when they visit, is also located here. More than 1,200,000 people (about one-sixth of the total population) live in Munster in some of Ireland's most spectacularly lush and beautiful countryside, from the rolling hills of County Clare to the beautiful coastline of West Cork. Highlights include the Ring of Kerry, the Dingle Peninsula, the Cliffs of Moher, the Burren, and many gorgeous castles and monasteries.

Munster is famous for its music. Every July since 1973, Miltown Malbay, in County Clare, has hosted the Willie Clancy Festival, in honor of the beloved musician (1918–1973) who was a master of the most complex of wind instruments, the Uilleann

Opposite: A sunlit horse stands on a grassy hill in County Clare overlooking the Atlantic Ocean. Ponies and horses have always been an integral part of life in Ireland. I will pass on some great advice from a young rider on the coast of Connemara: "Never buy a horse without four good legs—that's what holds them up." —EB

pipes. The name is a translation of the Irish phrase, *píobaí uilleann* (literally, "pipes of the elbow"), which refers to their method of inflation. I love these pipes. They are much more melodic and sweeter than Highland bagpipes, yet they are still haunting. There are recitals, lectures, concerts, classes, and, of course, fantastic traditional music at this festival from professionals and amateurs alike. The Irish have no shyness in either regard—they will get up and give a song anywhere, as the mood strikes them and especially at the festival.

The Irish love of talk is also legendary, as is their way with words, which is literally music to my ears, along with their lilting accents. I have been told to "mind my head," "mind the step," "put on your jumper, it's cold," "go, way with ya," and, a particular favorite of mine, "it's a soft day," which means "the sky is overcast with dripping fog and you become wet but ever so gently." Magic is a regular part of Irish lore, too, with serious discussion of leprechauns, fairies, and banshees (a kind of scary fairy whose scream, if heard by a human, is considered a portent of death) ranking right up there with discussion of saints and theology.

Interestingly, the number of Irish-language schools (known as *Gaelscoileanna*) has increased significantly during the past decade. Munster now has the second-highest number of Irish-speaking primary schools and the highest number of Irish-speaking secondary schools in the nation.

Michael Collins (1890–1922), the famous Irish revolutionary leader, hailed from Munster. Munster is also where many of the best hurlers come from, hurling or hurley being one of the great national sports of Ireland, along with rugby and Gaelic football. Gerry is a huge fan of hurling, having played it himself when he was a young man, and so we include a sidebar on hurling (see page 55). —EB

My friend, Donnacha Rynne, is pictured at Willie Week, with a big grin and a thumb's up. His grin isn't just for the camera—that's the way he is most of the time, despite a lifetime of health challenges and other difficulties. He is a fine singer from a family of fine singers. If you are ever lucky enough to go to Willie Week, I hope you are also lucky enough to meet Donnacha, who is passionate, interesting, and open to all the possibilities of living. He has been an inspiration to me. —GA

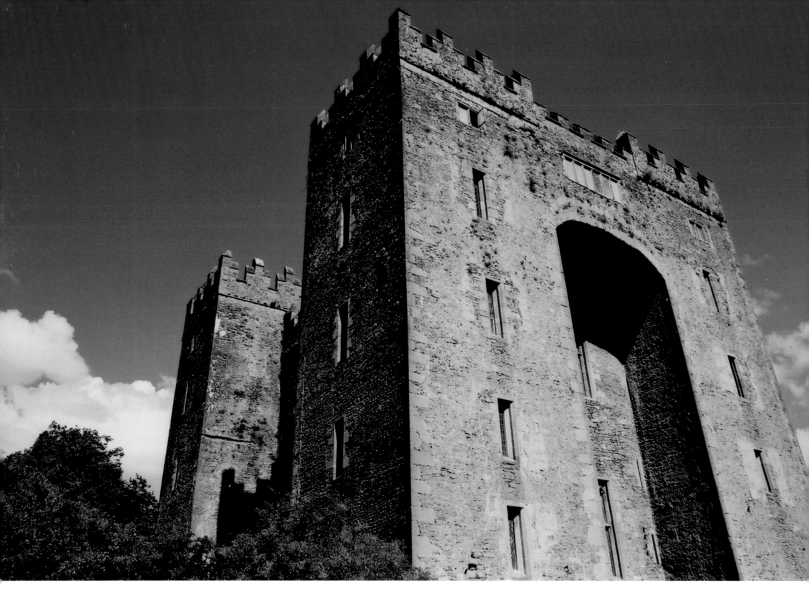

There are castles throughout Ireland. A few of my favorites in Munster are Ross Castle and Bunratty, which is close to Shannon airport. Bunratty Castle is filled with period tapestries on the walls and medieval furniture. It is famous for its daily banquet that recreates a medieval feast, with a four-course dinner and plenty of wine and honey mead. There is no silverware; one must eat as they did back then, with fingers. A king and queen preside over the festivities, and someone always goes to the dungeon! A charming folk park that replicates life in nineteenth-century Ireland sits behind the castle, complete with farmhouses, village shops, animals, and homes furnished as they would have appeared at that time, from the poorest one-room dwelling to Bunratty House (built in 1804), a fine example of a Georgian residence for the gentry. —EB

Above: Bunratty Castle, a large tower house (stronghold) built in ca.1425 and restored by the 7th Viscount Gort in 1956, is located in the center of Bunratty village, in County Clare, alongside the Ratty River, which flows into the nearby River Shannon.

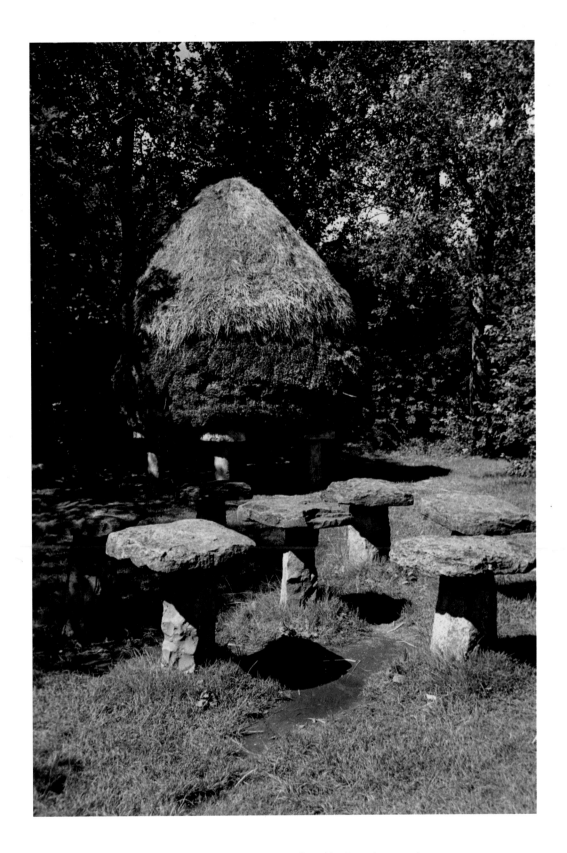

Hay is stacked to dry in the traditional way, as reproduced in the culture park adjoining Bunratty Castle. I've often wondered how anything dries in this very wet climate! —EB

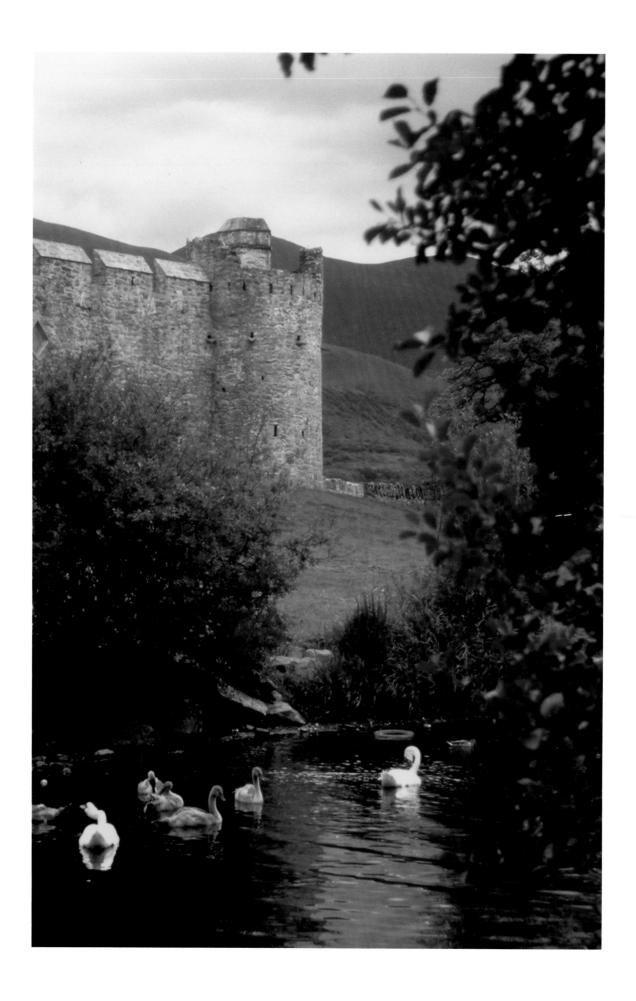

Above: This tea house in Balleyvaughan, County Clare, with its beautiful cascade of roses, serves wonderful pastries and scones.

Opposite: Ross Castle, in County Kerry, was built in the late fifteenth century. It is typical of strongholds (tower houses) constructed by Irish Chieftains during the Middle Ages. Swans are a part of the landscape wherever one travels. —EB

On a clear day, one can look toward the district of Connemara from the Cliffs of Moher.

This and the following spread: The Cliffs of Moher, one of many designated heritage sites, rise to a sheer height of 700 feet (213 meters) in some places. Located in the Burren region of County Clare, the cliffs consist mainly of Namurian shale and sandstone beds, cut through in places by river channels thought to be 300,000,000 years old. The cliffs also contain very active bird colonies, with an estimated 30,000 birds and more than twenty species, including choughs, guillemots, gulls, hawks, ravens, shags, and Atlantic puffins, which live in large colonies at isolated parts of the cliffs and on Goat Island, a small, grassy island in the sea just below the cliffs. I have hiked the easy trails and the harder trails, all the while watching the mesmerizing water below. The clean, wild winds coming off the Atlantic remind me of standing on the bow of a ship. They are so strong at times that you feel as if you can lean forward over the edge and not fall down! —EB

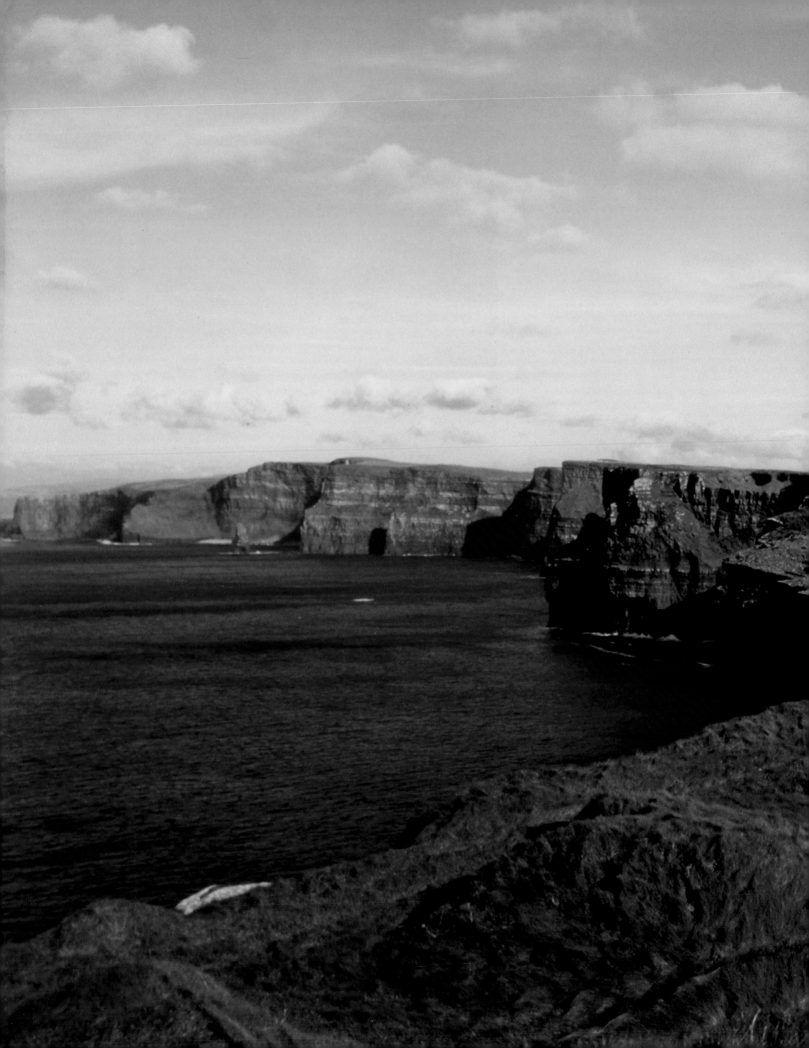

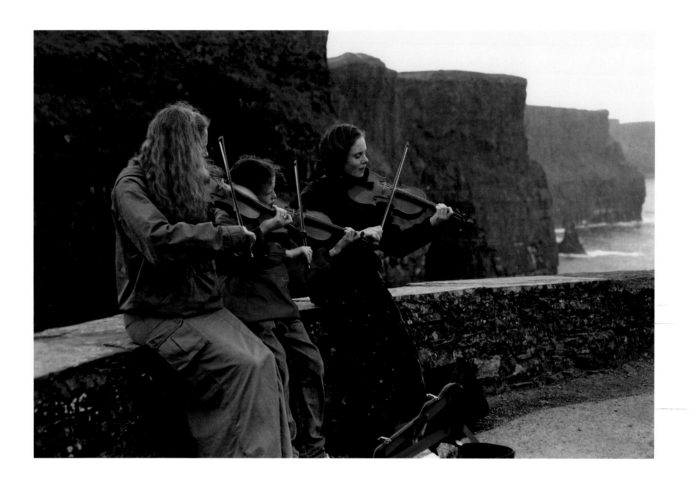

Girls fiddling against the backdrop of the Cliffs of Moher, one of Ireland's most popular tourist attractions. —EB

Ah, the Cliffs of Moher. When I came out of prison in the 1970s, I journeyed there with friends and family. I have a photograph of myself and my son, Gearóid, then just over four years of age, on my shoulders in driving rain with the cliffs behind us. Years later, I had the opportunity to fly in a three-seater plane from Spanish Point along the length of the cliffs, then out across Galway Bay, dipping down over the Aran Islands and back again for panoramic views of the Burren. It was a never-to-be forgotten, roller-coaster of a flight, our plane driven by a bulky farmer (or so he seemed to me), as he rolled up the sleeves of his woolly pullover and lifted us skyward off the edge of Ireland. He drove his little plane like a tractor, easing it gently through airy potholes and chugging his way through and over a startling vista of sea, sky, and rocky coastline, delighting in our excitement as we skimmed and kited on warm thermals high above it all. —GA

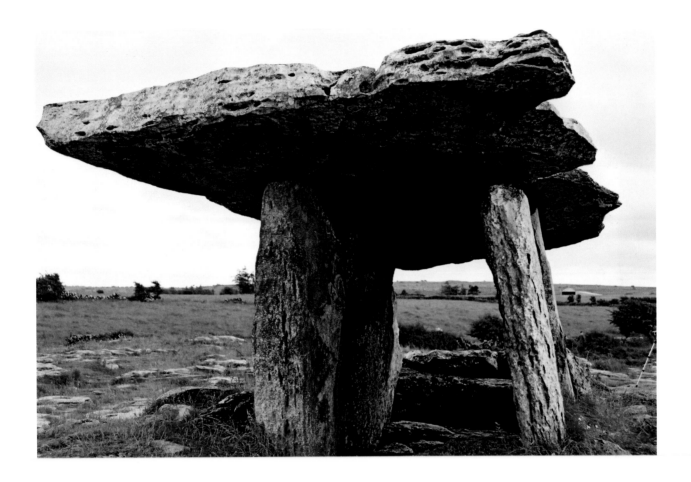

The Poulnabrone Dolmen is located in the Burren, one of the best known and most photo-graphed of all dolmens in Ireland. Legend has it that, if you crawl under this dolmen, it heals your back. The day I visited, there were so many tourists I decided not to, even though I had an aching back. But as I turned to leave, my foot caught on the shale, and I was thrown under the dolmen onto my hands and knees. My sister was with me, and we had a good laugh—and my back has been fine ever since. —EB

This colorful scene affords a view of Galway Bay and, in the distance, the Cliffs of Moher.

The Burren, in County Clare, is a stark limestone landscape of enormous beauty and hidden caves and secrets. It is one of the largest karst landscapes in Europe and a botanist's dream, with more than 1,100 species of plants, including a mix of Alpine, Arctic, and Mediterranean varieties. Settled during the Stone Age, it has scores of megalithic tombs, hundreds of circular earthworks, and deep, limestone caves. It is one of only six national parks in Ireland. —GA

By the twenty-first century, 80,000,000 people in the world would claim Irish descent, with 41,000,000 of them—one-sixth the current U.S. population—living in the United States. The emigrants spread out to many diverse places, including England, continental Europe, South America, and Australia. I was stunned to learn that Ché Guevara was half-Irish. His grandmother was a Lynch from Galway who moved to Argentina. His father said of Ché, "You have to remember the blood of Irish rebels flows through my son's veins."* Not surprisingly, Ché was fascinated with the Irish struggle for independence.

Landing in Shannon Airport during the early 1960s, Ché and his comrades spent the night in the small coastal village of Kilkee, a popular seaside resort which is surrounded by spectacular cliffs and crashing surf. Ché and his group walked into a bar, where a young artist named Jim Fitzpatrick (above) was working. Jim went on to create the iconic image of Ché seen around the world, replicated on a mural (opposite), which is located in Belfast. Fitzpatrick wanted Ché to be remembered in death as he was in life: charismatic and personable. Initially, he made the image available to all, but he has since granted the copyright to Ché's daughter, Aleida, on behalf of the Cuban people and Havana's Ché Guevara Center for Cultural Studies. Jim said to me of Ché that he "had great admiration for the fact that we [Ireland] were the first country to shake off the shackles of the British Empire; we were the first country to free ourselves from the British after 800 years of struggle." Kilkee now has an annual Ché Guevara festival. —EB

Above: Jim Fitzpatrick is a well-known artist specializing in depicting Irish images, legends, and myths (see www.jimfitzpatrick.com).

*From an interview with an unnamed journalist that appeared in the Mexican journal *Siempre* (September 1959).

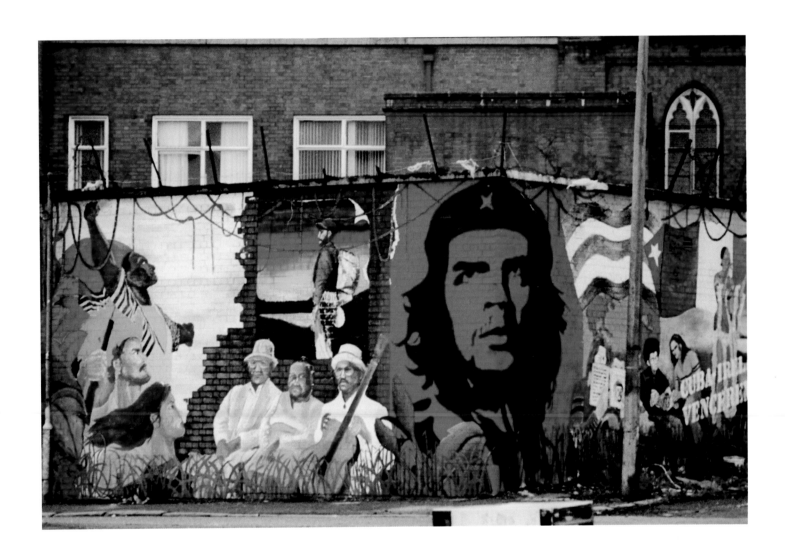

This mural in Belfast depicts Ché Guevara and Cuban life.

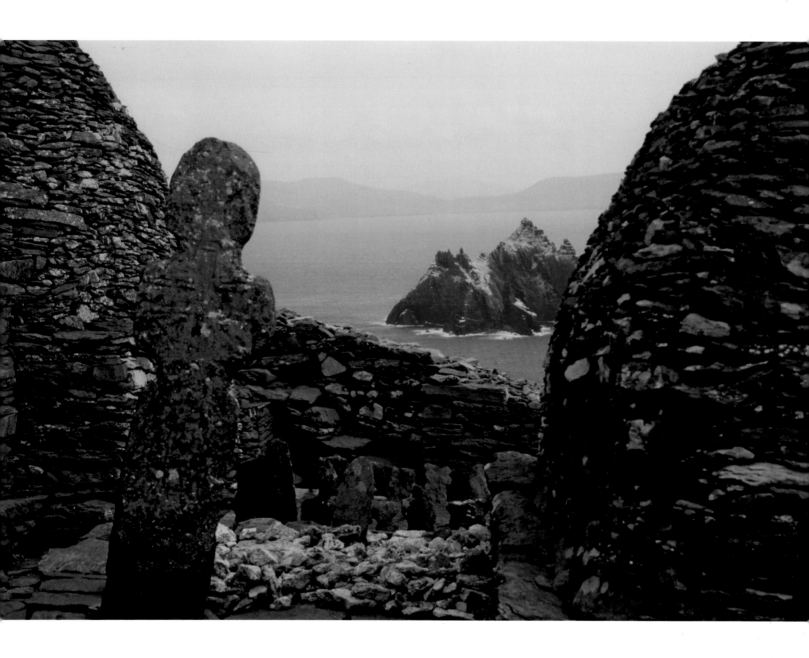

The Skellig Islands are comprised of two small, rocky islands—Great Skellig (also known as Skellig Michael) and Little Skellig—located in the Atlantic Ocean off the coast of County Kerry. Although they appear volcanic—looking like the tips of small, rocky mountains sticking out of the water—they are made of the same 350,000,000-year-old Devonian sandstone found throughout County Kerry, from the headlands in the southwest to the shores of Killarney's lakes. —EB

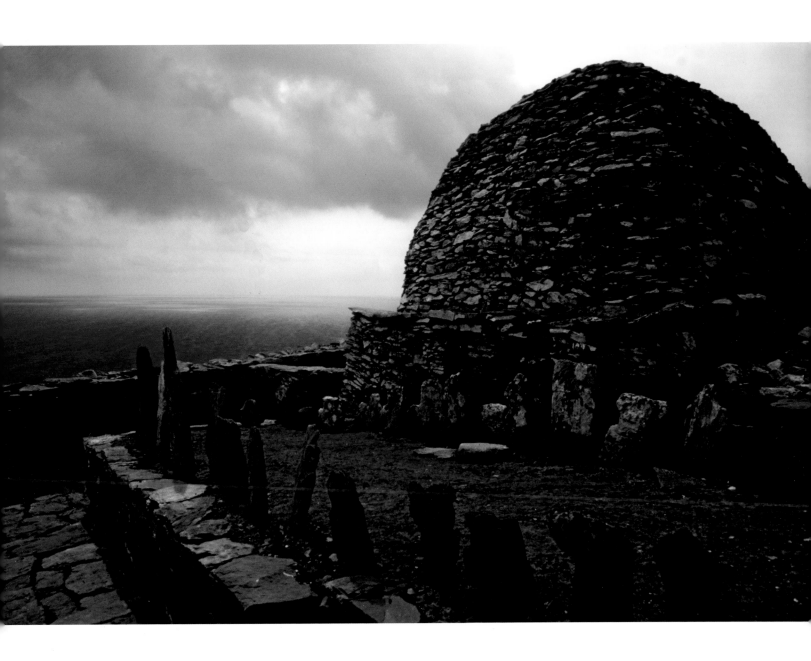

Skellig Michael is a UNESCO World Heritage Site, with the remains of a monastery (above and opposite) built during the Early Christian period (roughly the fifth to eighth century). Little Skellig is renowned as the home of the second-largest colony of gannets in the world, with some 30,000 pairs of these seabirds, which resemble pelicans. —EB

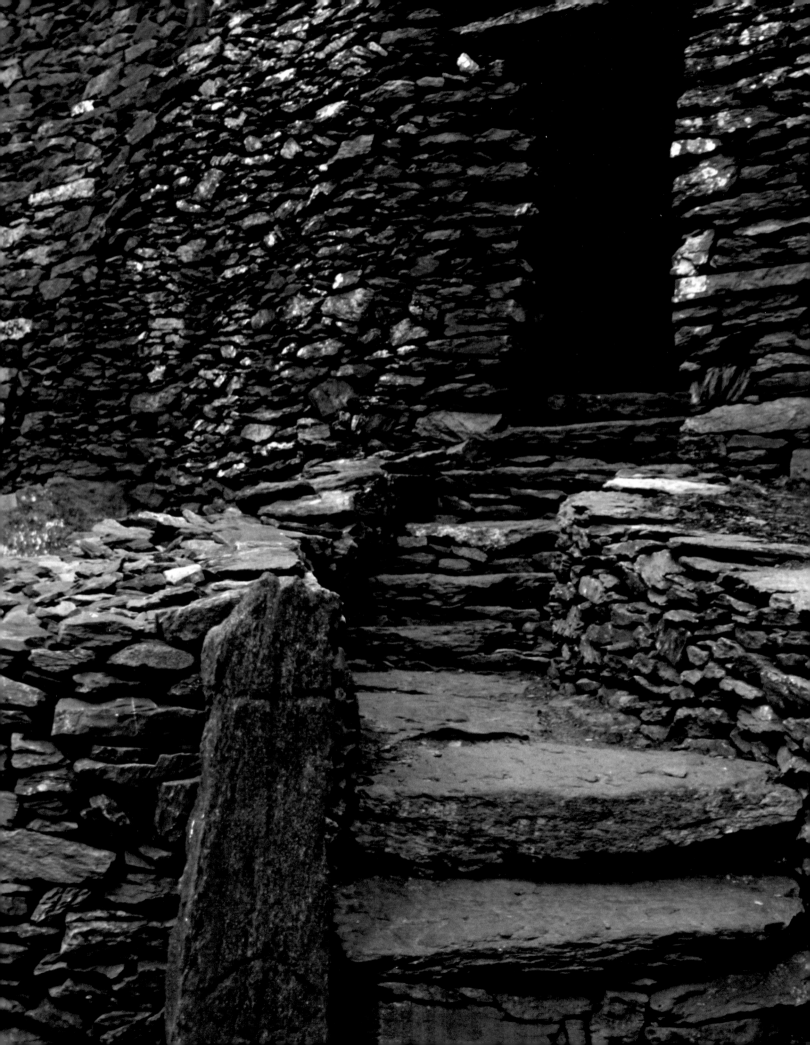

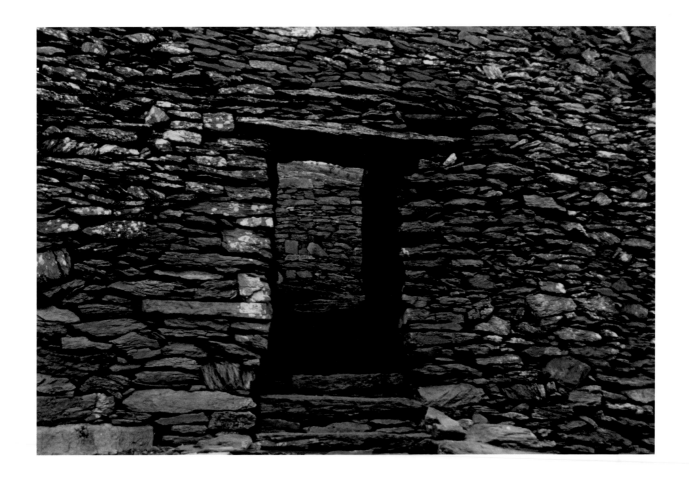

Arriving at the harbor for my departure to visit Skellig Michael, I saw people putting on camouflage outfits. I thought, "How fun, an adventure company." When I got on my boat, they gave me one, too. I was concerned for my camera but found a safe, dry spot in the cabin. Good thing, too, as my camo jacket was anything but waterproof. As we bounced toward the islands, waves pounded over the boat. Watching the mainland recede in the distance, I couldn't help but think of those on the famine ships during the nineteenth century who didn't want to leave, and I was very moved, imagining the painful longing they must have felt for their homeland. Meanwhile, all around me people were fainting and throwing up, as the boat pitched up and down. When we landed and started walking up the 1,000-foot, uneven shale steps, the wind blew fiercely, drying me instantly and covering me in a fine veil of sea salt. We hiked up to the beehive-shaped huts (pages 34–35) where the monks had lived. With nothing to sit on but uneven shale, it looked anything but comfortable. —EB

County Kerry, which juts into the Atlantic Ocean from the southwestern tip of Ireland and is bounded on the north by the River Shannon, features many inlets and peninsulas. Like the rest of Ireland, its history is complicated and includes various wars, rebellions, and uprisings against the British. Kerry is one of the most beautiful and most mountainous counties in Ireland, with lots of stone circles, the famous Lakes of Killarney (opposite), and the Gap of Dunloe, a rugged and narrow mountain pass of glacial-carved sandstone popular with rock climbers that lies between Macgillicuddy's Reeks and Purple Mountain on the Iveragh Peninsula near the Lakes of Killarney. (The word "reek" is derived from the old English "rick," which means "stack.") It's a geologically rich area and contains the country's three highest peaks: Carrauntoohil (3,406 feet or 1,038 meters elevation), Beenkeragh (3,308 feet or 1,008 meters) and Caher (3,284 feet or 1,001 meters), as well as many others that exceed 2,000 feet (610 meters) in elevation. Because of its location proximate to the North Atlantic Current, part of the Gulf Stream, the county boasts milder temperatures and high rainfall, which allows for subtropical plants, such as ferns, to thrive here. —EB

Following spread: Sheep graze the bottomlands of the Gap of Dunloe.

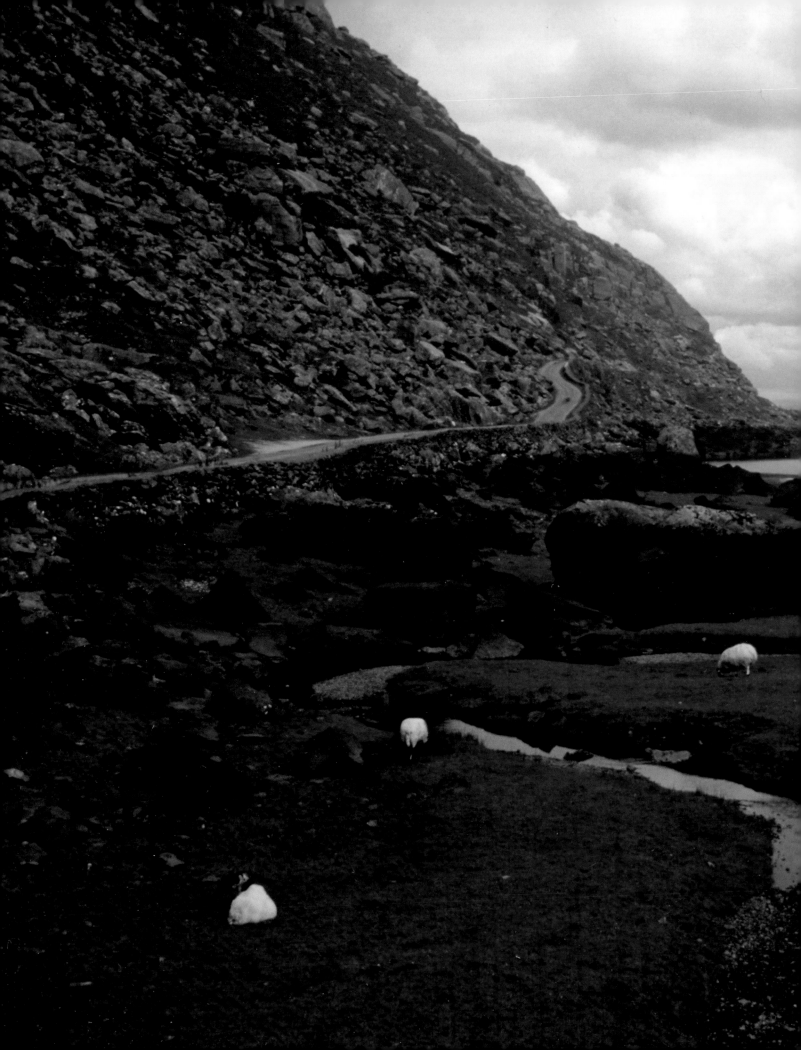

Opposite and the two following spreads: I took a horse-and-buggy ride through the Gap of Dunloe, which is so steep that the entire group had to get out so the horses could make it up the hill. We passed craggy cliffs, meandering streams, and deep, green valleys with expansive panoramas. After stopping for lunch, we left the carriage behind and boarded boats (like those pictured on the following spread) for the rest of the trip, navigating our way through three lakes connected by two rivers and ending up at the inlet just below Ross Castle (pictured on page 22). It was a memorable adventure. —EB

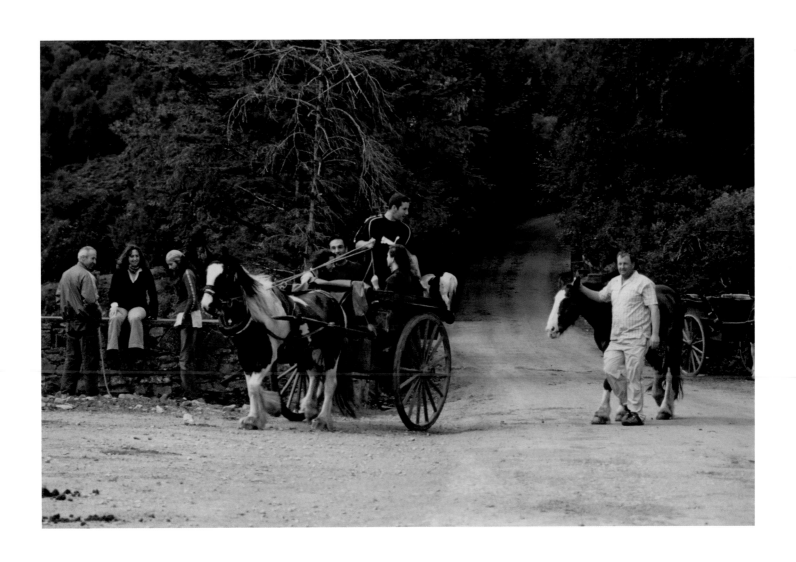

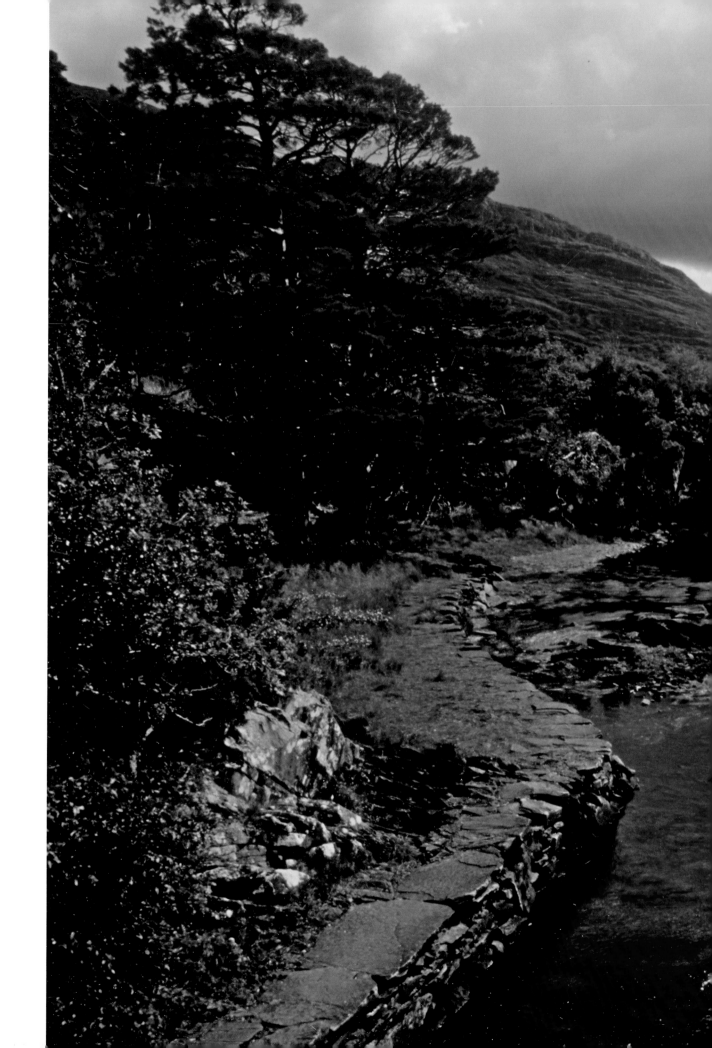

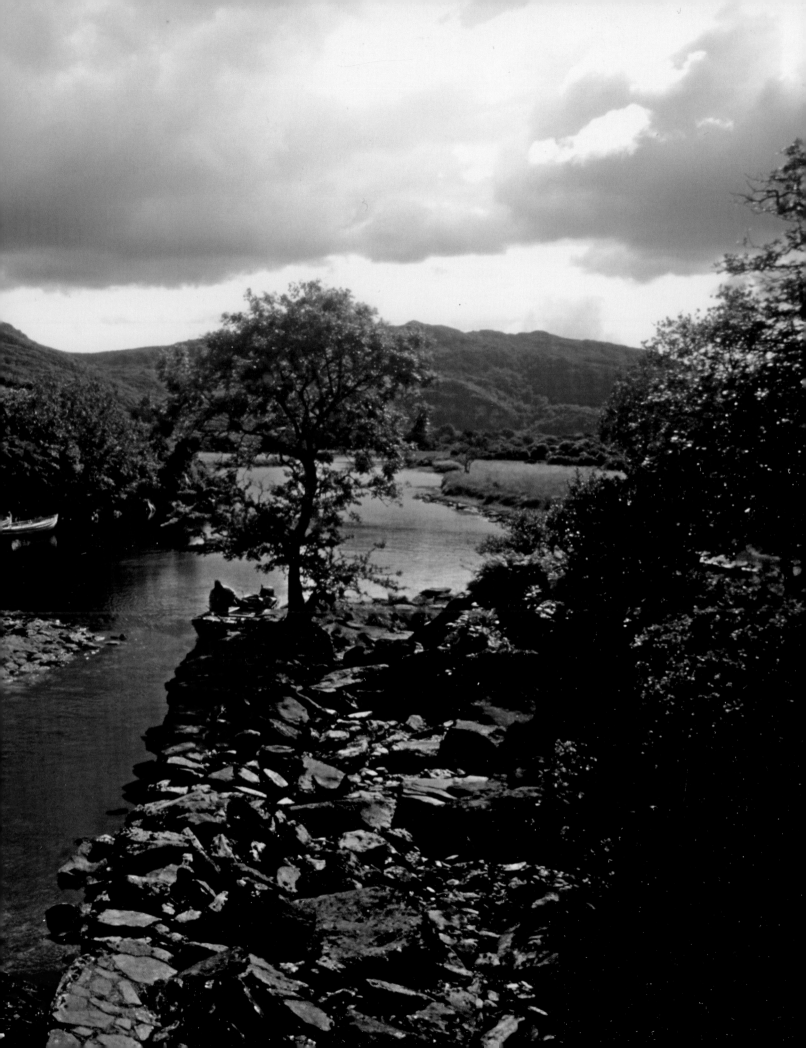

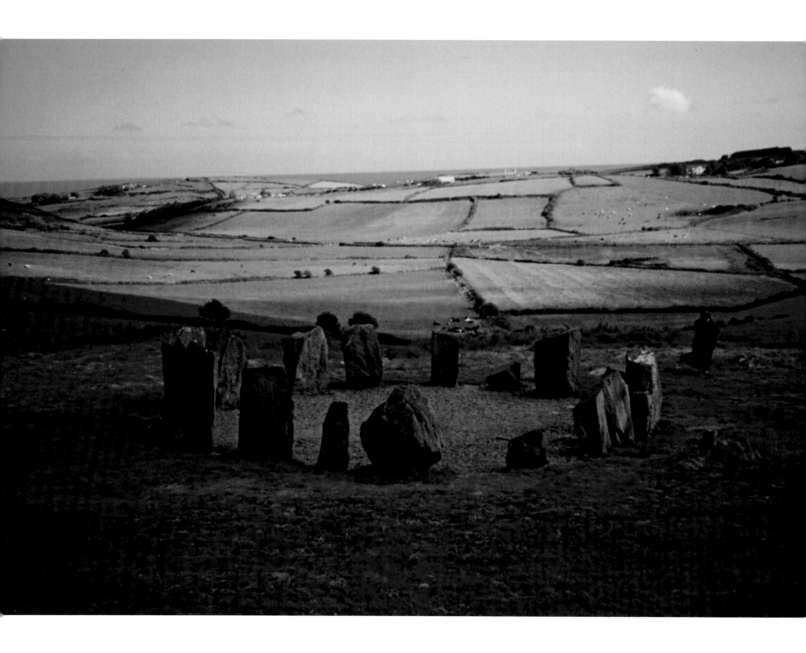

Drumbeg (also spelled Drombeg) stone circle, located just east of Glandore in County Cork, is one of the most visited megalithic sites in Ireland. Thirteen of the original seventeen stones survive. Between two of them is a large hole that, we were told, was used as a primitive cooking pot. It would be filled with water and heated stones thrown in to cook the food. This Bronze Age site was excavated and restored in 1957. It is believed the site was active in CE 800–1100.
—EB

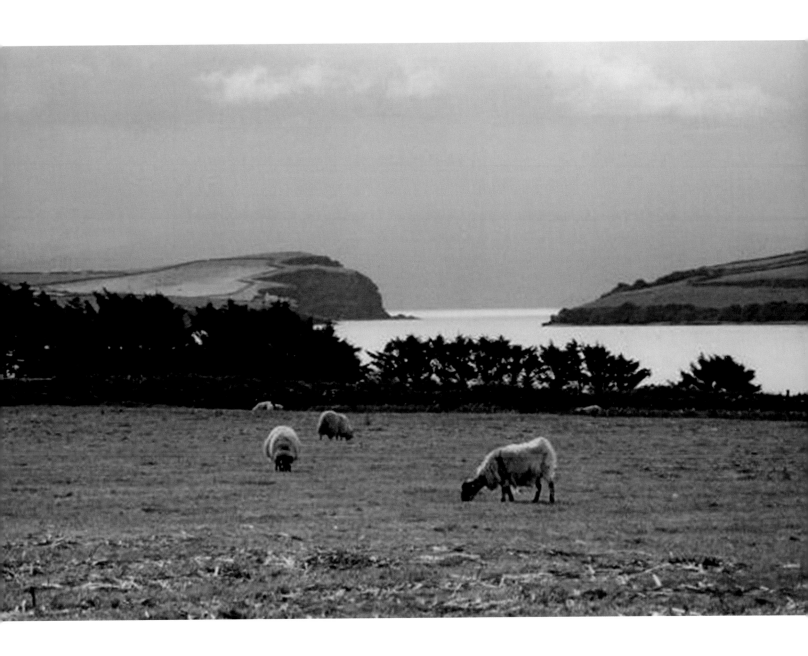

The harbor of Dingle, on the western coast of Kerry, was developed as an important port following the Norman invasion in CE 1169–1171. It is the only one on the Dingle Peninsula. Fungie, the famous (aka Dingle) bottlenose dolphin began frequenting the harbor and delighting visitors in 1984. —EB

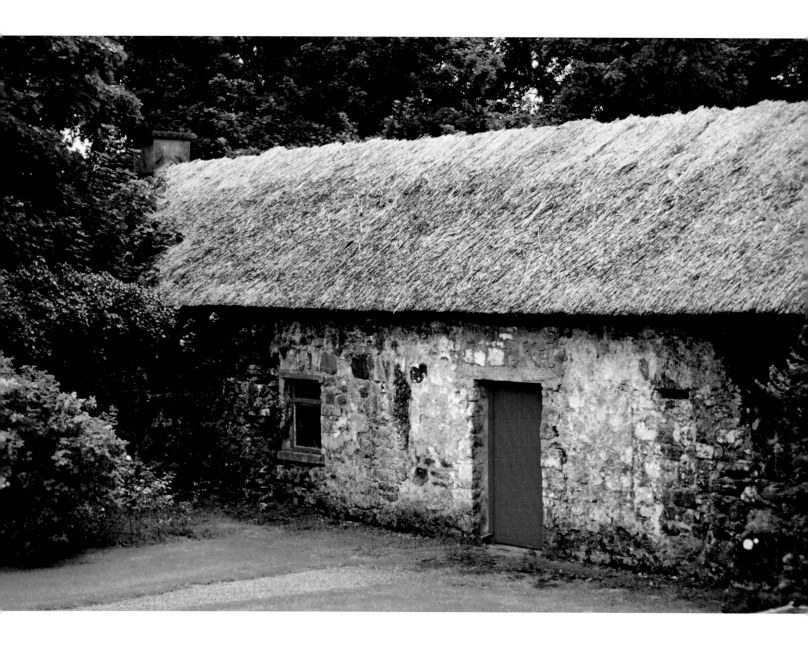

The marvelous fresh air of Ireland is often laced with burning peat wafting up from traditional thatched-roof cottages like these (above and opposite) in County Clare. I love the variety of the creative designs within the thatch, and I love the organic, musty smell of burning peat. Unfortunately, fewer than 1,300 thatched-roof buildings remain in Ireland out of the hundreds of thousands that existed but half a century ago. Thus, a central feature of the Irish landscape is rapidly disappearing, as is the craft of thatching. —EB

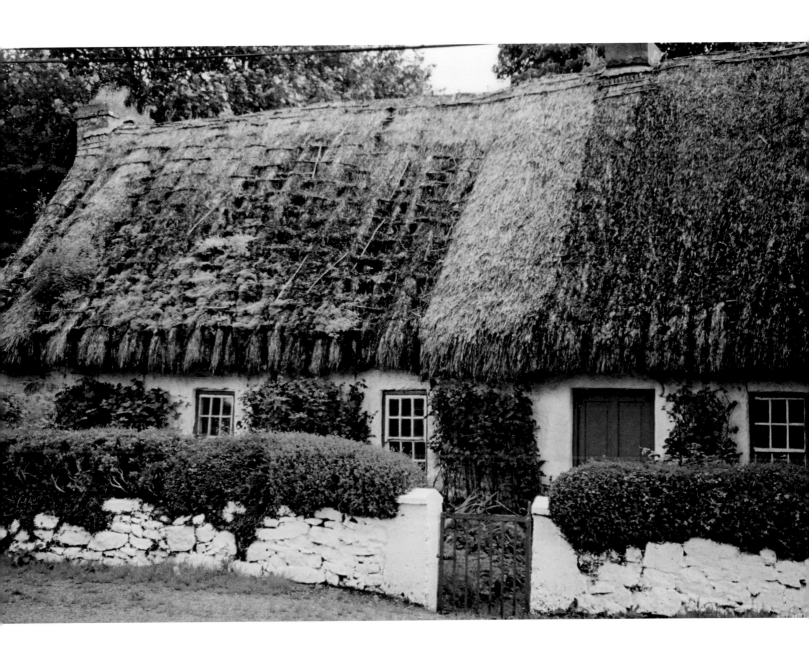

Pink is my favorite color. If you don't believe me, ask my granddaughters, Drithie, Luisne, or Anna, who will testify to my preference for this gloriously soft color, which I like to think of as the most subversive of hues. I like to imagine the owners of our pink buildings as a great Irish movement proudly hanging out this bright color as a cheerful contrast to our reputation as a conservative people. Wayfarers like me are delighted to stumble upon pastel-colored cottages such as those in Doolin (opposite), after wending their way through the famously wet and green terrain. Doolin is a noted center of traditional Irish music, often played in its fabulous pubs. It is also a gateway to the Aran Islands and Burren and borders the spa town of Lisdoonvarna. —GA

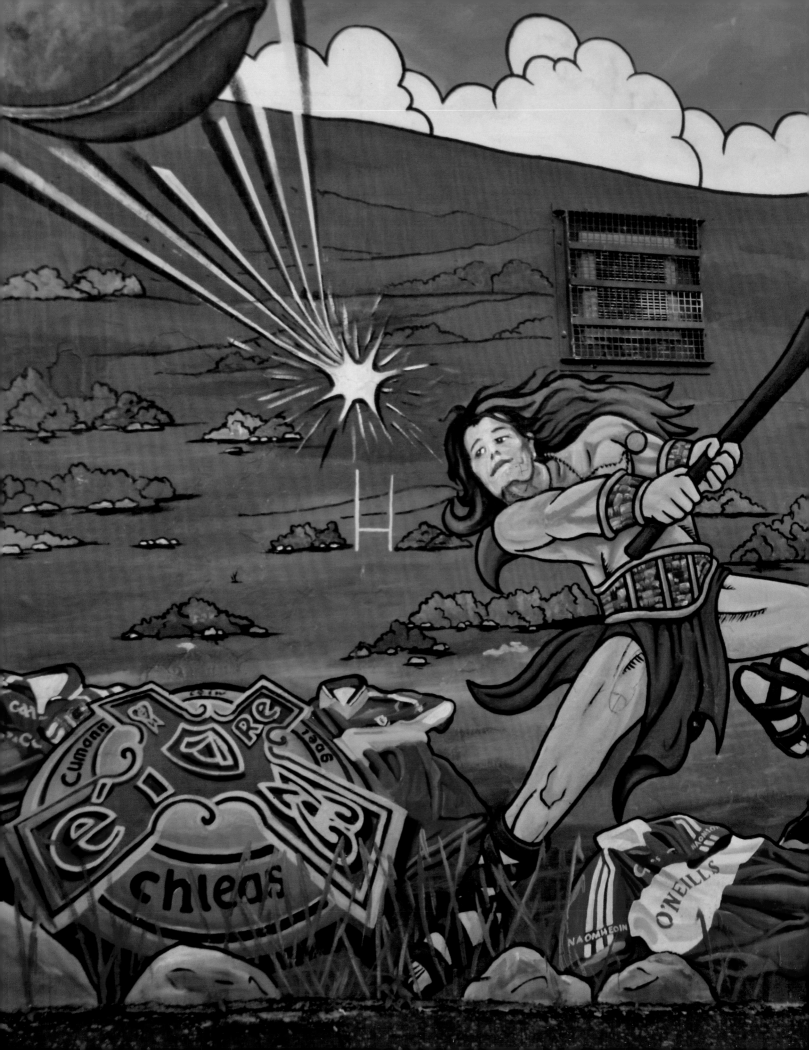

HURLING

Hurling is the oldest and fastest field game in the world. It pre-dates St. Patrick's arrival in Ireland, and there are records citing the game dating as far back as the fifth century, when it was played by warriors. Today, it is played by two teams, each with fifteen hurlers, on a grass playing field about 450 feet (137 meters) long and 270 feet (82 meters) wide.

The hurley stick, also called a hurl or *camán*, is made of ash and measures about three feet long (one meter). It has a curved, broad, striking end, called the *bos*. This is used to strike or to carry a small leather ball or *sliotar*, as the two teams battle to score goals or points against each other. The goal posts are not unlike those used in rugby.

Hurley is a tremendously skillful game, with players hitting the *sliotar* at great speed, hooking and blocking each other as they vie for posses-sion. A good game of hurley has speed, drama, courage, skill, and athleticism. There is high fielding, as players leap into the air to pluck the sliotar out of the sky or to "pull on it." There are a variety of skills, including sideline cuts, long pucks—*poc fada*—the ability to strike the sliotar with the hurl while running at speed or to steal it from the opponent.

I believe that hurling is one of the best things in life. Of that there can be no doubt. Ever since Gerry Begley and Paddy Elliot introduced me to a hurling stick when I was about five years old and they were young gladiators representing Dwyer's GAC in West Belfast, the passion for hurley has never left me.

The Christian brothers from Saint Finian's Primary School on the Falls Road, in Belfast (but Munster-born to a man), brought discipline and organization to our juvenile sporting endeavors. In the back of our class, I idled away the time by fantasizing how I would play for Antrim. (I never did.) Now I idle away the time fantasizing about how good I used to be. The older you get, the better you remember having been, appears to be a common tendency for sports people in my peer group, spoofers all, including me.

My best schoolboy memory was being singled out for praise by our *banisteoir* (manager) for my performance on a Belfast versus Dublin schools game in Casement. I was injured during that game and limped back and forth between my granny's and school for ages afterward wearing my wound like a badge of honor.

My Uncle Paddy and Uncle Francie were handy hurlers. So was my Uncle Dominic. My older brother, Paddy, was a handy hurler also. On the days before internment in August 1971, I remem-ber a squad of us, including young women from the Seán Treacy's Hurling Club, pucking a sliothar back and forth between us on the old pitch at McCrory Park in Belfast. (Hurley is also played by women. Their game, *camogie*, is more graceful than the male version but just as exciting.)

A few years later in the cages of Long Kesh prison camp when we were refused permission to have hurling sticks we made our own. Cleaky and big Duice and the more practically minded Gaels in our ranks did so by removing lengths of timber from the innards of our nissen huts and shaping out hurls for the rest of us.

The screws (prison officers) were mightily alarmed and impressed when we Cage Eleven hurlers showed off our skills on the playing fields of Long Kesh. Unfortunately, our boxwood hurleys were no substitute for the real McCoy. Ash is your only man. Cleaky's camáns barely lasted ten minutes. But, as he said later, we made our point.
—GA

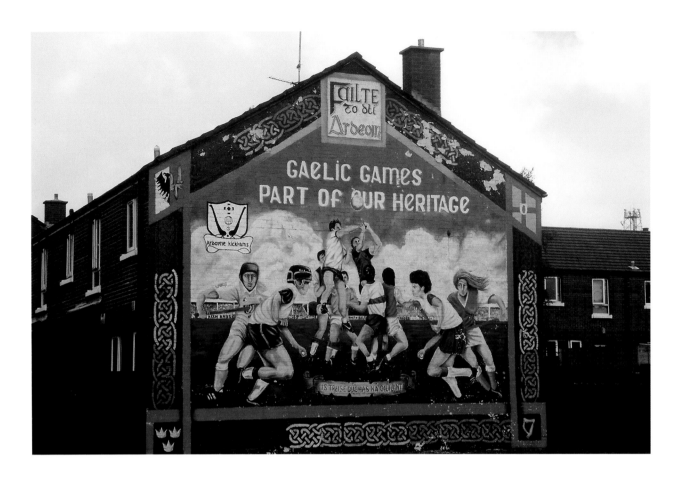

Above: This mural in Belfast celebrates hurling as the national sport.

Opposite: A friend and I traveled to see the finals of an All-Ireland Poc Fada Hurling and Camogie Championship for men and women. It was quite an uphill hike to get to the competition, which was in the magnificent Cooley Mountains in northern Louth. To start, the teams followed a bagpipe procession up the hills, with us trailing behind, huffing and puffing. And then they played, running up and down the mountains! Each contestant must have a spotter, as the sliotar inevitably lands in very deep, purple heather. We hiked part of the course and were exhausted. Our arduous climb was well worth it, though, for the view is unsurpassed. The Carlingford Lough, the glacial fjord that here separates the border between North and South, stretched out below us in both directions, and we could see ships passing through, with the magnificent Mourne Mountains, a granite mountain range popular with hikers and climbers, forming the backdrop to the grand scene. —EB

Page 54: This mural in Belfast beautifully depicts Ireland's mythic hero, *Cú Chulainn* (Chu Chlainn), who is often compared to Achilles (the mythic Greek hero of the Trojan War), playing hurley. —EB

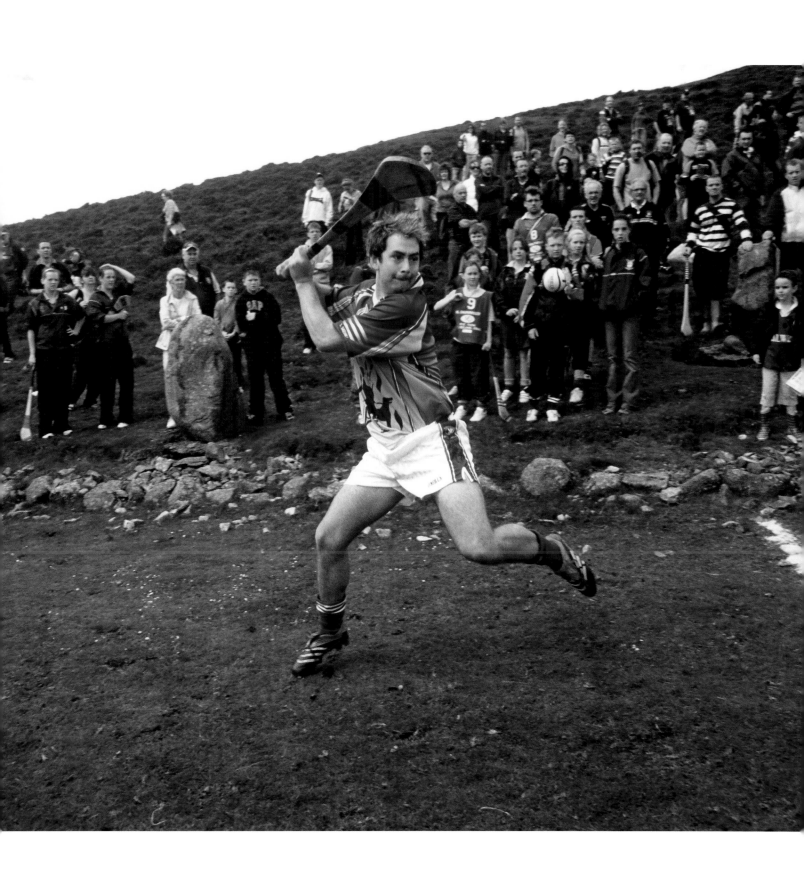

Two Irish women enjoy a bit of camaraderie and a rest from touring the ruins at Glendalough. Despite the partial destruction of the sixth-century monastery in 1398 by English forces, it has always continued as a place of pilgrimage and a religious site of importance. —EB

Leinster

LEINSTER IS THE EASTERNMOST PROVINCE OF IRELAND and, with more than 2,500,000 people, the most heavily populated. About half live in Dublin, the capital of the country. I now represent the constituency of Louth, which is in the north-eastern part of the province, close to the Ulster border, about an hour from Belfast to the north and from Dublin to the south. For twenty-three years, I was honored to represent the citizens of West Belfast in Ulster, but, in 2011, I was elected as a TD, or *Teachta Dála* (Representative), to the Irish Parliament. It is a special privilege to be a TD for this wonderful place and its very welcoming people.

Although the constituency is called Louth, it includes a piece of County Meath. Both counties Louth and Meath stretch along Ireland's eastern coast from the border southward. The countryside is strikingly beautiful and historic. It resonates with the Neolithic legacy of *Brú na Bóinne*, which is a World Heritage Site, and a remarkable complex of Neolithic chamber tombs and passage graves that predate the Egyptian pyramids.

Leinster is also the site of Annagassan on the shore of Dundalk Bay, where *Linn Duachaill*, one of the best-preserved examples of an early Viking settlement, was rediscovered after 1,000 years. Indeed, Leinster contains many Viking sites; even the name 'Dublin' comes from the Viking *Dubh Linn* and 'Wexford' from *Weis Fjord*. It is the province with the most counties, twelve, which include Carlow, Dublin, Kildare, Kilkenny, Laois, Longford, Louth, Meath, Offaly, Westmeath, Wexford, and Wicklow.

Leinster's landscape is as diverse as its counties, from the expansive farmland in the north to the dramatic Wicklow Mountains south of Dublin. The Wicklow Mountains are the largest area of continuous high ground in Ireland. Their glaciated, rolling, peat-covered uplands are blanketed in purple heather and bright yellow gorse. They provided the stunning setting for the movie "Braveheart" (1995), which was filmed there and won an Academy Award for best picture of the year.

County Meath is the seat of the high kings, with its ancient coronation site, Tara, and the early Celtic site of Newgrange. Much of our most wonderful music and poetry also comes from Leinster. From the Mountains of Mourne to the Boyne and all the bits in between we find echoes of our famous poets: Peadar Ó Direáin, Art McCooey (*Art na gCeoltai*), Patrick Kavanagh, and Francis Ledwidge, who was killed in France during World War I. Come and walk in their footsteps, in the heart of the Cooley Mountains or the green grassy slopes of the Boyne, through the walled streets of Drogheda, or along the shores of Dundalk Bay. You won't be disappointed! —GA

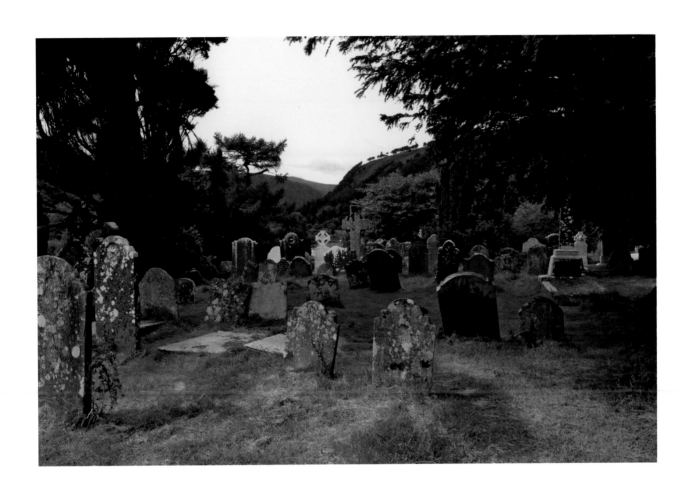

Glendalough, the "glen of two lakes," is an abandoned Cistercian monastery in
the Wicklow Mountains founded during the sixth century CE by St. Kevin, a famed
holy man. The graveyard (above) is one of its remaining features.

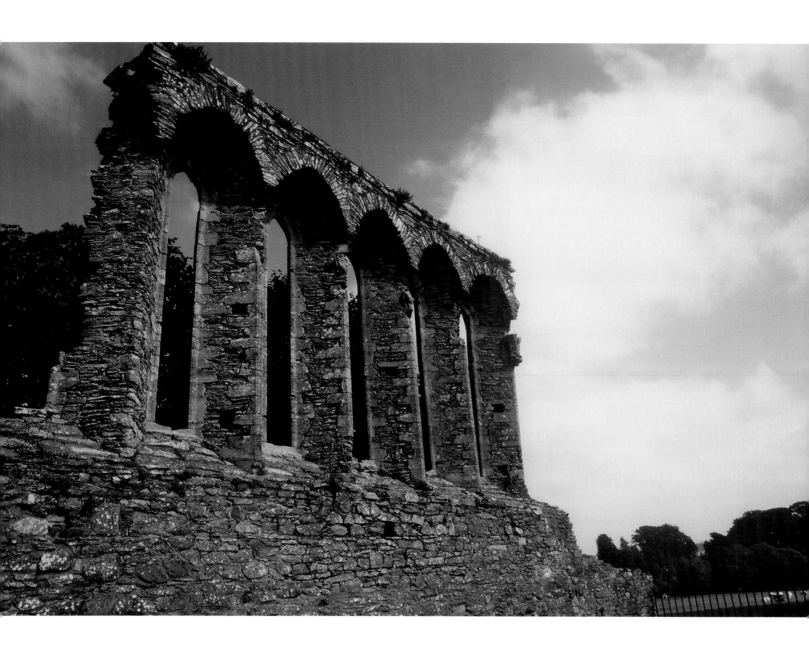

One can imagine the past grandeur of this church, now a ruin in County Wexford.

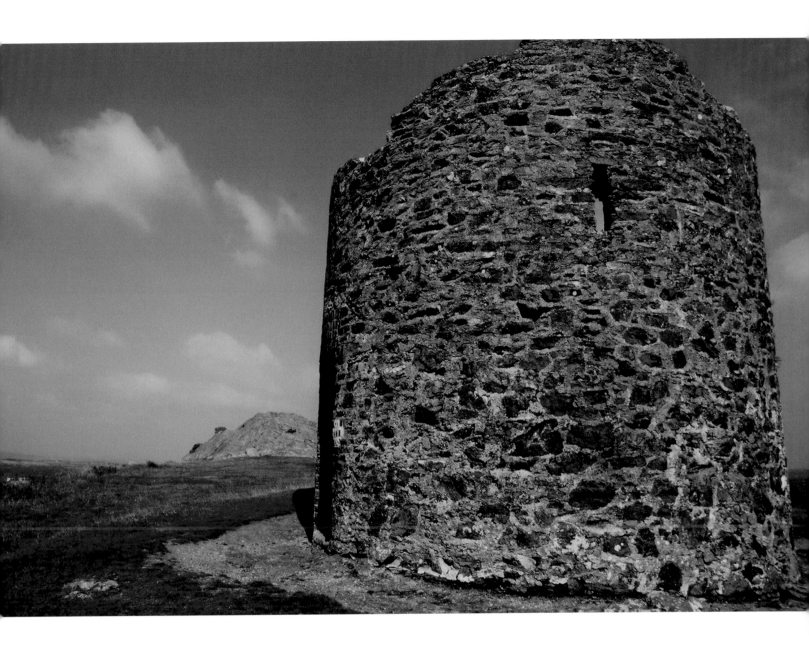

This tower ruin on Vinegar Hill in County Wexford is a reminder of the Battle of Vinegar Hill fought here and in nearby Enniscorthy on June 21, 1798, a turning point in the Irish Rebellion.

The Long Woman's Grave, in the Windy Gap Omeath of the Cooley Mountains, is associated with one of Ireland's most memorable myths.

Decades ago, I started walking in the Cooley Mountains. I wandered along the spine of Corrakit (following spread) to the Long Woman's Grave (The Cairn of Cauthleen) and then down through Glenmore before swinging left up and across Bearna Maebh. With a few good dogs, I tracked mountain goats and watched hawks swooping on unsuspecting pigeons.

I walk there to this day. To my right is Dundalk Bay, and on a clear day away beyond that is the Hill of Howth and further still, if it is really clear, the Sugarloaf, Wicklow, and Dublin mountains. To the left are Carlingford, Lough, and the Mountains of Mourne, while tucked in the lee of Sliabh Foy and the edge of Lough is the picturesque village of Carlingford.

I have many happy memories here long before it developed its very fine eating houses and finer cuisine. I spent lazy Sundays on its deserted seafront, gazing across at Warrenpoint and Rostrevor while a British gunboat patrolled the waters between us, and I wondered if they were watching me watching them watching me. Thankfully, the war is over, and only ghosts patrol these waters now where Vikings and then British paratroopers once had their day. —GA

The beautiful Boyne Valley (right) is located in County Meath, north of Dublin. Salmon and trout can be caught in the river, which was first recorded in a second-century map by Ptolemy, the Greek geographer. The bucolic river valley is steeped in Irish history and dotted with stunning megalithic monuments. —EB

Following spread: The misty Mountains of Mourne offer a variety of landscapes—from dramatic peaks to gentle foothills and scenic farms—to explore in a confined geographical area. They most famously inspired C. S. Lewis to create the kingdom of Narnia in his classic series of fantasy novels for children, *The Chronicles of Narnia*. —EB

The most famous complex in the Boyne Valley is
Brú na Bóinne, so named for its location along a
bend in the river. The largest of these mounds is
Newgrange, an ancient temple and passage tomb, a
ceremonial, religious, and spiritual site as significant
to the ancients of Ireland as were the pyramids to
the Egyptians and Stonehenge to the inhabitants of
Britain—but even older, constructed more than 5,000
years ago. —EB

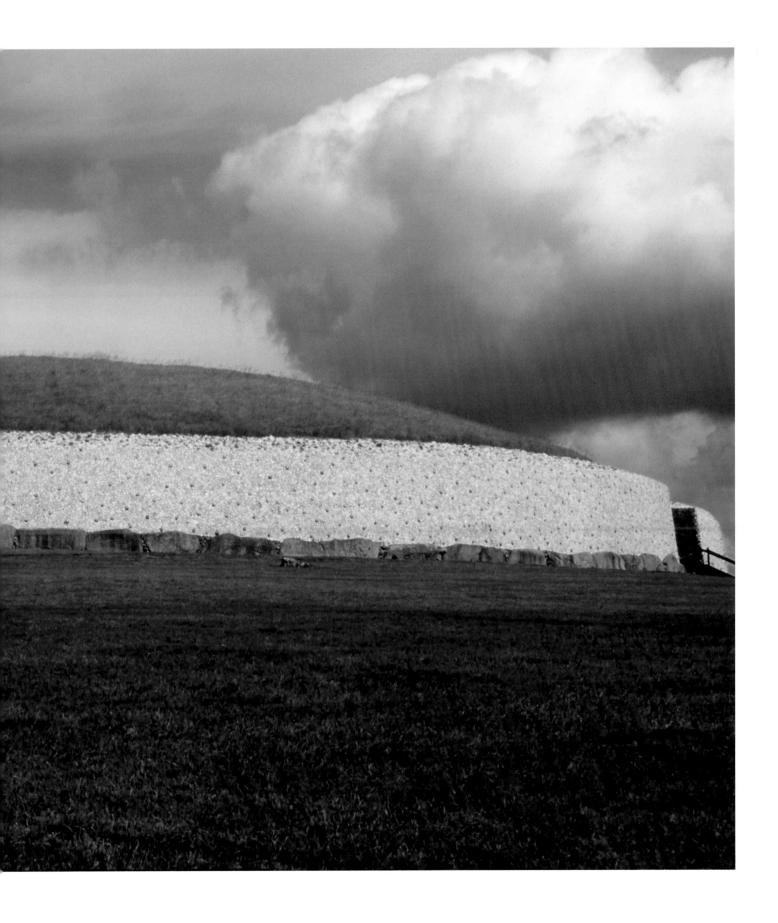

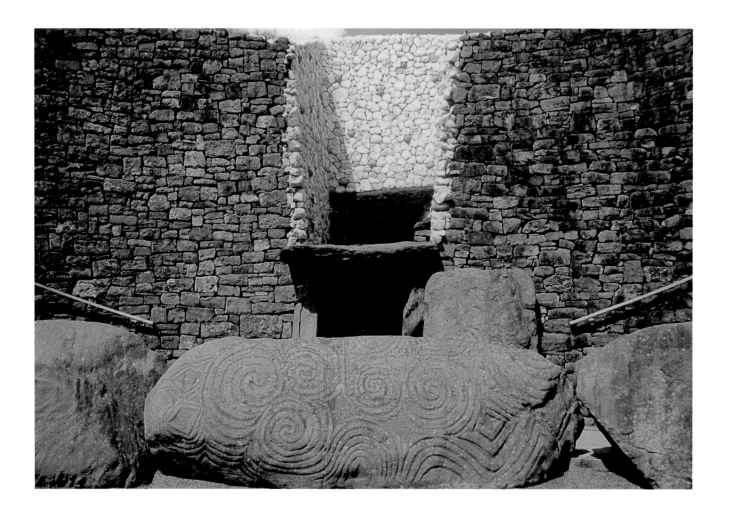

Above: Entering the tomb, I was intrigued to see triple-spiral designs carved on the massive stones, which are also found in aboriginal carvings in Australia and North America. The interior chamber has been watertight since its construction. It is also pitch-black inside, a stark contrast to the bright white, river rock that covers part of the exterior and glistens in the sunlight. Newgrange was built so that the interior passage and chamber are illuminated by the winter solstice—a remarkable feat when you consider, again, that it was built more than 1,000 years before Stonehenge. I was profoundly moved by the experience of standing in dust that has been walked on by the ancestors. —EB

Opposite, top: A well-preserved outbuilding at Newgrange harkens back to a time when everyday buildings, as well as tools and weapons, were made of stone.

Opposite, bottom: Knowth, another smaller megalithic tomb at Brú na Bóinne. (along with Dowth and Newgrange) comprise a UNESCO World Heritage Site. The whole area is, quite simply, an amazing vortex of energy. Six times I tried to leave by different routes but kept ending up back where I started. I finally managed to get out of there on the seventh attempt, but I couldn't help but wonder if the fairies were playing with me and laughing out loud! —EB

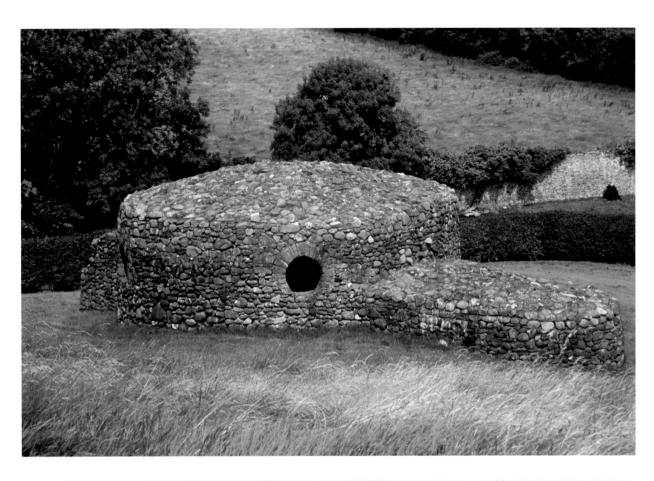

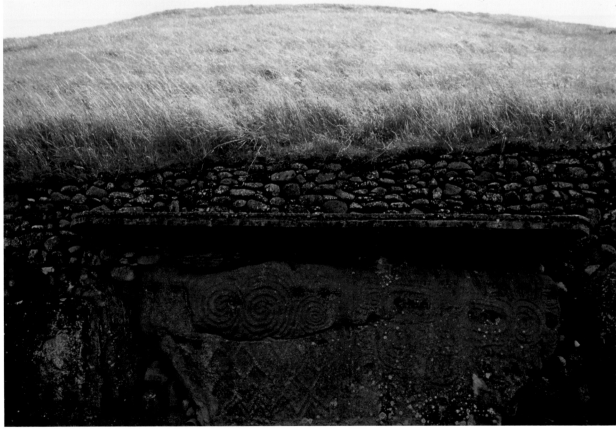

The legendary Hill of Tara, another famed archaeological complex located in the Boyne Valley, is thought to be more than 6,000 years old. Its significance dates from Celtic times if not earlier, as it was considered the seat of the high kings of Ireland. This was where coronations were held and, according to legend, where the Irish king married Maeve, the primal Earth goddess. Many magnificent hawthorne trees ring the *Lia Fail*, the "stone of destiny" (opposite), the site where the high kings of Ireland were crowned. I happened upon the Hill of Tara during a total solar eclipse which attracted a large crowd of people wearing special eclipse-viewing glasses. It was quite a sight: The ancient meets the modern! —EB

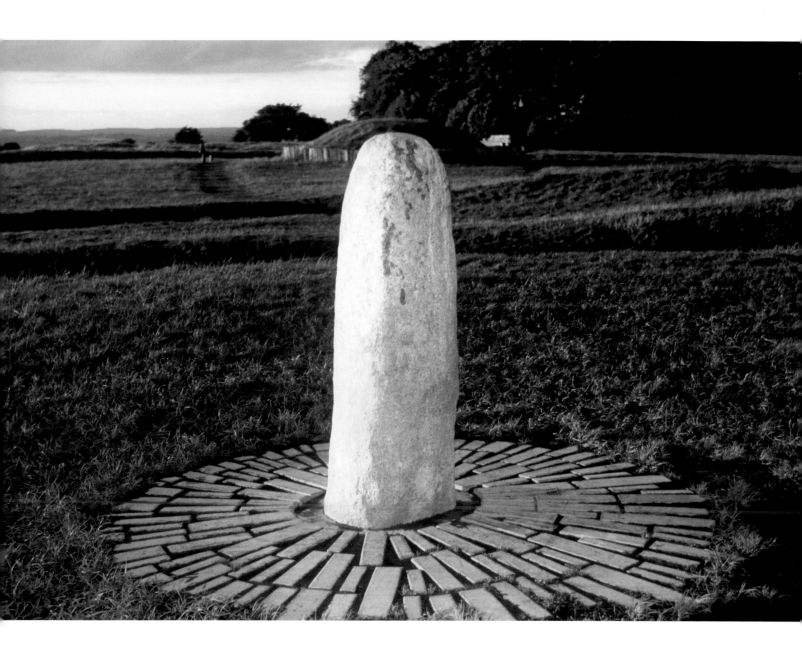

How *Lia Fail* came to Ireland from Scotland is the source of conflicting legends in Celtic mythology, but, even today, it is thought by some to be magical. A favorite story suggests that, when the "rightful High King of Ireland" put his feet on it, the stone "roared in joy and glee." —EB

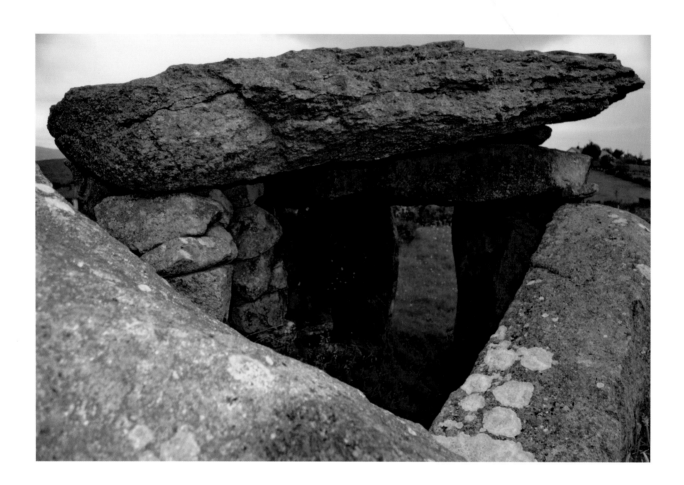

A dolmen, also known as a portal tomb or grave, is a type of single-chamber, megalithic tomb, typically built with several upright stones supporting a large, flat capstone. They are all over Ireland and can be found in the rest of western Europe as well. Most date from the early Neolithic period (4,000 to 3,000 BCE), and their builders are unknown. One day I set off with a friend in search of the dolmen Clongarty (above and opposite), which is located in the beautiful Louth countryside. We searched and searched and finally asked a local farmer if he could tell us where to find it. Smiling, he gave us directions that ended with, 'Yeah, there's a pile of stones up there.' We followed his instructions and found one of the most spectacular dolmens I've ever seen. —EB

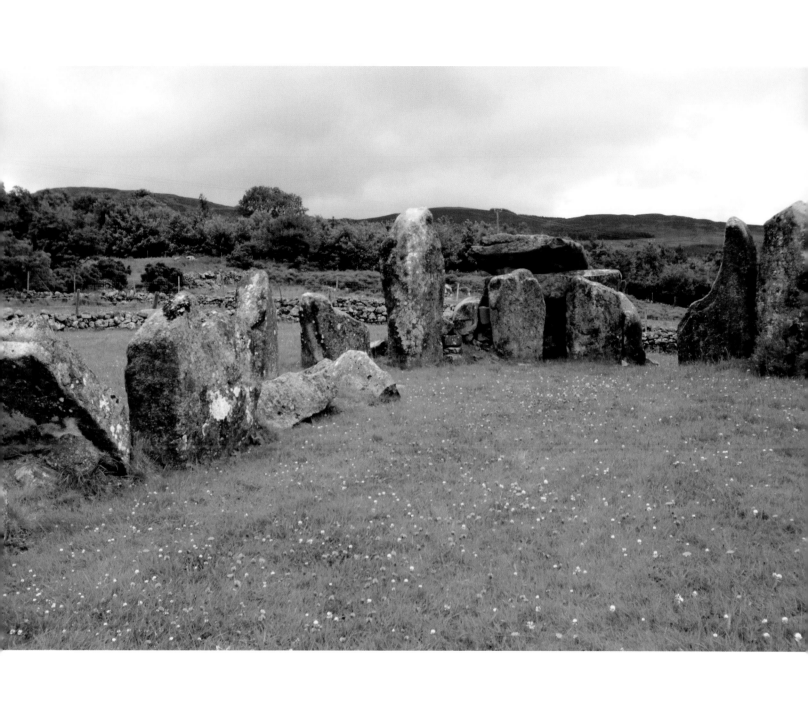

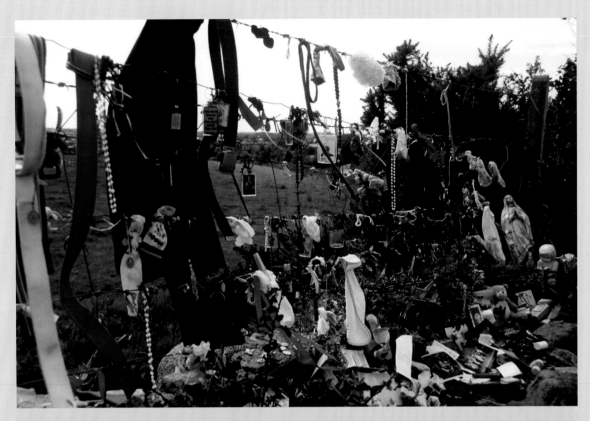

SHRINES

Stone wells and shrines can be found all over Ireland. The wells are thought to have very specific properties for healing different parts of the body, including the back, eyes, and teeth. Each is filled with offerings of hope and faith.

Ireland is a very religious country and there are shrines to Mary and other saints all over. St. Brigid's Well is considered a healing site like Lourdes in France or El Santuario de Chimayó,

which is located in the village of Chimayó about thirty miles north of where I live in Santa Fe, New Mexico. The sanctuary at St. Brigid's is beautiful and full of offerings people have left, asking for healing for themselves or others. St. Brigid is one of the patron saints of the Irish (along with St. Patrick) and also, long before the arrival of Christianity to Ireland, a Druidic goddess. —EB

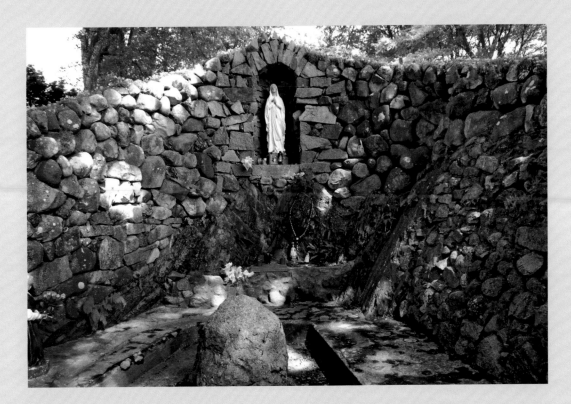

This shrine to Mary in County Louth, Leinster, has the feel of a grotto.

Oppositte: Each shrine in Ireland has its own character, such as the one in County Louth, Leinster (top), and St. Brigid's Well in Liscannor, County Clare, Munster (bottom).

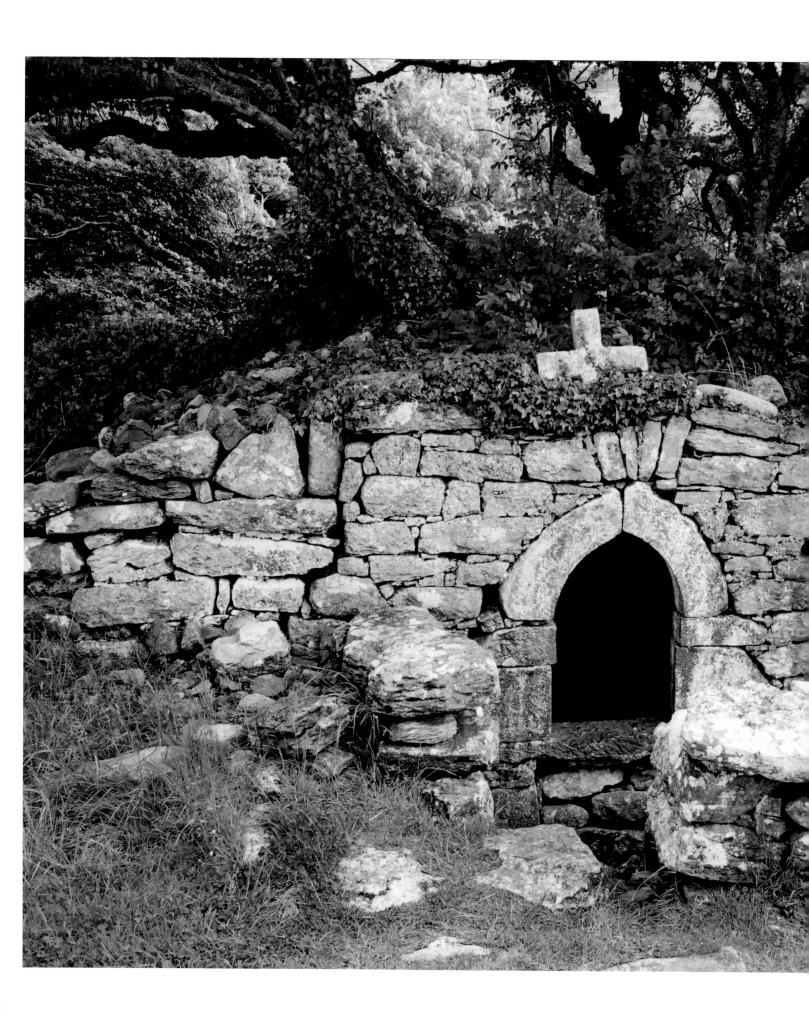

This beautiful holy well near Ballyvaughan,
a small village on the shores of Galway Bay,
displays artful craftsmanship.

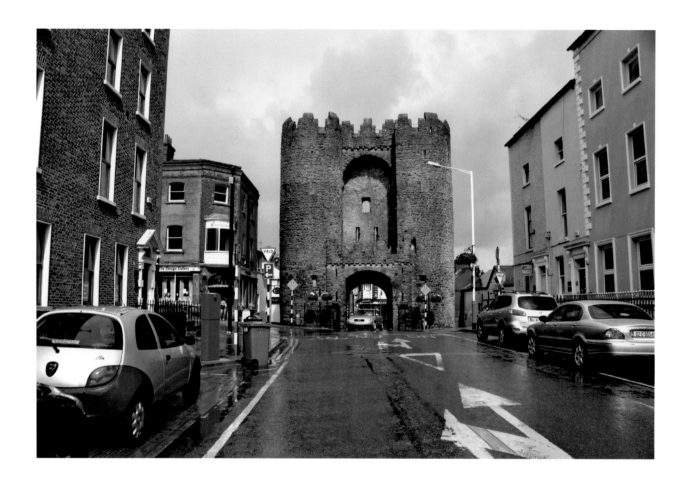

Seventeenth-century gates, such as St. Laurence's (above), remain key landmarks in Drogheda, the site of a pivitol conflict in Irish history. Oliver Cromwell captured the town in September 1649 and killed most of the garrison and many of the inhabitants. Others were sent to Barbados as slaves. The devastation caused by the Cromwellian invasion of Ireland, the confiscation of huge amounts of land by the English, and later victory of King William at the battle of the Boyne in 1690 reshaped Ireland. The Battle of the Boyne (Cath na Bóinne), fought near here on the River Boyne, which runs through Drogheda on on its way to the nearby Irish Sea, was fought between two rival claimants of the English throne, the Catholic King James and the Protestant King William. William's victory helped ensure the English and Protestant ascent in Ireland for centuries. —GA

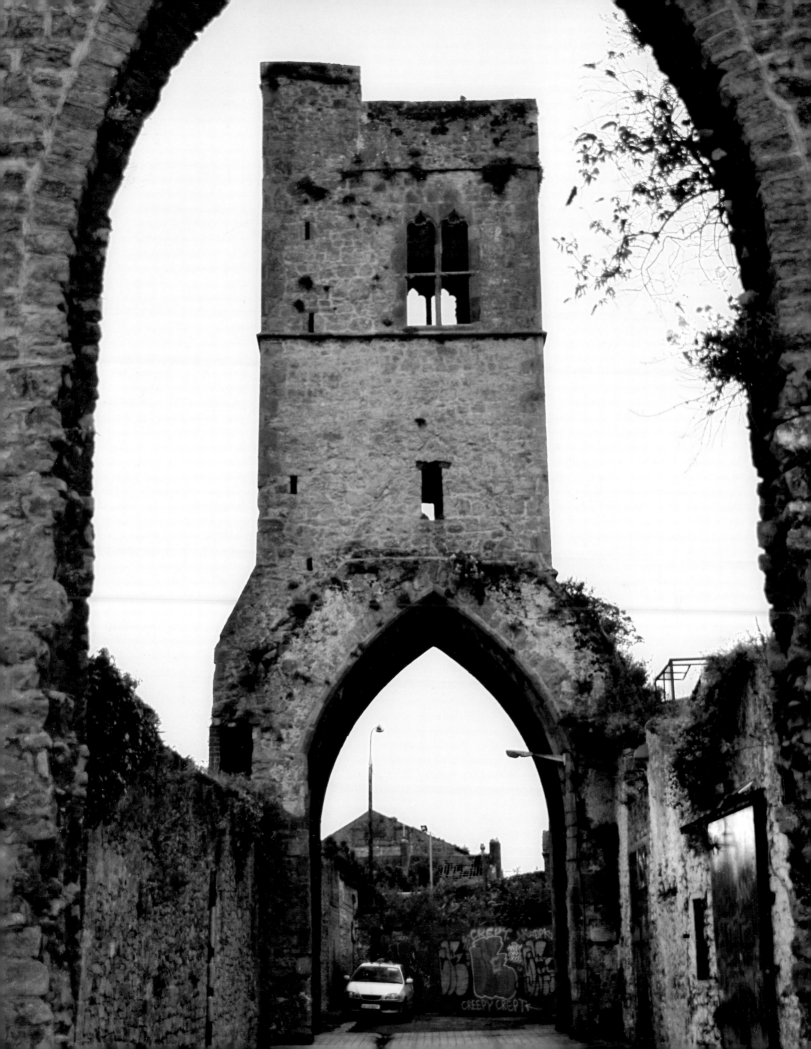

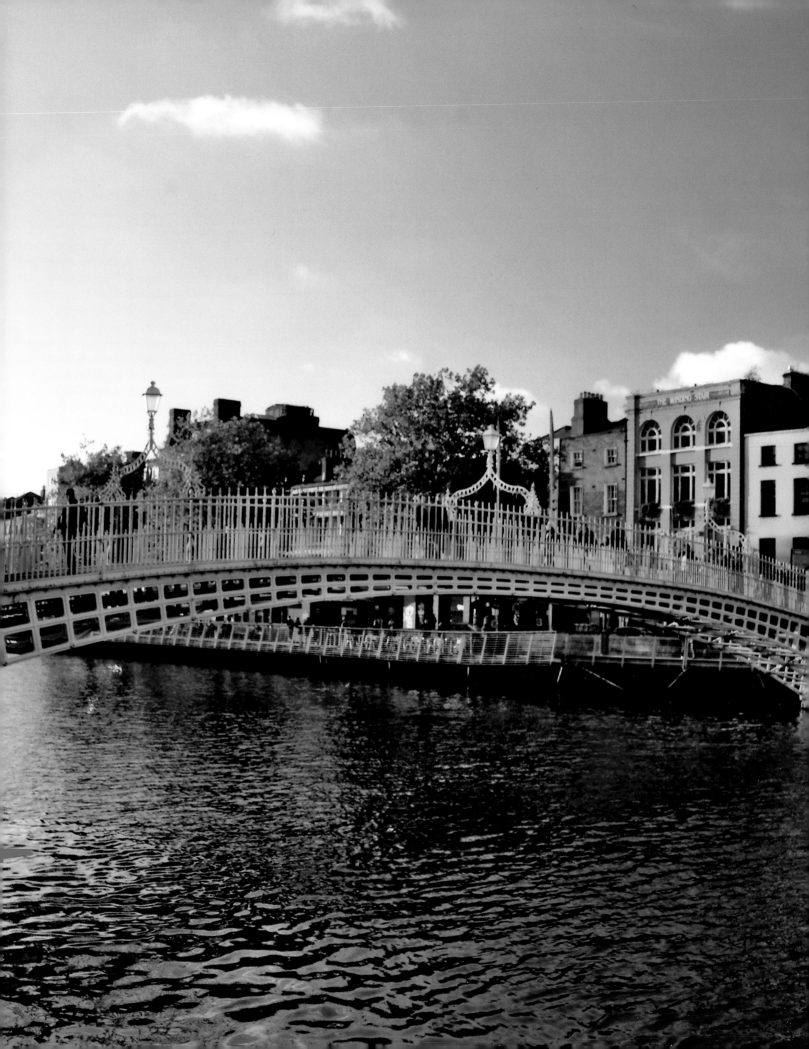

DUBLIN

Dublin reminds me of New Orleans. (I grew up in Hammond, which is about an hour northeast of New Orleans and Lake Pontchartrain.) They are both big, lazy, cosmopolitan cities with a river at their core—and music everywhere. Half the people of Ireland live around the River Liffey. Dublin has a rich history and is international in its cuisine, shopping, art, music, literature, and architecture, with a varied population that hails from all over the world.

Founded during the ninth century BCE as a Viking settlement near the midpoint of Ireland's eastern coast, Dublin has been Ireland's principal city since the Norman invasion. At one time during the seventeenth century, it was Europe's fifth-largest city and the second largest in the evolving British Empire. Today, Dublin ranks among the top thirty cities of the world, according to the Global Financial Centres Index, and is one of Europe's most youthful and cosmopolitan cities, with approximately half of its citizens younger than twenty-five and about fifteen percent now foreign-born.

The city is the center for the arts, media, and communications in Ireland. Its list of literary figures includes Nobel laureates Samuel Beckett, George Bernard Shaw, and William Butler Yeats and other influential writers such as Oscar Wilde, Jonathan Swift, Bram Stoker, Sean O'Casey, James Joyce, Roddy Doyle, Maeve Binchey, and Brendan Behan. In 2010, Dublin joined Edinburgh, Scotland, Iowa City, Iowa, and Melbourne, Australia, as a UNESCO City of Literature.

Wonderful sounds abound in the capital city: the clip-clop of shaggy-footed horses pulling buggies touring the ancient brick streets, the many street performers, and the screeching of raucous seagulls, which is a constant reminder that Dublin is on the Irish Sea. All the birds that live here— among them curlews, egrets, harriers, petrels, redshanks, several species of sandpiper, and, of course, gulls—take advantage of the magnificent, lush, green parks and lakes hidden in plain sight throughout the city. St. Stephen's Green is one of my favorites to sit in and enjoy a cup of coffee while watching swans and other birds flying and floating around the nearby lakes. Another sound is the roar of tourists wearing helmets with blonde braids and horns celebrating their Viking heritage. They scream especially loud when diving into the frigid waters of the port!

For me, one of the highlights of Dublin is Phoenix Park. At more than 1,750 acres, it is one of the largest enclosed urban parks in any European city. Originally planned in 1662 as a royal deer park, it still boasts a large herd of fallow deer that were introduced in 1680 by the Duke of Ormond. The Furry Glen, which is managed as a conservation area, provides sanctuary for other animals. Fifty percent of the terrestrial mammals found in Ireland reside here as well as in the wetlands of the park, along with about forty percent of Ireland's birds. About thirty percent of the park is covered by gorgeous, broadleaf trees such as ash, beech, horse chestnut, lime, oak, and sycamore, with more ornamental varieties contained within the Victorian People's Flower Gardens, originally established in 1840. —EB

Opposite: Ha'Penny Bridge, built in 1816, today is a very busy pedestrian crossing over the River Liffey.

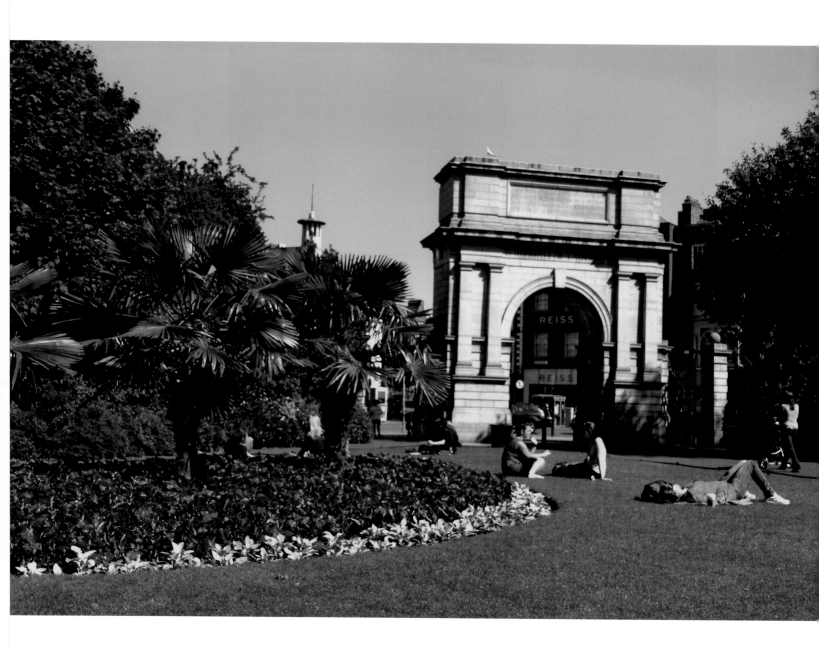

Locals and tourists alike lie on the green grass to enjoy the sun at St. Stephen's Green, which is one of Dublin's original commons. It's a great place to enjoy a cup of coffee and watch the birds. Prior to 1663 it was a marshy area used for grazing, but it became a park in 1664 when the commons was enclosed by a wall. Soon, houses were built around the rectangular park, and it became a location for the city's more prominent citizens who built stately Georgian-style

DUBLIN

Dublin reminds me of New Orleans. (I grew up in Hammond, which is about an hour northeast of New Orleans and Lake Pontchartrain.) They are both big, lazy, cosmopolitan cities with a river at their core—and music everywhere. Half the people of Ireland live around the River Liffey. Dublin has a rich history and is international in its cuisine, shopping, art, music, literature, and architecture, with a varied population that hails from all over the world.

Founded during the ninth century BCE as a Viking settlement near the midpoint of Ireland's eastern coast, Dublin has been Ireland's principal city since the Norman invasion. At one time during the seventeenth century, it was Europe's fifth-largest city and the second largest in the evolving British Empire. Today, Dublin ranks among the top thirty cities of the world, according to the Global Financial Centres Index, and is one of Europe's most youthful and cosmopolitan cities, with approximately half of its citizens younger than twenty-five and about fifteen percent now foreign-born.

The city is the center for the arts, media, and communications in Ireland. Its list of literary figures includes Nobel laureates Samuel Beckett, George Bernard Shaw, and William Butler Yeats and other influential writers such as Oscar Wilde, Jonathan Swift, Bram Stoker, Sean O'Casey, James Joyce, Roddy Doyle, Maeve Binchey, and Brendan Behan. In 2010, Dublin joined Edinburgh, Scotland, Iowa City, Iowa, and Melbourne, Australia, as a UNESCO City of Literature.

Wonderful sounds abound in the capital city: the clip-clop of shaggy-footed horses pulling buggies touring the ancient brick streets, the many street performers, and the screeching of raucous seagulls, which is a constant reminder that Dublin is on the Irish Sea. All the birds that live here—among them curlews, egrets, harriers, petrels, redshanks, several species of sandpiper, and, of course, gulls—take advantage of the magnificent, lush, green parks and lakes hidden in plain sight throughout the city. St. Stephen's Green is one of my favorites to sit in and enjoy a cup of coffee while watching swans and other birds flying and floating around the nearby lakes. Another sound is the roar of tourists wearing helmets with blonde braids and horns celebrating their Viking heritage. They scream especially loud when diving into the frigid waters of the port!

For me, one of the highlights of Dublin is Phoenix Park. At more than 1,750 acres, it is one of the largest enclosed urban parks in any European city. Originally planned in 1662 as a royal deer park, it still boasts a large herd of fallow deer that were introduced in 1680 by the Duke of Ormond. The Furry Glen, which is managed as a conservation area, provides sanctuary for other animals. Fifty percent of the terrestrial mammals found in Ireland reside here as well as in the wetlands of the park, along with about forty percent of Ireland's birds. About thirty percent of the park is covered by gorgeous, broadleaf trees such as ash, beech, horse chestnut, lime, oak, and sycamore, with more ornamental varieties contained within the Victorian People's Flower Gardens, originally established in 1840. —EB

Opposite: Ha'Penny Bridge, built in 1816, today is a very busy pedestrian crossing over the River Liffey.

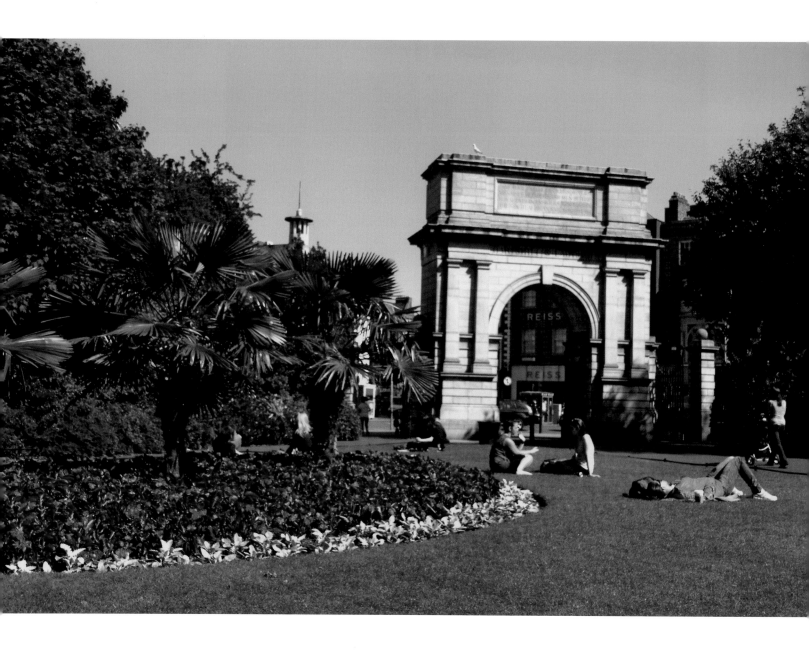

Locals and tourists alike lie on the green grass to enjoy the sun at St. Stephen's Green, which is one of Dublin's original commons. It's a great place to enjoy a cup of coffee and watch the birds. Prior to 1663 it was a marshy area used for grazing, but it became a park in 1664 when the commons was enclosed by a wall. Soon, houses were built around the rectangular park, and it became a location for the city's more prominent citizens who built stately Georgian-style

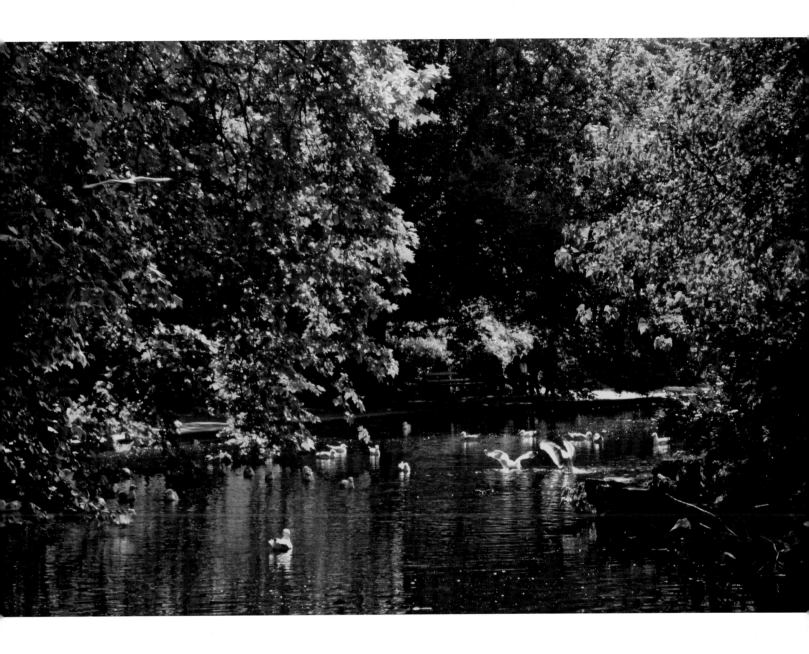

structures, few of which remain. During the 1860s, efforts began to make the park public
grounds, and William Sheppard designed the current landscape. The park officially opened to
the public on July 27, 1880. Fusiliers' Arch (left), erected in 1907, commemorates members
of the Royal Dublin Fusiliers who were killed during the Second Boer War. A large lake (above)
extends through much of the park and is home to ducks and other waterfowl. —EB

The National Botanic Gardens, founded in 1795 by the Dublin Society, today contains more than 20,000 living plants, including this fabulous yew tree. —EB

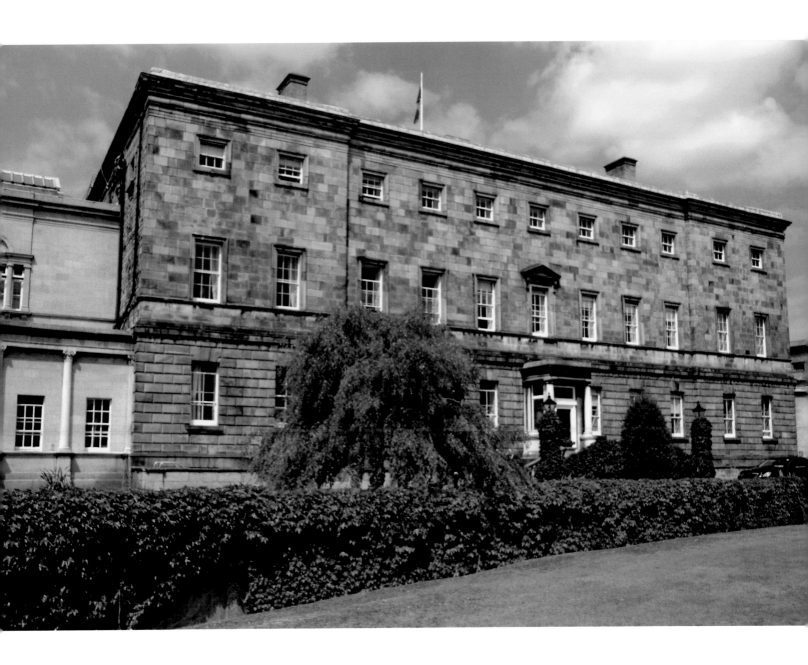

Leinster House, the seat of Oireachtas, the parliament of the southern Irish state since 1922, was built in 1745–1747 as a home for James Fitzgerald, the Earl of Kildare. Richard Cassels, a German-born architect, designed the Georgian-style manor that was, at the time, located on the unfashionable south side, far from most of the city's aristocratic residences north of the River Liffey. —GA

In 1696, William III of England levied a window tax to raise revenue. It was finally repealed in 1851, when those opposed argued it was a tax on light and air and as such affected people's health. There are still large buildings throughout Dublin such as this one, whose windows were bricked over so the owners could avoid paying that tax. When I learned this, it reminded me of the ingenious ways that people have devised to circumvent government foolishness, such as throwing tea into Boston Harbor or, in the case of the Vietnamese who, during the nineteenth century when the French taxed the footprint of their homes, erected extremely narrow but tall houses with as many as seven stories. —EB

Dublin is a great city of writers, musicians, artists, chancers, and decent people. It is a great walking city with a history of rebellion in other times and corruption in modern times.

I now work in Dublin in the Irish parliament, *Dáil Éireann*. The first meeting of *Dáil Éireann* took place in the Mansion House, the residence of the Lord Mayor of Dublin, in the afternoon of January 21, 1919, three years after the 1916 Rising. At the time, the British still occupied all of Ireland, and the gathering was illegal. Many of those elected in the general election in 1918 were in English prisons.

An Chéad Dáil Éireann, as the first Dáil was called, was in session for only two hours, but they were two of the most momentous hours in Ireland's history. The Dáil adopted three key documents: the Declaration of Independence, the Message to the Free Nations of the World, and the Democratic Programme. Through its establishment and these three historic documents, the Dáil asserted a continuity of objectives with the leaders of the 1916 Rising in setting up a separate parliament, government, and all-Ireland republic.

After the creation of the Irish Free State in 1922, the Parliament, with its two chambers, met in Leinster House (page 93), just around the corner from the Mansion House. Leinster House is a Georgian-style house built by James Fitzgerald, the Earl of Kildare, between 1745 and 1747. With great originality, he named it after himself, and, when he became the Duke of Leinster in 1776, he imaginatively renamed it again after himself, Leinster House.

It is claimed that the design of the building influenced James Hoban, who designed the White House in Washington, DC. One famous, occasional resident, Lord Edward Fitzgerald, was a leading figure in the United Ireland movement during the 1790s and was subsequently killed during the 1798 rebellion.

Today, it is difficult to walk through the place without some portrait or sculpture or other piece of memorabilia reminding you of the colonial occupation of Ireland by Britain and of Ireland's long struggle for freedom. When you enter through the main door into the large lobby, large portraits of Michael Collins and Cathal Brugha look down—some might say appropriately, as they were on opposing sides in the bloody civil war after partition—from opposite sides of the room. Across the lobby is a framed copy of the 1916 Proclamation, and along a corridor toward the stairs leading to the Dáil chamber is a striking portrait of an earlier Sinn Féin TD, Austin Stack. The chamber has busts of the 1916 leaders and other national figures. Most of the ushers know Irish, and they converse easily in the first language with the likes of me and other Gaels. —GA

Since 1828, Glasnevin Cemetery has been the burial place of some of Ireland's most celebrated patriots of the late nineteenth and early twentieth centuries, among them Michael Collins, who is considered the founding father of Irish democracy. Others include Harry Boland, a Republican who was a member of the first Dail, Charles Stewart Parnell, the founder and leader of the Irish Parliamentary Party, and Maude Gonne, the English-born Irish revolutionary and feminist. It's profoundly moving to walk among such incredible historical figures. —EB

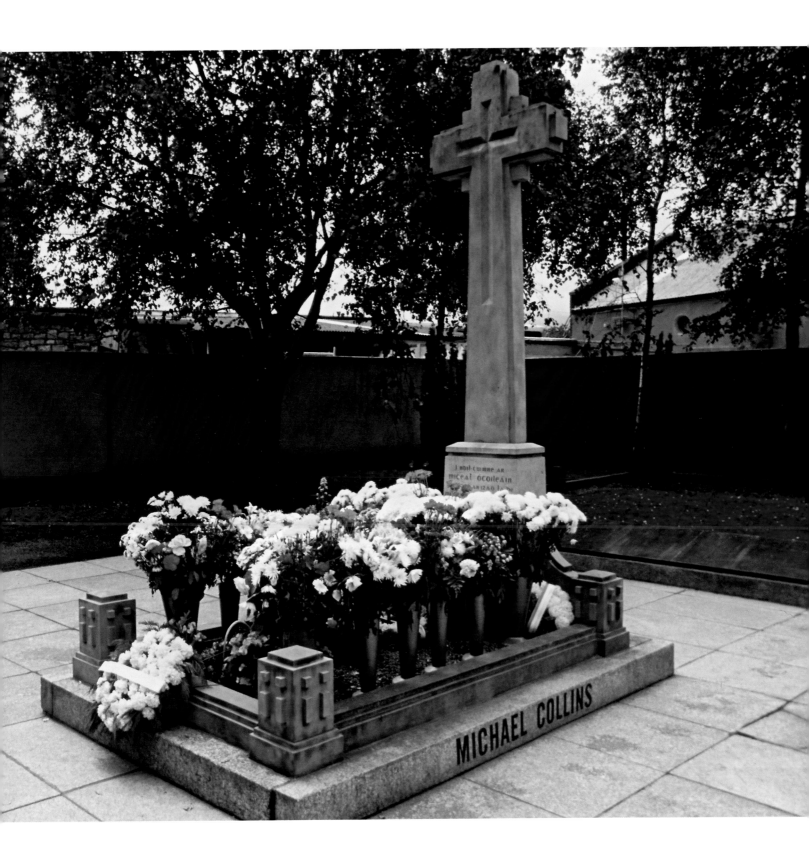

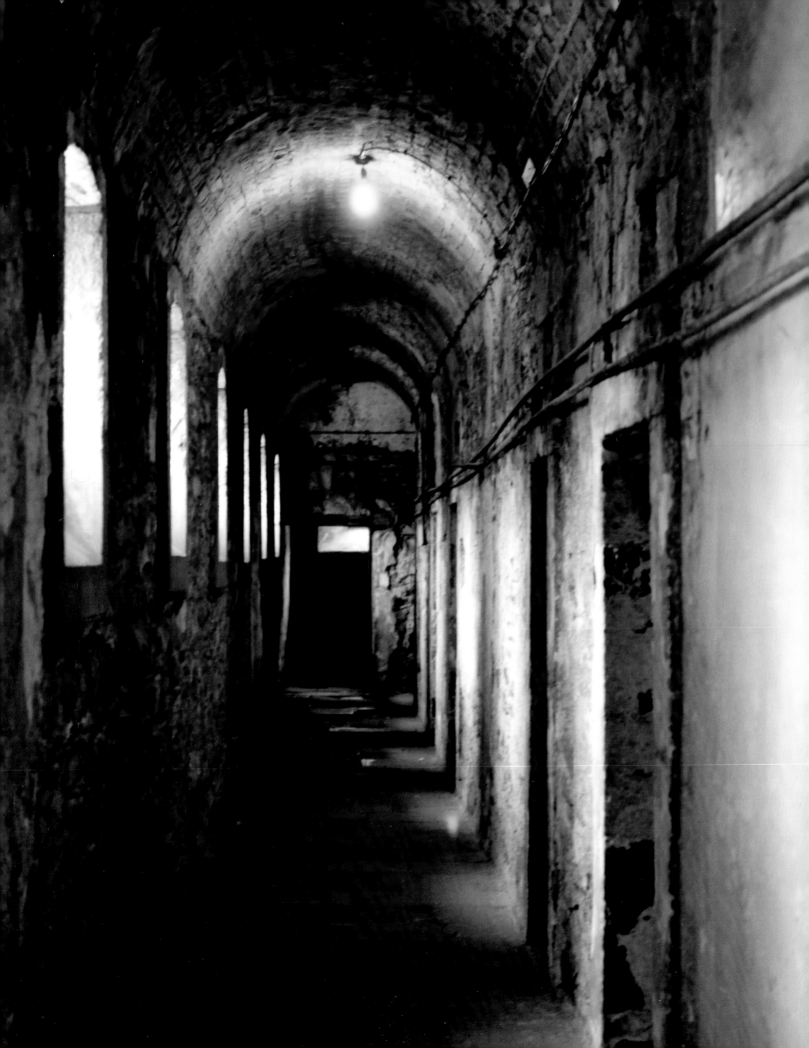

KILMAINHAM GAOL

*"You cannot extinguish the Irish passion for freedom. If our deed has not been sufficient to win freedom, then our children will win it by a better deed."** These are the last words of Pádraic Pearse, one of the leaders of the 1916 Rising, to his court martial by the British Army on May 2 of that year, two days before his execution in Kilmainham Gaol.

Kilmainham Gaol in Dublin is where most of the leaders of the 1916 Easter Rising, were executed. Fourteen men were shot to death in the prison yard after being court martialled. Those killed included the seven signatories of the Proclamation of the Republic. Kilmainham is, therefore, a special place of pilgrimage, and a visit there is a hugely emotional experience, particularly for former political prisoners like myself.

I went there not long after I was released from HM Prison Maze (also known colloquially as Long Kesh) in 1977. I wandered through the corridors imagining what the atmosphere must have been like sixty years earlier as Republican revolutionaries stood defiant against British court martials and waited in those cold, dark cells for their turn to die. Kilmainham closed in 1924, with a formal order of closure made in 1929. It is now a national monument, and those who guide its visitors through the history and the oppressive penal architecture do so with great and justifiable pride.

The first mention of a prison at Kilmainham goes back much further than 1916, to the beginning of the thirteenth century. The land, which was then the site of the priory of the Hospitaler Knights of St. John of Jerusalem, was given to them by their founder, Earl Richard Fitzgilbert-Strongbow.

The complex, which was self-contained, included a prison, *Tetra Domus De Malrepos*, the Dismal House of Little Ease. It was probably an asylum. It became the home of many Irish people—male and female, vagrants, the poor, debtors, criminal types, and political prisoners who were left for dead bound up in chains in the dungeons. Others were transported to the various British colonies. The list of prisoners is like the roll call of Irish rebellion since 1798. The last political prisoner was Eamon De Valera in 1923. Later, he became President of Ireland.

When I was briefly in the H-Blocks of Long Kesh and in Belfast prison, prisoners used to pass contraband, tobacco, papers, and messages by dangling a line from the cell window to the adjacent cell or the one below. Frieda Kelly, in her book, *A History of Kilmainham Gaol: The Dismal House of Little Ease* (1998), tells how one prisoner, Henry Joy McCracken, a rebel and member of the Society of United Irishmen who was housed in the jail in 1796, "devised the ingenuous method of sharing his claret by placing the bottle on a piece of string. This was cushioned by a sock, or a shirt sleeve, and eased out of the unglazed cell window into the eagerly awaiting hands of men whiling their last miserable hours away in the condemned yard." Some things never change —GA

*P. A. Pearse, "Address to Court Martial," statement written in Kilmainham Gaol, May 2, 1916. For more on this source and other writings of Pearse, see www.multitext.ucc.led/Patrick Henry_Pearse, and www.eirigi.org.

Opposite: A long, dark corridor at Kilmainham Gaol looks as eerie and forbidding now as when the jail was in use.

Leaders of the 1916 Easter Rebellion were
executed here in Kilmainham Yard.

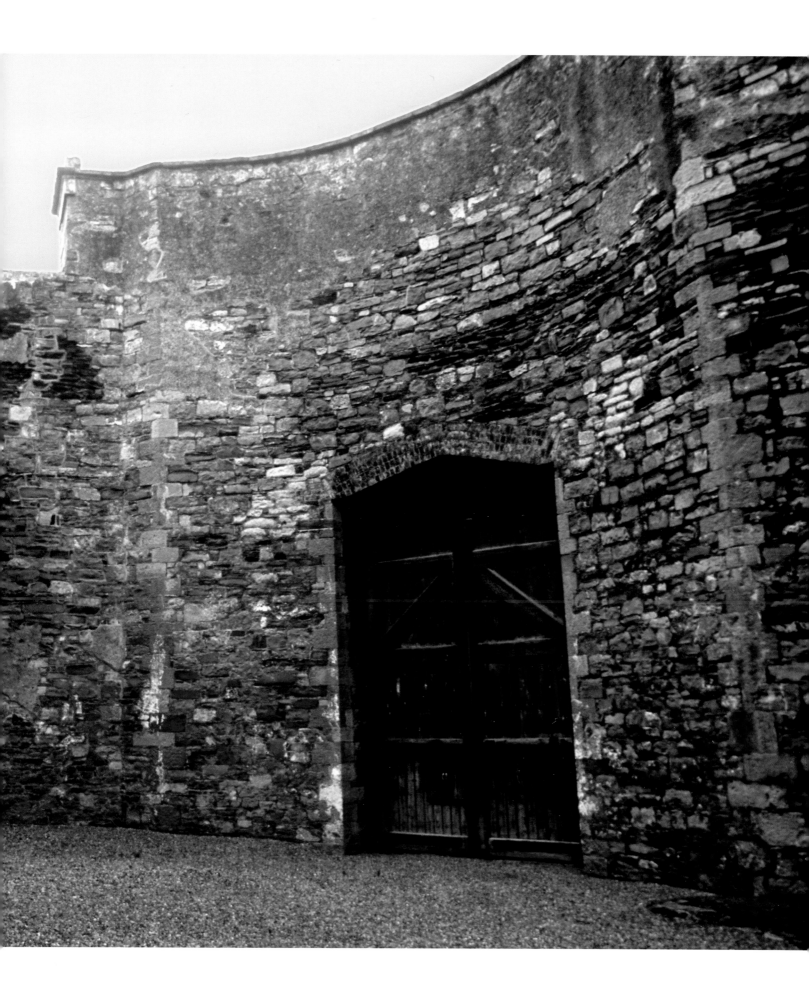

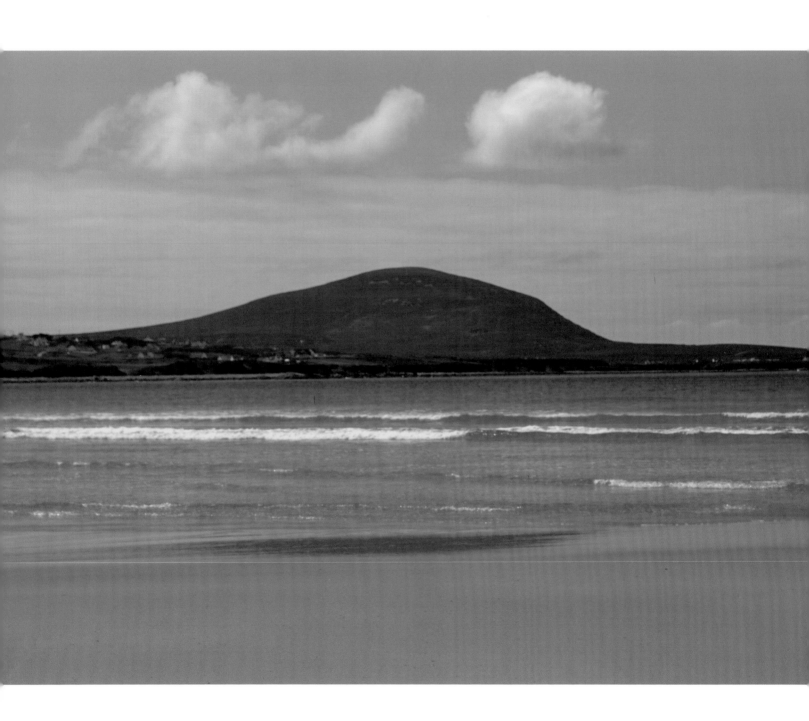

Ulster

FROM THE CITIES OF BELFAST AND DERRY to the gorgeous wind-swept mountains and cliffs of the spectacular Donegal coast, the province of Ulster is varied and beautiful. I am especially partial to Ulster, as my ancestors hail from County Donegal. One of my favorite places in this northernmost province is the Goward Dolmen in County Down, named after the mythical hero of the Fenian Cycle in Irish mythology. I have stood on the tip of the Inishowen peninsula, Malin Head, the most northerly point in Ireland, where EIRE (Ireland) is written in large, white stones to mark the territory during the two world wars of the twentieth century.

West Donegal is where I would live if I had the chance, right in the heart of the Gaeltacht, the Irish-speaking area of Ulster. (Donegal is part of the southern Irish state. I love West Donegal and its people, with their soft musical accents and the sweet lilt of their Gaelic, its hills and glens, rivers and lakes, deep cliffs and white, wide, long, and lonely beaches, like the one (opposite) across from Muckish (elevation 1,713 feet or 666 meters) in the Derryveagh Mountains. —GA

Opposite: Magheroarty Beach is one of the most beautiful beaches to walk. As an Irish friend confided once, "we have the beaches, just not the weather!" —EB

Ulster is the most unusual of the four provinces, politically and socially, as much of it is part of the United Kingdom. Of the nine counties, Antrim, Armagh, (London) Derry, Down, Fermanagh, and Tyrone are part of the United Kingdom, while Cavan, Donegal, and Monaghan are part of the Republic of Ireland. When people refer to Northern Ireland, they're referring to the six counties that are part of the UK, but there are actually nine counties in the province, so it can get confusing.

Belfast, the capital city, is located in County Antrim and is still divided between unionist and nationalist sectors. Relations between these communities have improved enormously since the beginning of the peace process, but it can still be a tough place, as Gerry, a native of Belfast, would be the first to point out. Nowadays, the majority of Belfast's citizens are rising to the challenges of making peace after decades of conflict, but the consequences of centuries of discrimination and hostility can still be felt.

Driving into Belfast for the first time, I was scared. I had seen too many news reports of riots and bombings and had no idea what to expect. But I discovered that Belfast is a very beautiful and friendly city, and I quickly grew to love both Belfast's urban areas and the lush, green hills of Divis and Black Mountain that rise up to the northwest and overlook this bustling metropolis. My experiences of Belfast are mostly of the Republican world. I have had contact with many Protestants, but my cultural experiences have been in West Belfast, mostly up and down Falls Road, which is the main road through West Belfast and the heart of the Republican community.

I have wandered many of the streets and country lanes across Ulster, stood on its gorgeous beaches, struggled up a few of its many mountain ranges, enjoyed the warmth and hospitality of its people, and, of course, tapped my feet to the unique and beautiful rhythms of its traditional music. But I am ever mindful of what the people of this part of Ireland have been through. Many of the people I've met and befriended in Ulster have suffered so much, yet they were always willing to welcome a stranger like me into their lives and communities. The people of Belfast are rising to the challenge of making peace, but it remains a divided city. The issues of flags, emblems, and parades can still cause serious unrest.

I took an Irish class in Glencolmcille, County Donegal. I believe that learning another language gives one insight into how a people think. Irish is a very healthy language in this way and a reflection of the tenacity of the people. In Gaelic, when you say, "I am sick" or "I am tired," the literal translation is, "I have sickness on me." I believe we are always speaking to our subconscious, and the Irish implies you have something on you that will come off. Using that analogy, the English version, "I am sick," translates as "I am the personification of illness." I prefer the effect of the Irish on my subconscious! —EB

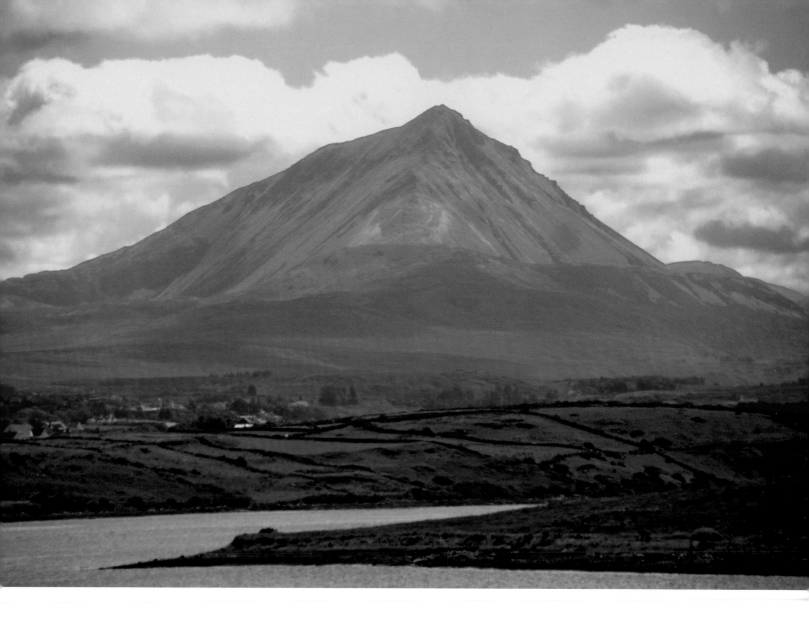

The view from the other side of Mount Errigal in the Derryveagh Mountains. On clear summer days I clamber up its craggy slopes, sometimes to the summit, where the views are outstanding. From there I can see the Sperrin Mountains in County Derry, Dunlewey Lake, and away in the distance the wild Atlantic, its waves rolling in to crash against the rocky shoreline beyond Bloody Foreland. This is my spiritual landscape, where my soul finds peace.

Errigal is 2,464 feet (751 meters) high, which makes it the highest peak in the Derryveagh Mountains and the tallest in Donegal. It is part of what is locally called the "Seven Sisters," which include (from southwest to northeast) Errigal, Mackoght, Aghla More, Ardloughnabrackbaddy, Aghla Beg, Crocknalaragagh, and Muckish.

On its east side lies the Poisoned Glen, a name that conjures up poison plants or perhaps, once upon a time, a place for dark magic and evil. The truth is more mundane. According to local history, the glen was originally called "The Heavenly Glen." In Irish, the word for 'heaven' is *"neamh,"* but an English cartographer misspelled it once, *"neimhe,"* which means poison, and the name stuck. —GA

Foxglove and wild mountain heather grow wild on the boulder-strewn hills en route to Mount Errigal, the tallest peak of the Derryveagh Mountains at 2,464 feet (751 meters) elevation. —GA

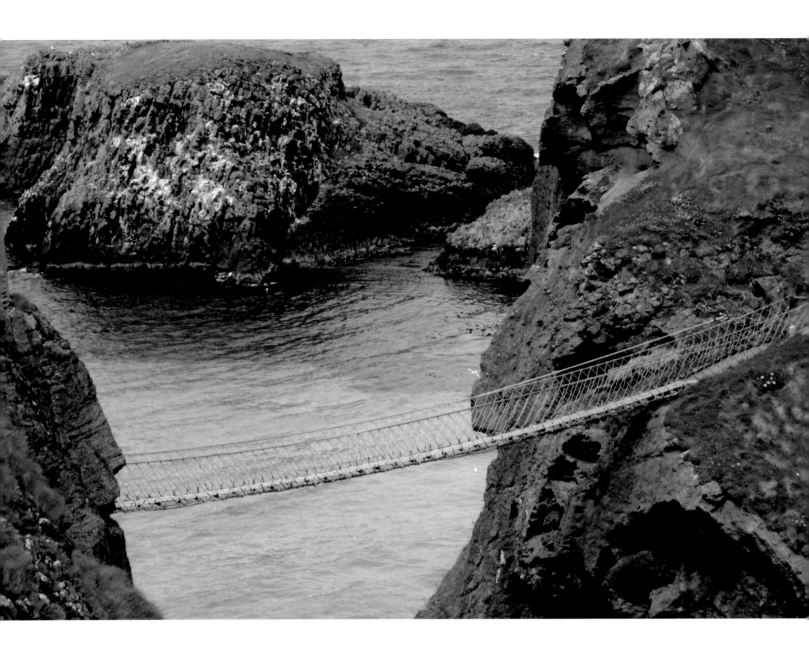

The Carrick-a-Rede Rope Bridge near Ballintoy in County Antrim links the mainland to Carrickarede (Carraig a' Ráid, or "rock of the casting") Island. Sixty-six feet (twenty meters) long and ninety-eight feet (thirty meters) above the rocks below, the bridge was originally built by fishermen for use during salmon season, but very few salmon are now left. So it's used mostly by tourists and is owned and managed by the National Trust for Places of Historic Interest or Natural Beauty. It's a little scary to walk across the bridge which sways in the wind. Martin, my friend from Belfast, was with me the day I was there. He later told me the only reason he walked across was because I did, and he didn't want to be outdone! —EB

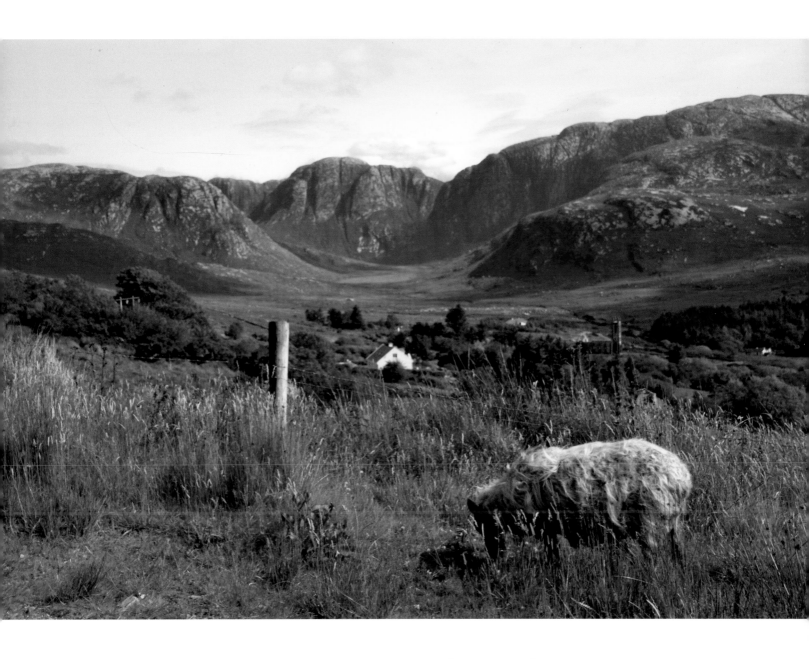

Glenveagh National Park, in Donegal, comprises some 41,900 acres (16,956 hectares), making it Ireland's second-largest national park. Glenveagh means "glen of the birches," and the park, established in 1984, shelters the largest herd of red deer in Ireland. Pictured above is a sheep grazing in one of the park's scenic glacial vallies. —EB

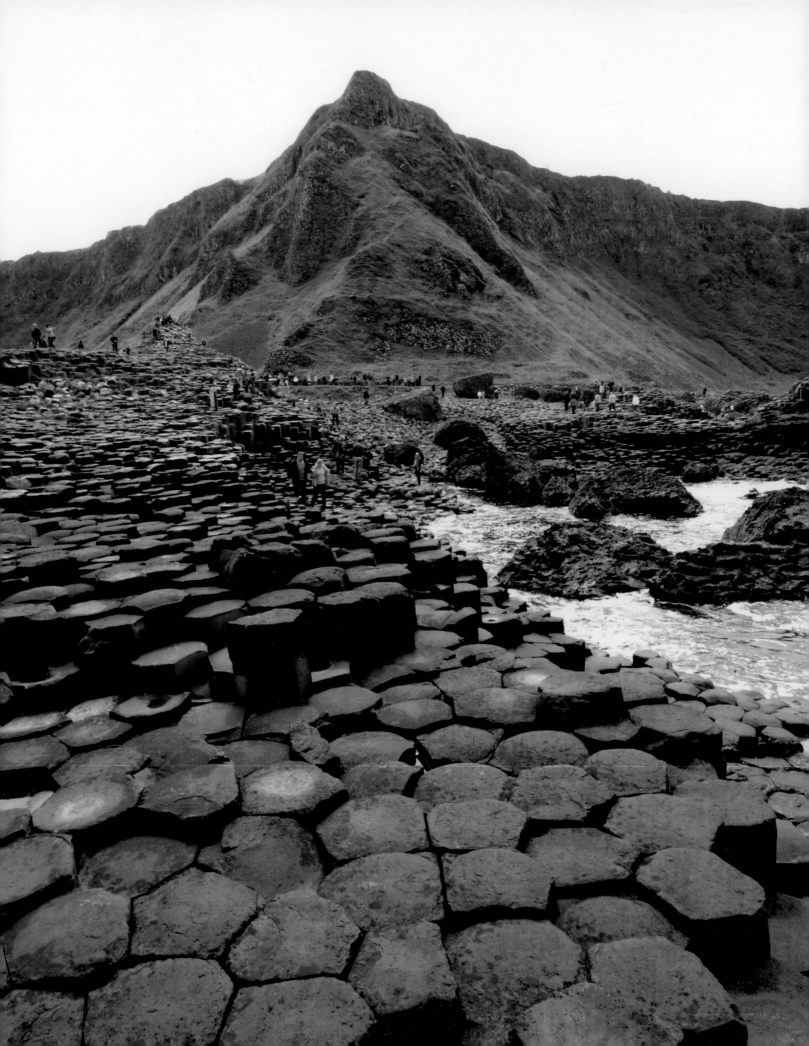

The Giant's Causeway, *An Clochán an Aifir* or *Clochán na bhFonhórach*, means the "Causeway of the Formorians," one of the ancient peoples in Irish mythology. The Scots' Gaelic word for giant is *fuamhaire*. The causeway is also known as *Tochar na dTreanfhear*, causeway of the strong men or warriors. Located three miles from Bushmills, where the famous whiskey is distilled, its 40,000 interlocking basalt columns stretch for some twenty-four miles. It is Northern Ireland's most popular tourist attraction.

Some suggest that this unique formation is the result of a volcanic eruption, but it is well known in these parts that Finn McCool (*Fionn Mac Cumhaill*), the famous Irish giant, built the causeway to Scotland. He and a Scotch giant, Benandonner, who was much bigger, didn't get on well. In fact, they were always raiding each other's bailiwicks.

One day Fionn was resting at home, when his wife dashed in to warn him that Benandonner was coming up the lane looking for him. Quick as a flash, Fionn Mac Cumhaill jumped into their child's cot. When Benandonner burst into the room, Fionn's wife confronted him. "You wouldn't come in here like that if my husband was here," she exclaimed. "What kind of a giant are you, attacking a woman and a wee baby?" Benandonner was mortified. When he saw the size of "the child" in the trick, he became very frightened and thought, "If that's the size of the child, what size must his Daddy be?!" And with that he dashed back across the causeway to Scotland, tearing it up as he went along.

If you get up to the Giant's Causeway, you should also make your way to Bushmills. Don't be put off by the unionist flags and emblems. Bushmills is very good whiskey indeed. The word "whiskey" comes from the Irish *Uisce Bheatha*, the water of life. The Scots stole the recipe from us, but they still haven't perfected the process. After Bushmills, if you are still sober, you can make your way to Carrick-a-Rede (page 108) and walk the rope bridge there. —GA

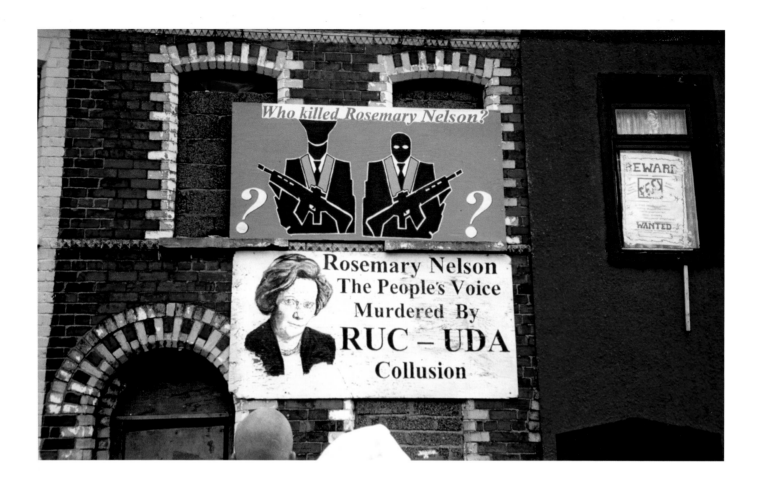

Above: Belfast is full of murals. The Irish have a tradition of honoring people and events in this way. This mural honors Rosemary Nelson (1958–1999), a prominent human rights attorney who was murdered by loyalist paramilitaries in 1999. —EB

Opposite: This mural honors Bobby Sands, who led and died in the 1981 hunger strike in H Blocks, or Long Kesh, in Belfast. I have a dear American Indian friend, Dino Butler, who was imprisoned in Canada and inspired by the hunger strike of Bobby Sands. Dino was in a similar situation: the prisoners wanted the honor and the right to pray in their own ancestral way, with the pipe, sage, and sweat lodge. In a conversation with me, he said of Bobby, "He was a hero to me. He chose to leave the world with heart and courage. Not too many people have that spirit. Rather than live under oppression, he chose his freedom. He helped me through some troubled times." Dino was later acquitted of all charges. —EB

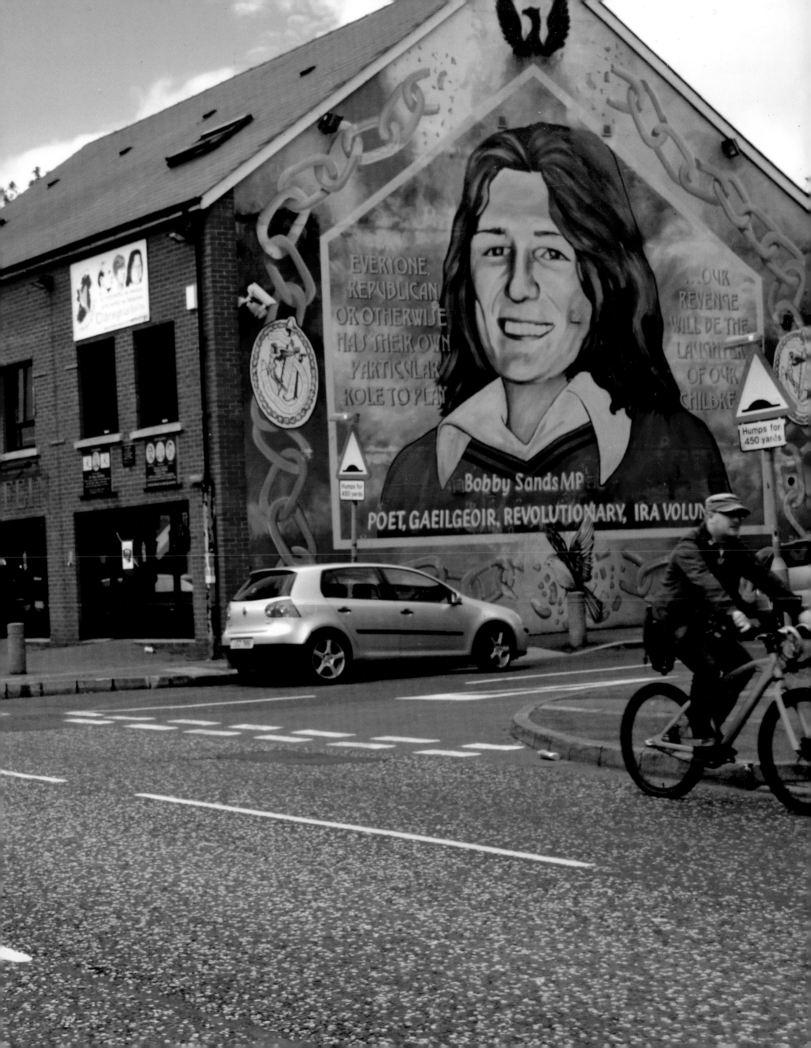

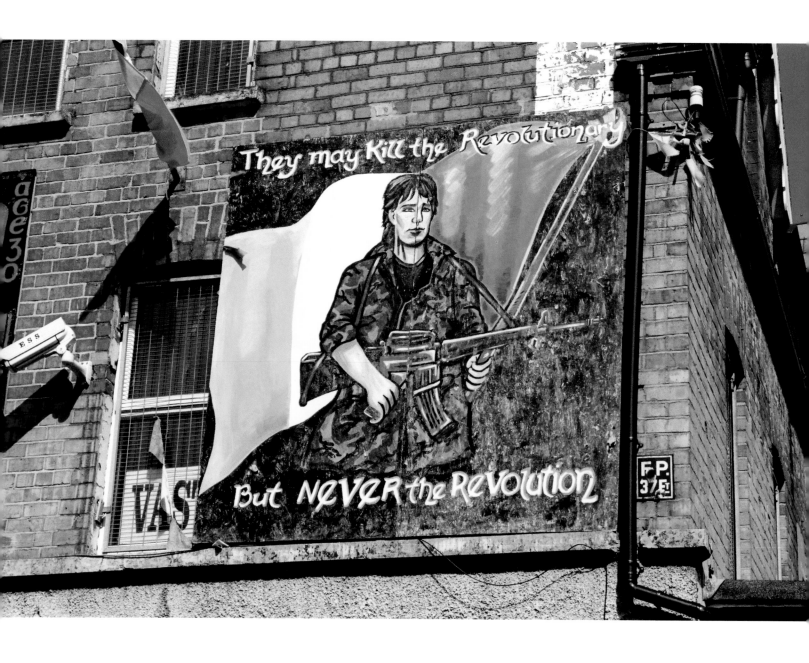

This is one of many political murals in Republican West Belfast.

Did you know that John Lennon was half-Irish? He discovered his roots in a manuscript his estranged father had written about his family history. Thrilled to learn that his ancestors were Irish musicians, he embraced his Irish roots and considered himself more Irish than English. He wrote "Luck of the Irish'"and "Sunday, Bloody Sunday" in protest of the British injustices toward the Irish and paid for the funerals for the victims of the massacre that came to be known as Bloody Sunday, which occurred on January 30, 1972, when fourteen unarmed civil rights demonstrators were shot dead by British Army paratroopers in Derry. —EB

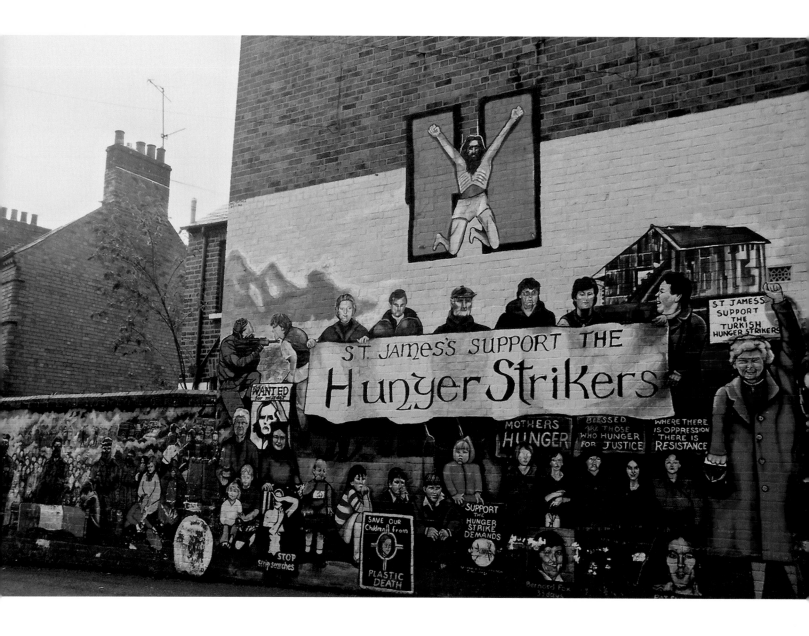

This mural commemorates the hunger strike of the 1980s, when ten prisoners in HM Prison Maze, aka Long Kesh (where Gerry Adams was himself imprisoned during the 1970s), went on strike to secure basic human rights and dignity as well as political, instead of criminal, status for all Irish Republican political prisoners. The maximum-security prison, closed since 2000, was located about nine miles southwest of Belfast. —EB

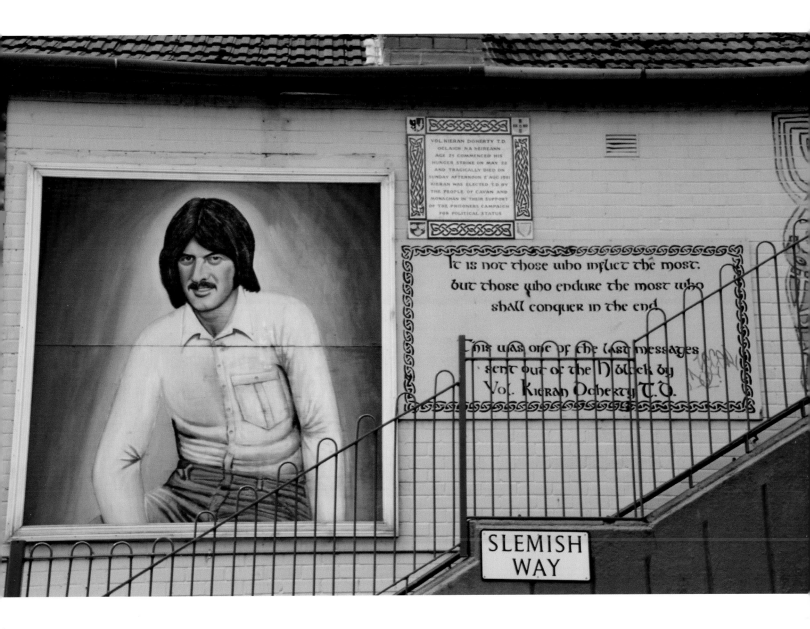

Kieran Doherty was a friend of mine. He was also a TD or Teachta Dála, elected to the Irish Parliament in Dublin on June 11, 1981, by the Cavan-Monaghan constituency of Ulster. He was part of the same hunger strike in which Bobby Sands died. Kieran himself died on hunger strike after seventy-three days, on August 2, 1981, having never had the opportunity to represent the people who elected him. —GA

Saoirse do Peltier

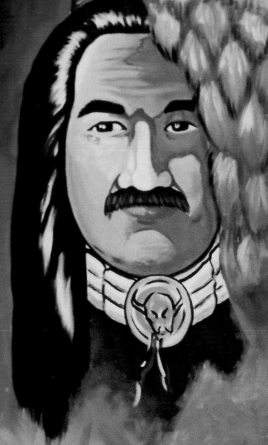

WANI WACI YELO

Sign up on line www. Leonard Peltier Defense Committee

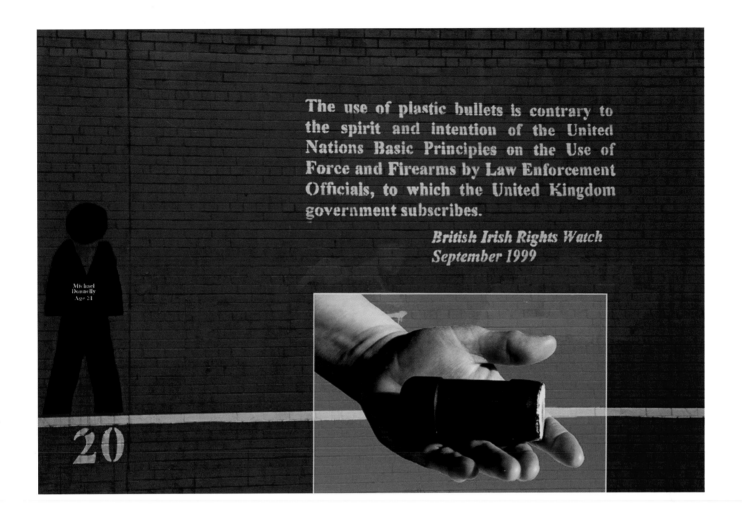

The use of plastic bullets is contrary to the spirit and intention of the United Nations Basic Principles on the Use of Force and Firearms by Law Enforcement Officials, to which the United Kingdom government subscribes.

British Irish Rights Watch
September 1999

Above: When I first heard of plastic bullets, I assumed they were small, innocent deterrents that could inflict no harm. Then I held one. It was the size of my palm and extremely hard, almost as hard as a real bullet and, I learned, just as effective. The British Army only uses plastic bullets in the north of Ireland, never in Britain. —EB

Opposite: The Irish feel great solidarity with the oppressed people of the world, as evidenced by this mural in support of Leonard Peltier (Anishinabe-Dakota), the activist and member of the American Indian Movement (AIM) whose controversial trial resulted in a sentence of two consecutive terms of life imprisonment for alleged first-degree murder in a 1975 shootout on the Pine Ridge Reservation, during which two Federal Bureau of Investigation (FBI) agents were killed. Many feel that Peltier was framed by unreliable witnesses and extremely faulty ballistics information presented by the U.S. government at the trial. —EB

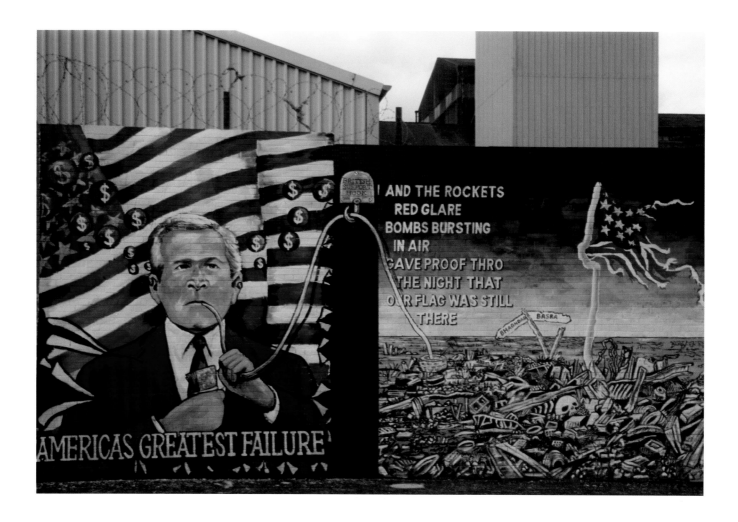

Above: Here is one Irish response to President George W. Bush and the involvement of the United States in the war in Iraq.

Opposite: This sign offers a wry take on the Irish "Tidy Town" competition, which rates more than 700 participating communities that compete for a cash award and the title of Ireland's Tidiest Town. The program, organized in 1958 by the Department of the Environment, Community and Local Government, has been a hit ever since. —EB

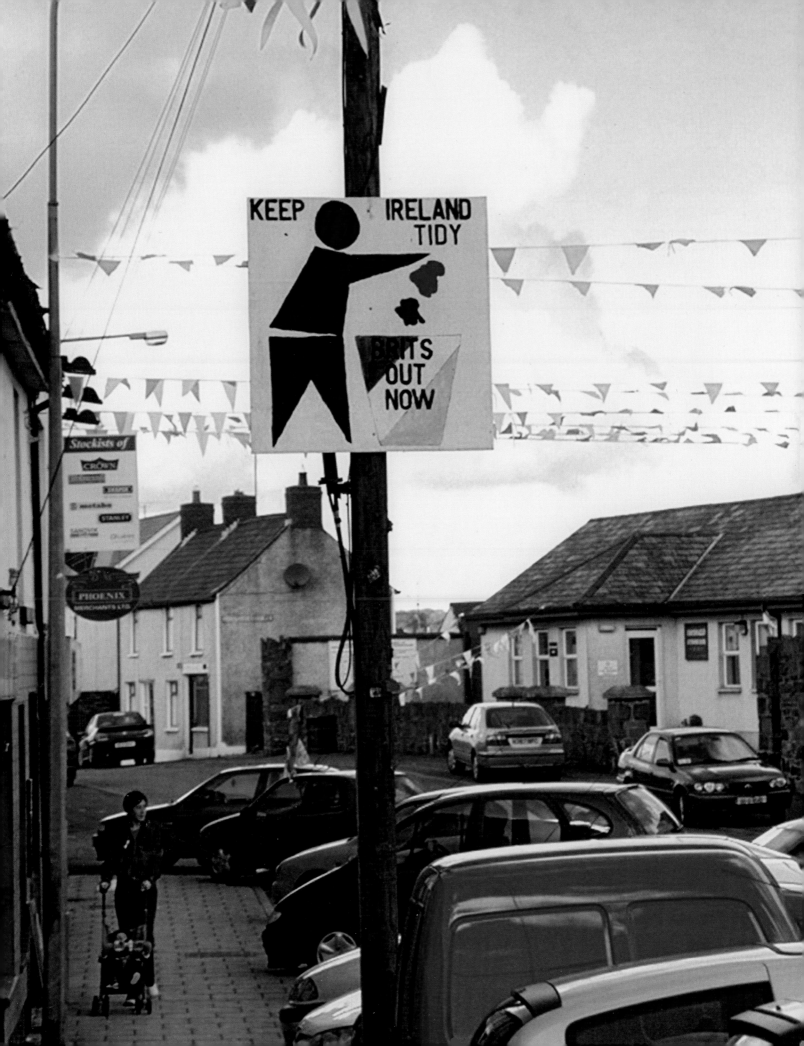

South Armagh, on the border between the north and south of Ireland, was at one time the most militarized part of Western Europe, the beauty of the countryside marred by the hilltop army posts of the British. I have visited this region many times and seen the remains of old checkpoints, all of which have since been removed, thanks to the success of the peace process. The humor and the tragedy of this area is that some houses had front parlors located in the North, while their kitchens were in the South. —EB

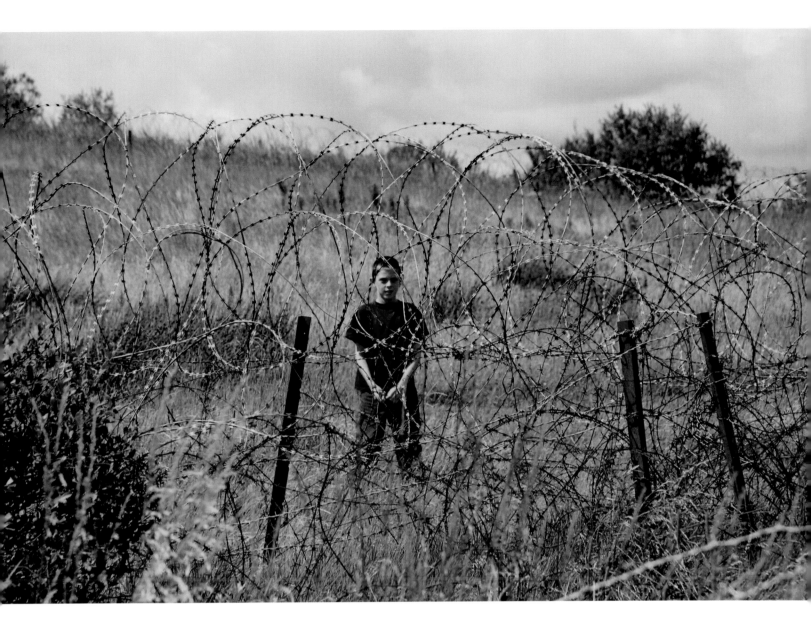

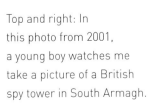

Top and right: In this photo from 2001, a young boy watches me take a picture of a British spy tower in South Armagh.

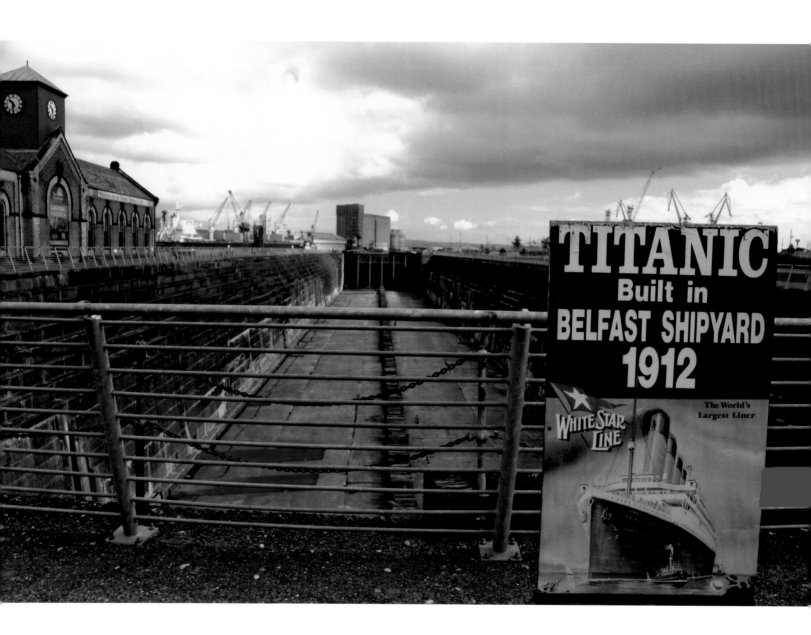

The spectacular Titanic Museum at the Harland & Wolff Shipyard is well worth a visit. It was the world's largest shipyard at the time the *Titanic* was built for the White Star Line from 1909–1912, along with its sister ship, the *Olympic*. The museum showcases the birth of the *Titanic* and the vibrant and tumultuous history of shipbuilding in Belfast. I love the comment in one of the exhibits in which it is written, referring to the *Titanic*, "She was fine when she left here." —EB

124

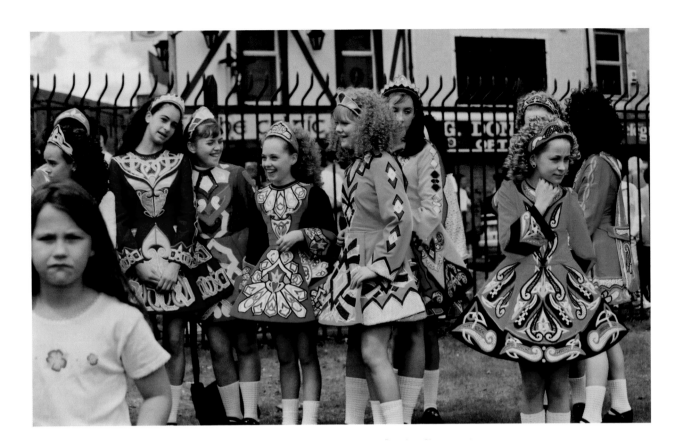

Above: Irish dancing is as old as our other traditions, and it shows in the names of the dances: the Haymaker's Jig, the Walls of Limerick, the Siege of Ennis, and the Waves of Tory. Irish dancing was given international legs when Riverdance strutted and swaggered and somersaulted its way across the world in 1994. One of my nieces, Áine, like many other Irish girls, spent her young life dancing in competitions throughout Ireland, chaperoned by her mother and my sister, Deirdre. Later, she travelled the world with Riverdance and met her husband, Conor, somewhere along the way. Irish dancing was good to them both. Here, young dancers, decked out in their costumes, await their turn. —GA

Right: This young dancer is stepping out at the annual festival in Falcarragh, a place close to my heart in West Donegal. But she could be in any of the thousands of events like this throughout our little island. Everywhere the Irish gather in celebration, with young dancers, boys as well as girls, entertaining us with jigs and reels. —GA

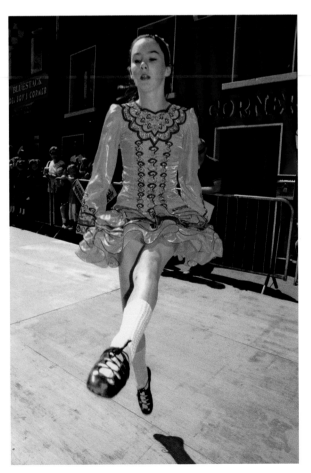

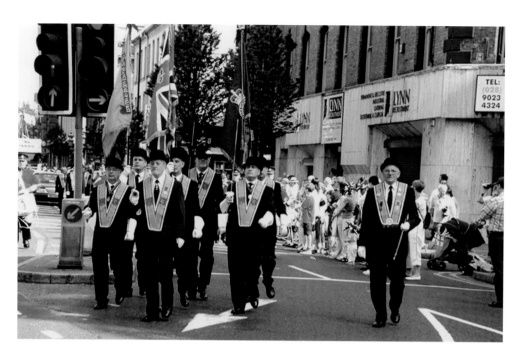

Above: A parade of the Orange Order, a Protestant fraternal organization founded in 1796 in County Armagh. Its name refers to the Dutch-born Protestant King William of Orange, who defeated the army of the Catholic King James II at the Battle of the Boyne in 1690, which, among other things, helped assure the continuation of Protestant ascendancy in Ireland. The Order's mission is to defend Protestant civil and religious liberties and to promote unionism; that is, the continuation of a strong political link between Northern Ireland and Great Britain. Sometimes these parades can cause unrest, as the Order will insist upon marching right through Catholic neighborhoods in Belfast, which tend to be primarily nationalist and prefer a united Ireland. —GA

Below: Young supporters of the Orange Order are having fun during the parade.

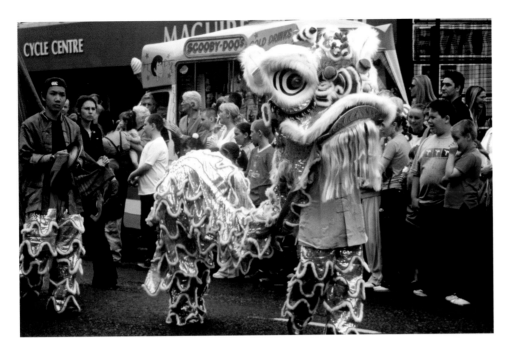

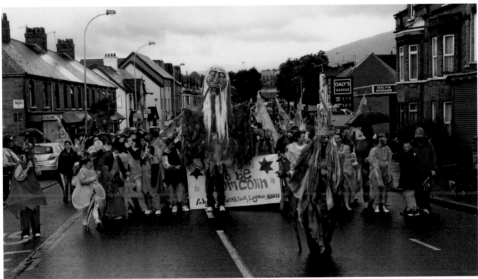

The *Féile an Phobail* (Festival of the People or the Community's Festival) was established in 1988 in West Belfast in response to the demonization of the people of that area by the Irish and British establishments. An extravaganza of music, literature, debate, drama, the visual arts, sport, and all-round good fun held every August, it has grown into the largest community festival in the country.

Féile is a vibrant, multi-faceted event that attracts national and international artists as well as local talent. It also uniquely provides platforms for public discourse and reconciliation between unionist and nationalist, Protestant and Catholic. It has hosted major debates that have included U.S. Congressional representatives, British Conservative MPs, representatives of Sinn Féin and the Democratic Unionist Party, former British soldiers, loyalist paramilitaries, leading IRA figures, and officers from the Police Service of Northern Ireland. This ethos of inclusivity has also seen the Féile bring together young people from opposite sides of the "peace wall," to paint messages of unity rather than graffiti. Féile has inspired other festivals in Belfast, including *Draíocht*, the Children's Festival, begun in 1998, and *Féile an Earraigh*, the Spring Festival, also begun in 1998, and also partnered with Cork's Lifelong Learning Festival, begun in 2003. —GA

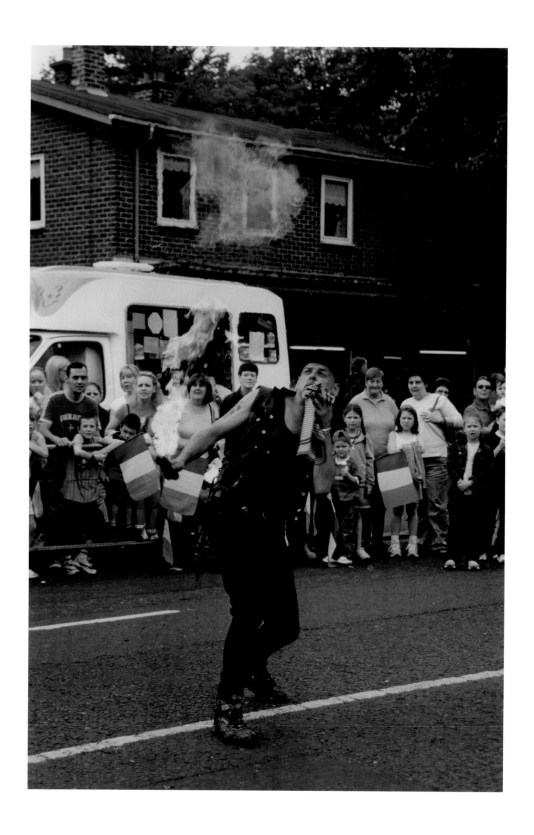

A fire thrower performs during the *Féile*.

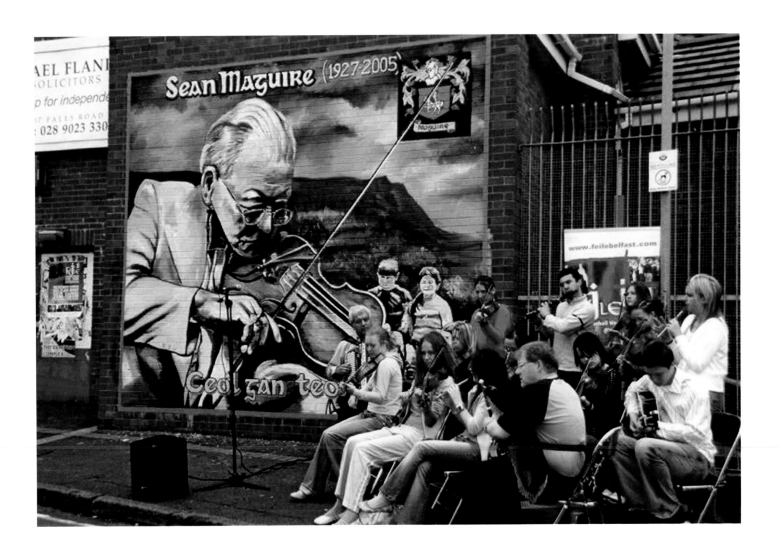

The band plays on during the unveiling of a mural in the Republican area of Derry honoring Sean Maguire (1927–2005), a former All-Ireland Fiddle Champion from Belfast, who was inducted into the Hall of Fame of Culture Northern Ireland in 2010.

The Black Taxis service of West and North Belfast is famous the world over for taking visitors around the city and giving them a potted history of the place. Originally, however, they functioned as a transport service for the citizens of West and North Belfast.

During the early 1970s, Belfast was in turmoil. The conflict known as "The Troubles" was at its height, and barricades and riots were commonplace. The main roads were regularly blocked, and bus service was often suspended, especially in West Belfast. A few local people went to London, bought some old black taxis, and set up an alternative service. It was a unique solution to a unique problem, providing transport for citizens of this area in the midst of major conflict. Before long, hundreds of these sometimes very old and dilapidated black hacks were traveling throughout the city, with as many as eight people crammed into them. If roads were blocked, they drove down alleys, over the rubble of riots, and along footpaths. Nothing stopped them—not even the British Army's checkpoints (opposite, top).

The taxis ferried people to and from work and kept families in contact with each other. But their success came at a cost: They became a major target for the British and unionist forces and were demonized by their media. Eight drivers were killed in sectarian attacks, and scores more were assaulted, arrested, and harassed.

As the community has evolved, so have the Black Taxis. The Falls Taxi Association is now a blueprint for community economic development, with 220 drivers, twenty-six other employees, a new complex on King Street, and a new passenger terminal (opposite, bottom). They were the first public transport service to go bilingual, reflecting our native language and the needs and rights of those who speak Irish. The history of the taxi association is a history of community resistance, commitment, and success. Long may it prosper!" —GA

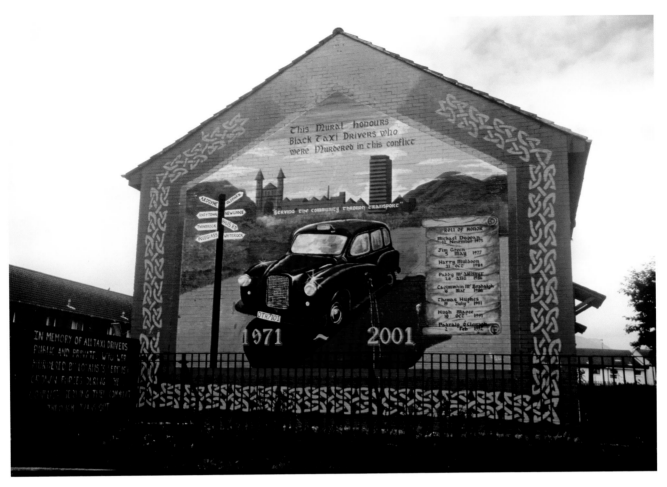

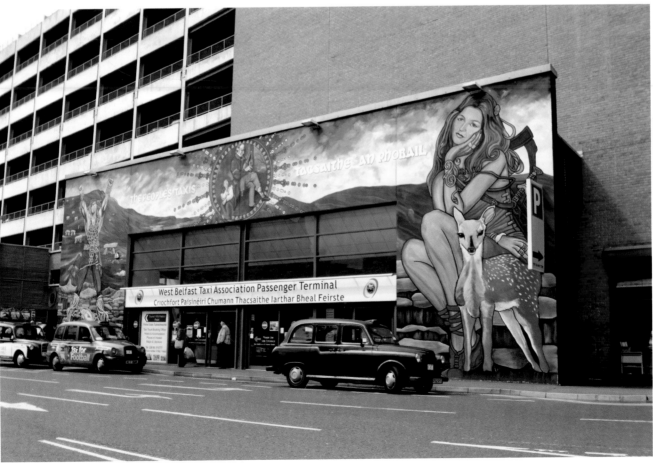

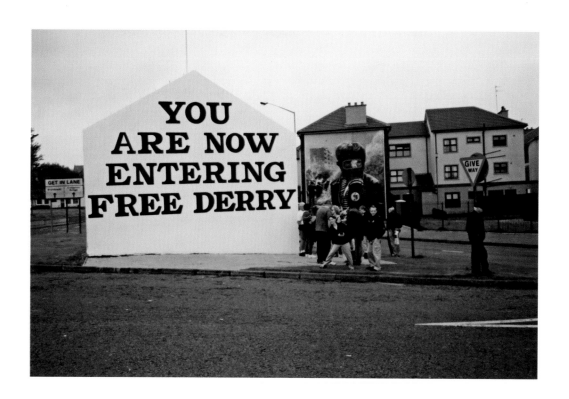

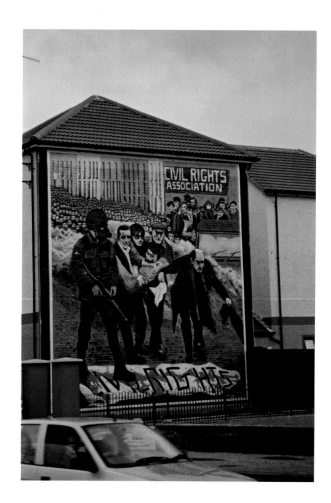

Murals are prominent
along the streets of Derry.

DERRY

I love Derry. It is a city I have visited often since the 1960s. On my way to the Donegal Gaeltacht (Irish-speaking region) as a schoolboy to spend my summer learning Irish or later with my friend, Joe Magee, as we hitchhiked our teenage way into the northwest, we were oblivious to the build up of righteous anger at the way citizens in that city were being treated. (Derry was then a nationalist city run by a unionist minority.)

The first blows of what came to be described as "The Troubles" were struck by the state police, the Royal Ulster Constabulary (RUC), against civil rights marchers in October 1968, and, by 1972, Derry was in open revolt. There was a popular uprising against the injustice of the unionist-dominated northern state. Derry became the scene of one of the worst atrocities of the conflict, when fourteen civil rights marchers were shot dead by the British Parachute Regiment.

For thirty years, the families, along with their friends, neighbors, and supporters, courageously campaigned for the truth to come out about this massacre. Finally, in 1998, in the course of the negotiations that were part of the peace process, then-British Prime Minister Tony Blair agreed to the establishment of a public inquiry into the events of January 30, 1972. The Bloody Sunday or Saville Inquiry, as it came to be known, published its report on June 10, 2010. The British went to extraordinary lengths to prevent any part of it becoming public before Prime Minister David Cameron addressed the British Parliament on June 15. The families of the victims were closeted in the Guildhall, Derry's Council building, and given an advance look at the report, but they were allowed no contact with the outside world until after Mr. Cameron spoke.

I began my journey to Derry early that morning in bright sunshine. I passed through the small town of Dungiven, where several hundred small, wooden crosses had been erected on the green verge. Each bore the name of a person shot and killed by the British Forces in disputed circumstances.

I reached Derry around 2:00 p.m. Half an hour later, the crowd had spread toward the Bloody Sunday memorial. The idea was to complete the march commenced on January 30, 1972, that was cut short by the British Army's attack on the marchers. Stewards shepherded members of Bloody Sunday's families and other victims of state killings to the front of the mass of people. There was a good-natured, excited sense of expectation, as thousands of people fell in behind the families. The names of the fourteen victims were read aloud, and there was a minute's silence. Then we set off for the Guild Hall, the destination of the original civil rights marchers more than forty years ago. Someone started to sing 'We Shall Overcome,' and I was swept back in time to America's civil rights movement.

In the Guild Hall Square, the crowds cheered loudly, as family members ensconced inside the city chambers read the Saville Report, waved copies from the stained-glass windows, and gave thumbs-up signals. We knew then, even before listening to Mr. Cameron, that the families felt vindicated.

One of the women relatives tore up a copy of the Widgery Report and flung it to the wind. Widgery was part of the British state's cover-up of what had happened, a lie it stuck to for decades. I picked up some of the pieces afterwards and placed them in my copy of Saville, a keepsake of a remarkable day. —GA

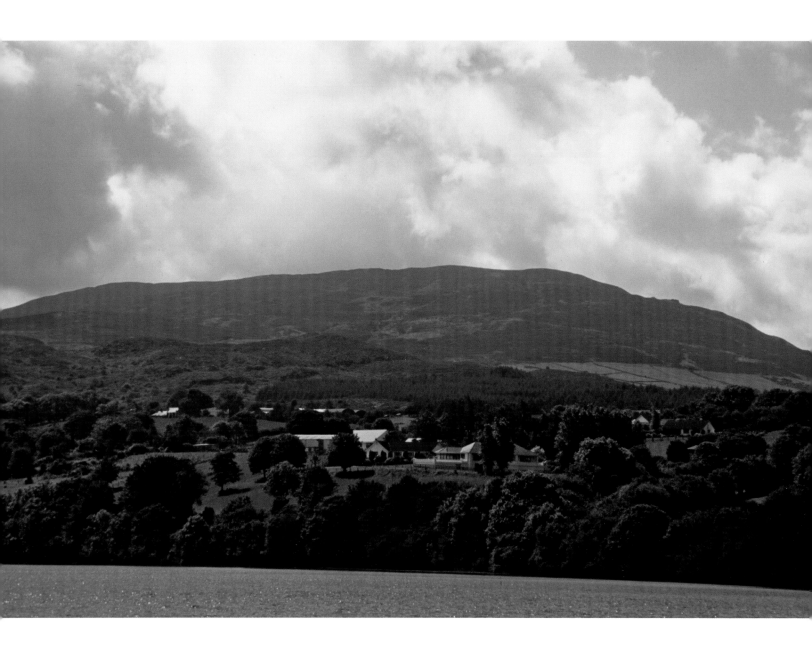

Belfast is my home. It is where I was born and have lived most of my life. It rises up from the Lagan Basin, framed by the Belfast and Hollywood hills. It's a magnificent setting. I would find it very difficult to settle anywhere that didn't have hills on the horizon.

These hills have watched Belfast grow. They have acted as meeting places for rebels and safe havens for Catholics holding secret masses during the penal days (1691–1760). I walk the hills when I can. From the top on a clear day you can see the Mourne Mountains to the south and the Isle of Man and Scotland to the east. —GA

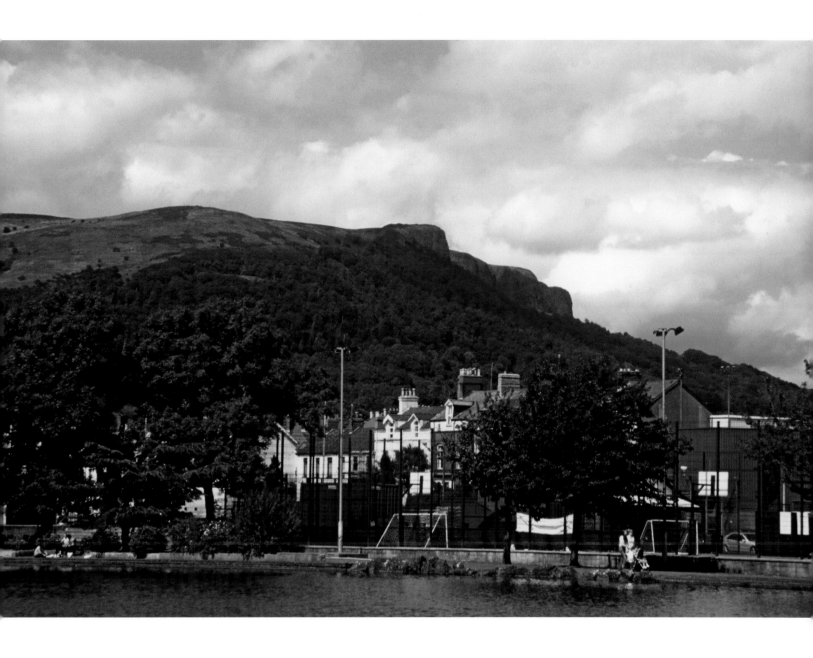

McArt's Fort, on the summit of Cavehill, historically known as Ben Madigan (1,214 feet or 370 meters elevation), is an example of an old ráth or ring fort. It is protected by a precipice on one side and by a large ditch on the other side. There are about 30,000 to 40,000 of these across the island, of which only a few hundred have been excavated. Most date from the sixth to seventh centuries BCE. But McArt's uniqueness doesn't end there. During the 1790s, it was a meeting place for leaders of the United Irish Society, the first Irish Republicans, including Theobald Wolfe Tone and Henry Joy McCracken, who plotted rebellion against the British. In 1798, they struck for freedom but were defeated. Many of the leaders were killed or executed, but their philosophy of freedom, equality, justice, and citizen's rights continues to give historical voice to an alternative, progressive Belfast. —GA

A dog runs in the surf on Magheroarty Beach.

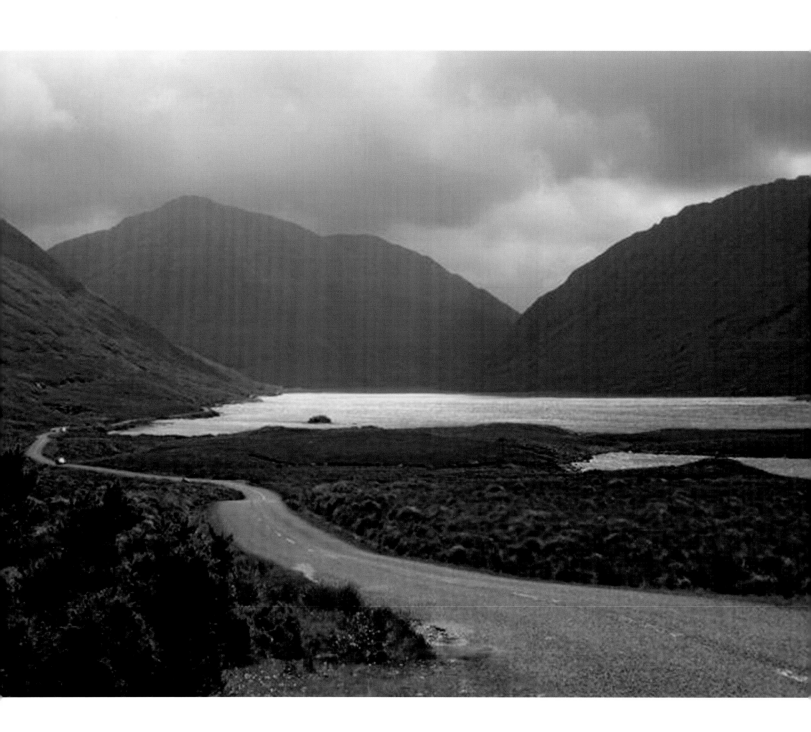

The route that people walked to the famine ships, along the shores of Lake Doolough
in County Mayo, is still used by residents and tourists alike.

Connacht

THERE ARE FOUR PROVINCES in Ireland: Munster, Ulster, Leinster, and Connacht. Each is fiercely proud of its history, but all are united in their love of Ireland, its language and music, its dance and sport, its literature and history, its poetry and drama, its mountains and valleys, its coasts and rivers, its resilience in the face of centuries of colonialism and adversity.

Connacht, in the west of Ireland, includes the counties of Galway, Leitrim, Mayo, Roscommon, and Sligo. Much of its rugged coast is downright inhospitable, but good agricultural land exists inland, where the largest cities such as Galway are also located. Still, Connacht is best known as the mystical home to many of the stone circles, dolmens, cairns, and passage tombs in Ireland. It's impossible to say which part of Ireland is the most beautiful, but the abundance of majestic landscapes and historic sites here is especially striking. Some of the sites date to CE 400–500.

Those who live here have retained an acute and strong sense of Irish culture, music, dance, and storytelling, perhaps because they have traditionally been more isolated from the rest of the country, with their land more rugged and wild and less inhabited. The province also boasts the largest number of Irish-speaking people, with more than 30,000 alone in County Galway. Many years ago as a young man, I was hitchhiking through the region and was struck as well by their pride and defiance, as epitomized in a sign I read by the cash register in a market outside the town of Spiddal, County Galway: "*Irish, German, French, Spanish spoken here. English understood.*"

Part of this lingering resistance to the English is due to *An Gorta Mor*, also known as "The Great Hunger" or "the potato famine" of 1845–1852. To call it a famine, however, is really a misnomer. Even as the potato crop failed, due to a blight that damaged the plants, there was food aplenty. The tragedy was enhanced, if not caused, by a more insidious situation: the export of most of the crops by British landlords and their agents from Ballina, Galway, and other ports along the west coast. People had the choice either to give their crops to the landlords or be forced off the land. As a result, more than 1,000,000 died from starvation and disease, and in the decades following, another 3,000,000 fled the country. By the end of the nineteenth century, the population had shrunk from eight to four million. —GA

Back then, support of the Irish cause, at least in spirit, came from an unlikely place. The Choctaw, Cherokee, Muskogeecreek, Seminole, and Chickasaw Indians, among others, had also been forced off their ancestral lands in the Southeastern United States, in 1830, in a tragic event known as "the Trail of Tears," in which more than 2,500 people perished along the way. When they heard of the Irish "long walk" to the famine ships, the Choctaw took up a collection and sent $174 to the Irish Relief Fund. Having endured a similar kind of repression and forced exile, they empathized with the native Irish. —EB

This memorial in Doolagh commemorates those who died en route to the famine ships.

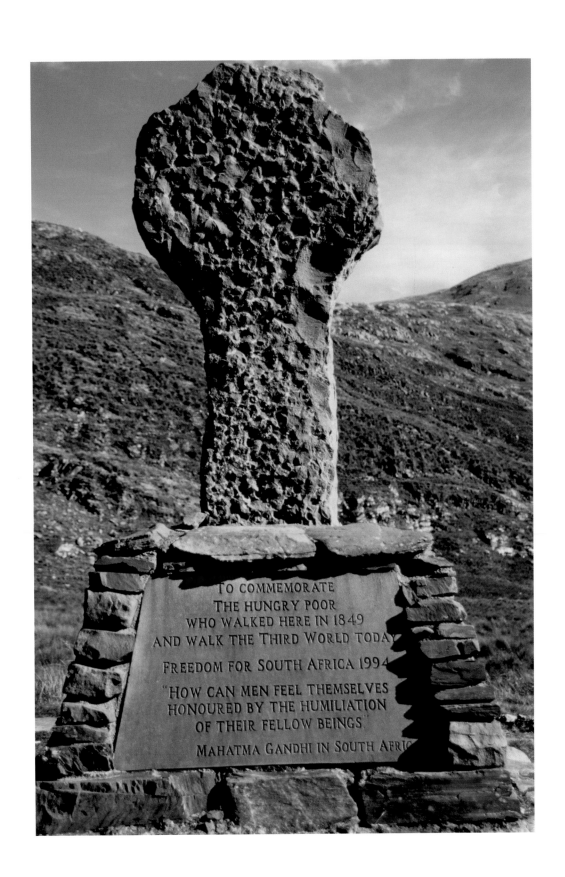

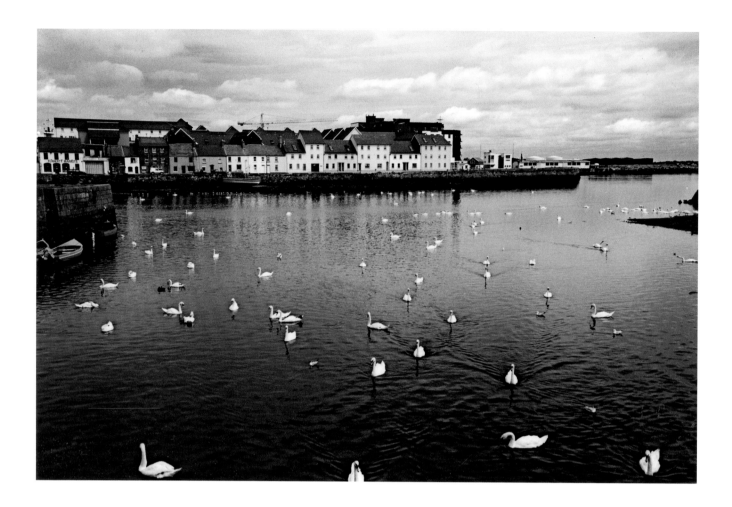

I always feel a hint of the mystic in Galway City. There is a sense of possibility and adventure. It's said that the dark complexion and dark hair of the people owe their origin to the Spanish soldiers and sailors who were washed ashore, when the great Spanish Armada was wrecked in storms off Ireland's Atlantic west coast in September 1588. Galway City is also the gateway to Connemara, known to some as the 'real emerald' of Ireland. Connemara has a great sense of itself, and the Irish language (Gaelic) is vibrant here. TG4, the Irish-language television station, is based here, and a young, energetic generation of filmmakers, musicians, and broadcasters showcase their talents on television screens in homes across the island. The scenery is majestic. —GA

I love to feed the many regal swans on Galway Bay. It's breathtaking to watch the spectacular swans slowly flapping their enormous wings, as they fly down the River Corrib. Slowly, exquisitely, they lower their large bodies into the water, their necks as supple as snakes. These magnificent birds are big, and it can be intimidating to stand in a group of them holding bread, as they all vie for a treat. —EB

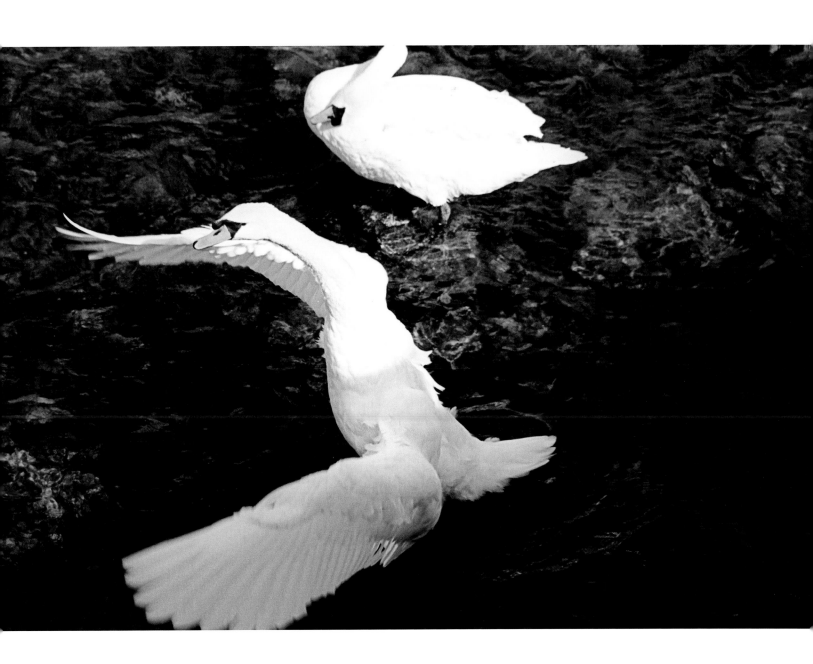

Swans delight in the waters of Galway City, Ireland's fifth most popu-
lous city and one of the country's cultural centers.

This photo creates an optical illusion
in the still waters of Clifden Harbor
in Connemara.

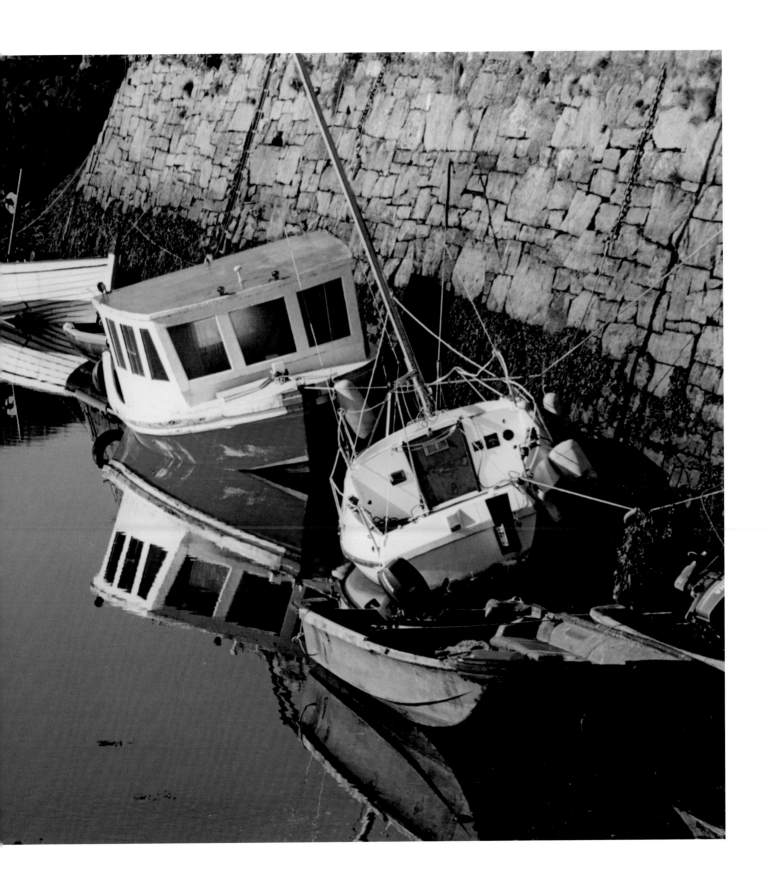

Window shrines are popular all over Ireland. Here is one in Inishbofin. Permanent settlement on the island began in CE 668, when St. Colmán of Lindisfarne (ca. 1605–1675) founded a monastery. He died there, and his feast is celebrated on August 8. —EB

ISLAND LIFE

There are a number of islands off the west coast of Ireland. I have visited Achill, Clare, Inishbofin, and Inishmór in the Aran Islands (not to be confused with Isle of Arran, off the southwestern coast of Scotland in the Firth of Clyde). A trip to any of these islands is always an adventure. I often wondered how the ancient seafarers were able to know where they were at sea. They had no GPS, and the skies are often cloudy, so how does one read the stars for position? But they knew.

On Inishmór I saw beautiful, stacked stone-walls enclosing plots of potatoes, vegetable patches, and sheep. Interestingly, there were no gates for the sheep pens. When I inquired, I was told that the farmer just pulls the rocks down, lets the sheep out, and rebuilds it when the sheep are brought back. I was inspired by the different perception of time these islanders have. It is such a refreshing view of the world, with no rushing about.

From the idyllic fishing village of Cleggan, just outside Clifden, a modern ferry goes to Inishbofin Island, about a thirty-minute crossing. The island's human history harkens back to BCE 4,000–8,000, but today its population is around 200, excluding the throngs of tourists who seek the island's sandy beaches and crystal-clear waters.

The island has long been a breeding area for numerous species of birds, some rare or threatened, and seals. Once I visited the seal colony there, where scores slid off their rocks and curiously observed me photographing them. They reminded me of dogs enjoying a swim. They would pop up next to the boat and then, just as quickly,

disappear under the water, as I clicked the shutter. It is an optical illusion to look at a family of seals sunning on the rocks and suddenly realize there is a baby camouflaged in the middle of two large adults. While visiting the seal colony, we passed an abandoned island with crumbling stone cottages. It must have been an amazing though challenging existence.

The tip of Achill Island has steep hills where sturdy, blackface sheep with skinny, black legs feed on the green grasses that grow on steep cliffs overlooking the Atlantic Ocean. I would be afraid to walk where they do. The view north and south on the edge of Ireland is sublime. You can see fingers of land and mountains making a dramatic, misty-layered panorama. My sister and I stayed in a lovely B&B here and watched a unique show unfold. One day, some sheep walked down a mountain to a small cottage and stood waiting outside a pen that held other sheep. Eventually, a man came out of the house, opened the pen, and let the waiting sheep in. They kept coming, one by one. I finally had to ask the man what was happening. He told us that, every year at the same time, the sheep come down, get shorn, and go back to the mountains. "How do they know," I asked? "They know," he told me. Just like the seafarers knew.

Another story I love to tell is of the man we met on Achill Island. He was selling amethysts and other gemstones and entertained us greatly with his tall tales and cheeky humor. Once, he said, he followed a leprechaun into a cave that was lined with gold. The man was tired from

the walk and fell asleep. When he awoke, all the gold was gone, except for the one chunk that was sitting on the table where we now sat. The leprechaun had taken all the rest! Then he gave us each a small piece of amethyst, danced around the living room with us to Irish tunes twinkling from an old record player, and ran off to the races!

And then there is Grace O'Malley, the legendary pirate queen, who had a castle on Clare Island, now in ruins. She was known as 'The Sea Queen of Connacht,' because she taxed all fishermen who entered her waters and, with her fleet of some twenty ships, raided and plundered as far away as England, whose rule she opposed. I am descended from pirates. Who knows? Maybe I am related to Grace. I had an aunt who lived on the Gulf Coast of Mississippi in a house built with bricks from the original house of the pirate Jean Lafitte. There was a tunnel from the house to the boat, so he could make a quick getaway. Like Grace, Lafitte fought the British—in his case, when they attacked New Orleans in 1815.
—EB

The Aran islands—Inishmór, Inisheer, and Inishmaan—sit at the entrance to Galway Bay. They are very special places, with great, wide skies, a profusion of wild flowers, rocky fields bisected by little roads or *bótharín*, and stonewalls everywhere, built in herringbone patterns from the same limestone associated with the Burren region in Munster. Often the only sounds are birdsong and the noise of the elements—wind and rain. Islanders still use the *currach*, a traditional boat usually made of tarped canvas stretched over a wooden frame. Great skill is needed to use this light structure on the rough Atlantic seas.

The beauty of the islands brought writers and others interested in the islanders and their history. One of the best known was J. M. Synge (1871–1909), a key figure in the Irish Literary Revival and a co-founder of the Abbey Theatre in Dublin, who visited often between 1898 and 1903. He lived with a local family, playing the fiddle and listening to the stories that were to influence his plays, The *Playboy of the Western World* (1907) and other seminal works. Later, in 1934, Robert J. Flaherty, the American filmmaker, made his extraordinary documentary, *Man of Aran*, a re-creation of the way of life of a culture at the edge of modern society. —GA

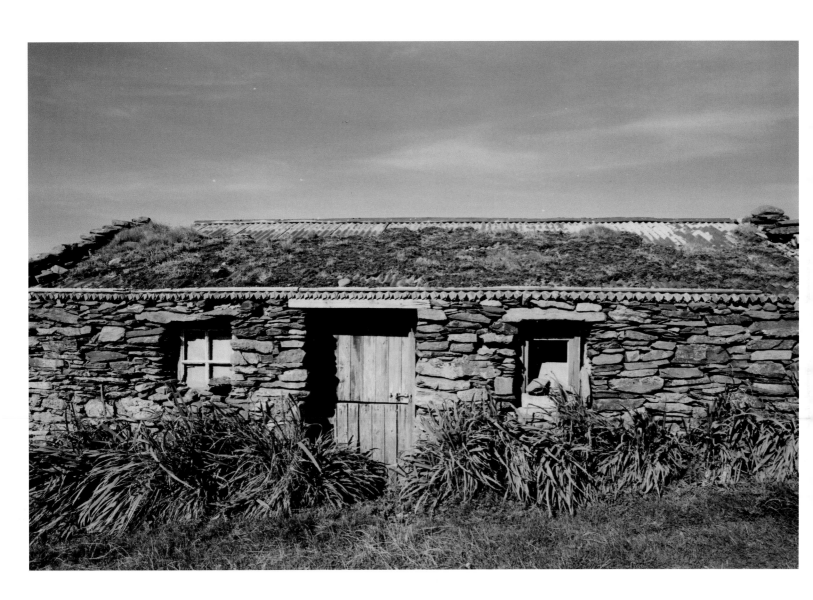

I love this old stone cottage on Inishbofin, "Island of the White Cow." The island lies
about seven miles (eleven kilometers) off the Connemara Coast, opposite Cleggan
Bay and Ballinakill Harbour, and it is reached by ferry on a thiry-minute crossing
from Cleggan, a picturesque fishing village. —EB

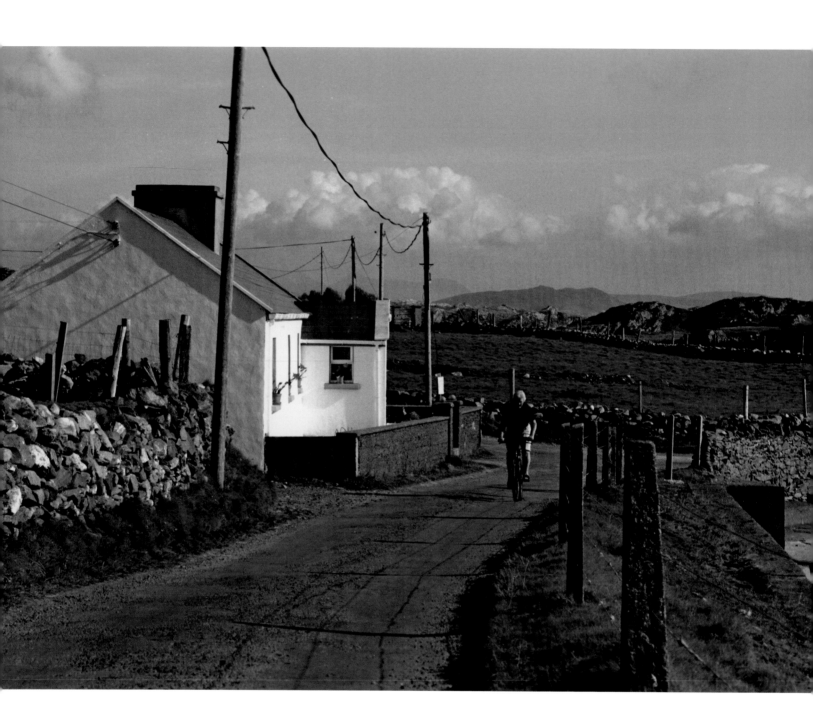

This lone cyclist navigates his way on a country road on Inishbofin Island. Although the island's population has shrunk from 1,462 in 1837 to the appoximately 200 residents today, its spectacular white sandy beaches, rare flora and fauna, and scenery are unchanged. —EB

There are wondrous Irish tales of seals, fueled, no doubt, by the echo of a human voice, which can be heard in the acoustic of their cries. On a lonely evening or serene early morning, their keening can be mistaken as the *caoineadh* of the banshee, the spirit woman, warning of an impending death. I prefer to see them in terms of another legend, that of the man who married a mermaid who had taken on human shape. She was, in fact, a seal woman, a descendant of the people who could not board Noah's Ark, so they changed into seals to survive the Great Flood. It is said that they sometimes change back into human form, cast off their skins, and dance. It's little wonder that a man would marry a woman who danced like that. Little wonder that his bride cries as she does. —GA

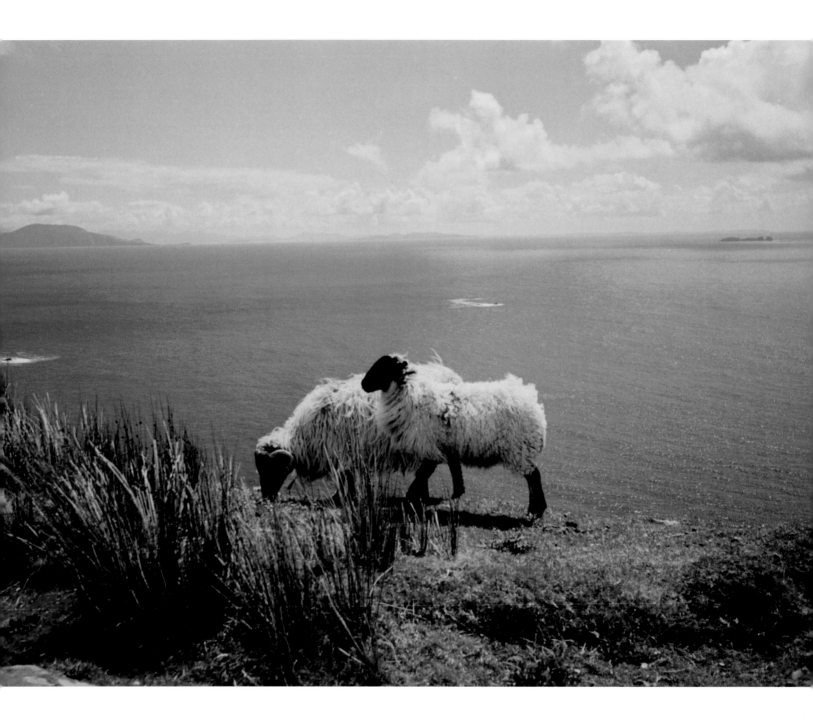

Blackface sheep adorn the landscapes of Achill Island. Human settlements were established between BCE 3000–4000, when the island was mostly forested. Today, eighty-seven percent of the island is comprised of peat bog, which limits agriculture to sheep farming. —EB

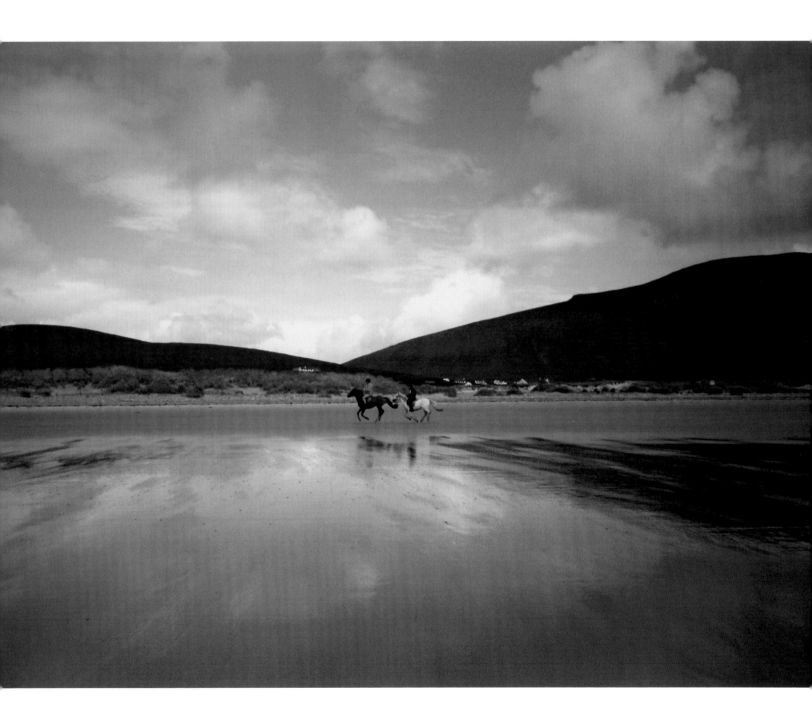

Riding horses in Ireland is especially romantic on a beach on Achill Island, the largest island off the coast of Ireland. Tourism is the key to the local economy and its approximately 2,600 residents. —EB

Islanders still use the *currach*, a traditional boat usually made of tarped canvas stretched over a wooden frame. In earlier times, animal skins and hides were used. The design and construction are unique to the west coasts of Ireland and Scotland, and the boat is still used both at sea and in inland waters. —EB

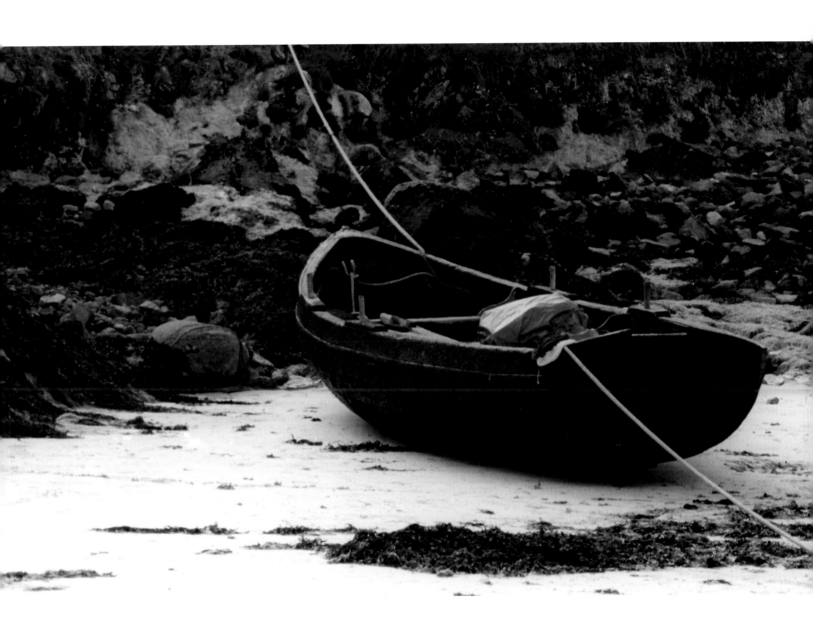

The dolmen is an integral part of our ancestral landscape. All over Ireland, these markers of ancient Neolithic graves do exactly what their makers planned: they draw our attention, curiosity, and admiration. We wonder who is buried below them. We are amazed at how ancient people erected such monuments. We are in awe of their ingenuity. And, as we stand in the shadow of a dolmen, usually on a remote gradient, it is obvious to us that we are in a holy place. The ancient Irish believed that the spirits of the dead live on in the stones and in the air and water of the places they loved. They are never far from us . . . nor we from them. —GA

Above: Two cherubic Irish children hide underneath a dolmen on Achill Island in County Mayo.

Opposite: A raven flies over a spectacular dolmen in County Sligo.

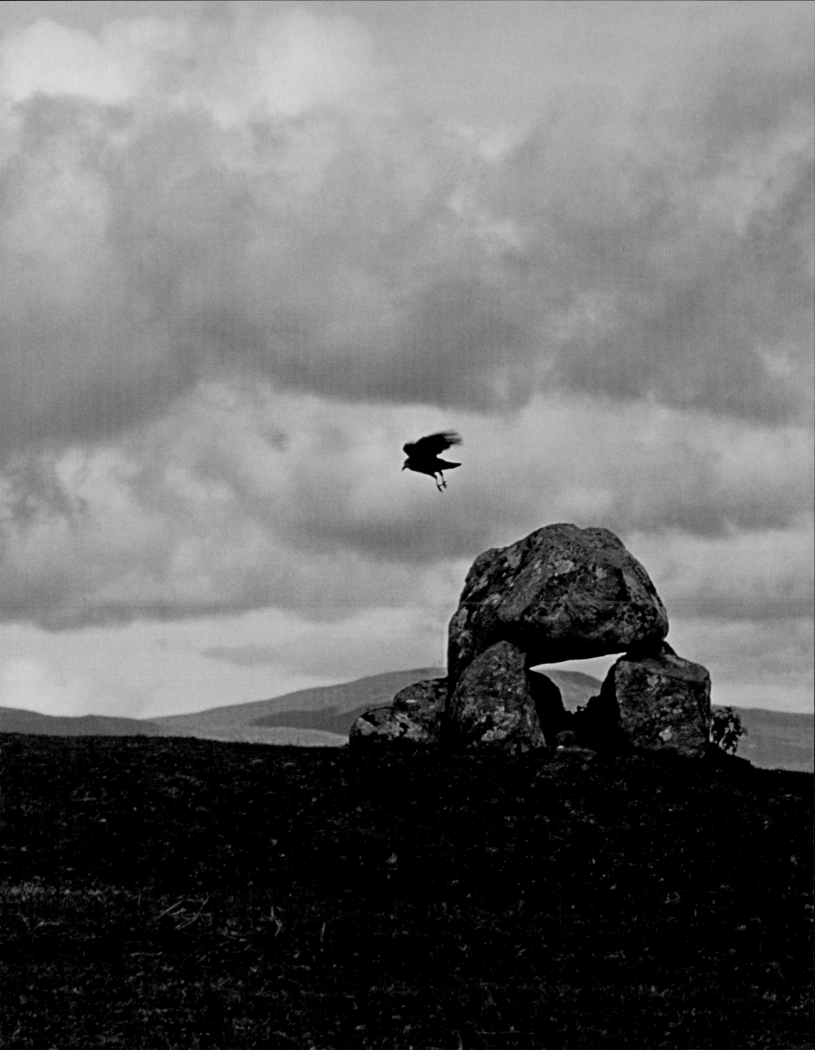

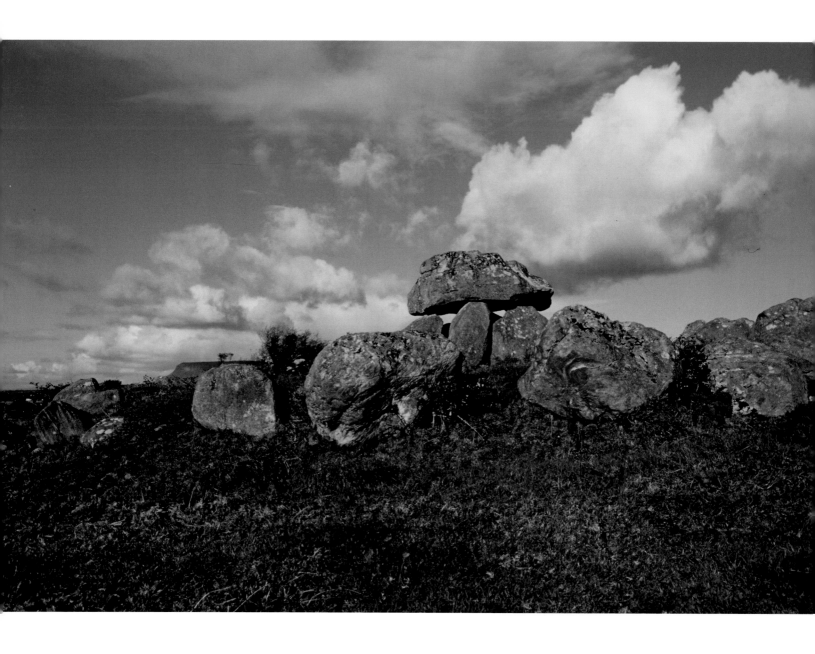

Carrowmoor, one of the four major passage-tomb cemeteries in Ireland, is located at the center of a prehistoric landscape known for ritual monuments on the Cúil Peninsula of County Sligo. Around thirty megalithic tombs can be visited today, where one can notice their "dolmen circles," a ring of thirty to forty boulders approximating thirty-nine to forty-nine feet (twelve to fifteen meters) in circumference. The tombs date to around 5400 BCE. —EB

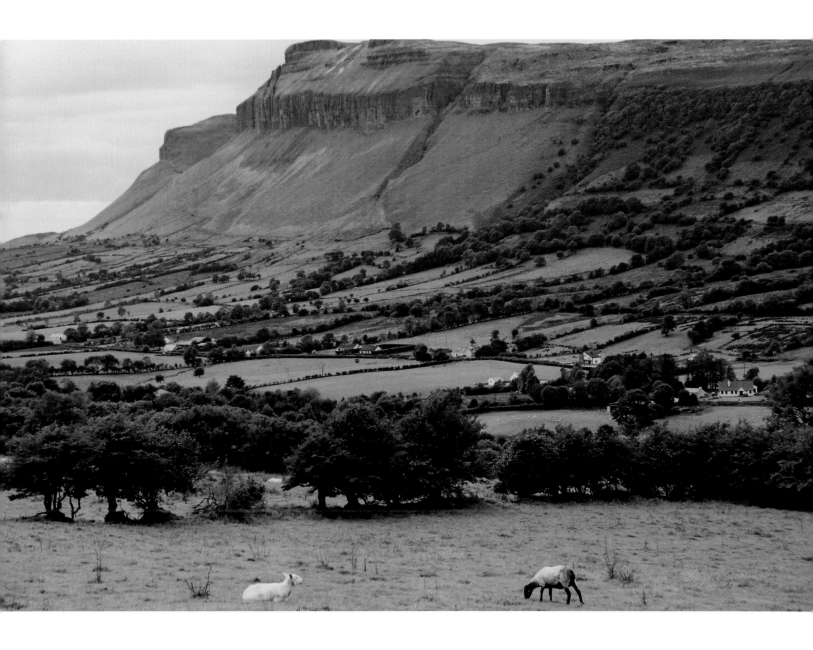

The area outside of Sligo is rich with megalithic monuments, one of the most famous of which is Carrowmoor. From this amazing heritage site you can see the top of Knocknarea Mountain, where Maeve (*Medb*), the legendary Queen of Connacht, is buried. She was so brave she was buried standing up. When the mountain is shrouded with fog, it is said she has her cloak wrapped about her. Ben Bulbin, a great and famous rock formation that inspired William Butler Yeats, is also visible from Carrowmoor. —EB

Above: These award-winning gardens in Ballysadare, County Silgo, are nourished by seaweed harvested by the Voya Spa in the scenic coastal village of Strandhill, one of my favorite places to go when I am in the area. Taking a seaweed bath is like bathing in liquid velvet. —EB

Opposite: Glencar Waterfall, located near Glencar Lake west of Manorhamilton in County Leitrim, is one of Ireland's most beautiful. It was the inspiration for William Butler Yeats's famous poem, "Stolen Child," which was based on Irish legends of fairies. It was written in 1886 and published in 1889. —EB

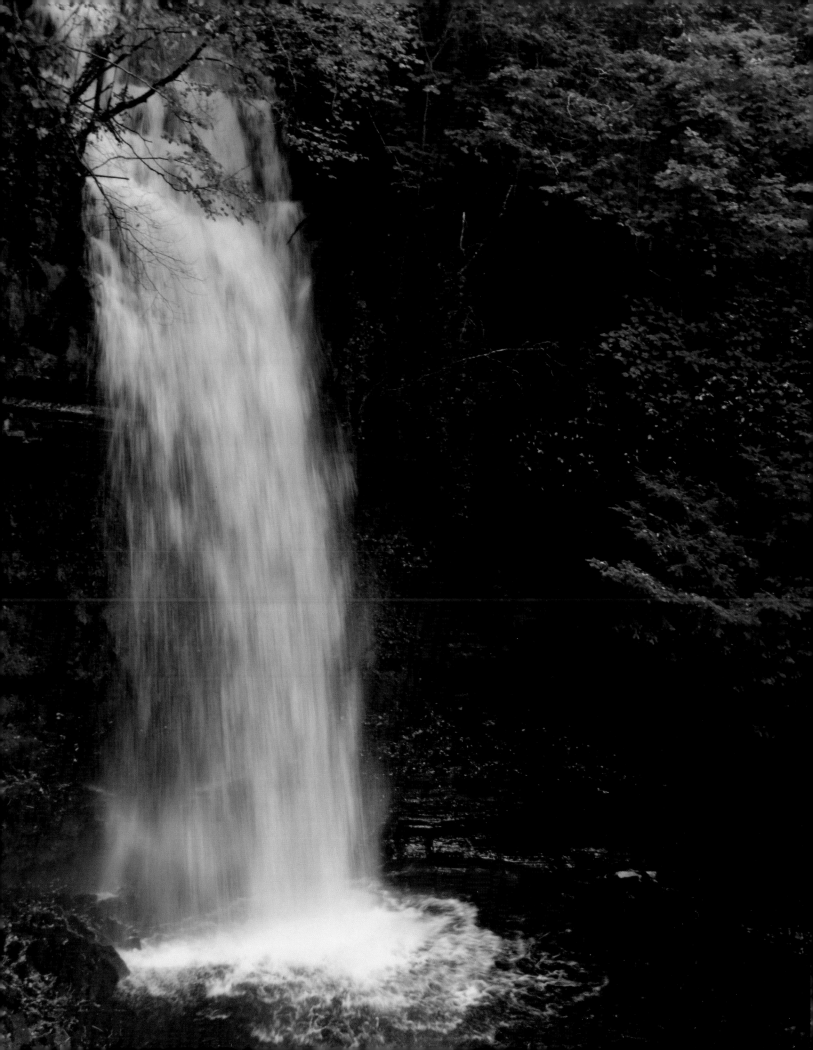

Kylemore Abbey is a magnificent castle in the Connemara, in County Galway, that features more than 40,000 square feet (3,716 square meters) and seventy rooms. Originally constructed as a castle to serve as the family home for the Mitchell Henry family from London between 1867 and 1871, it became a monastic refuge in 1920 for Benedictine nuns who had fled Belgium during World War I and has remained an abbey since. Kylemore occupies a most dramatic and beautiful setting at the base of heavily wooded mountains. On a still day, you can see its turrets, shrouded by thick, leafy trees, perfectly reflected in the lake in front. En route to the castle's ancient Gothic church, I love to walk through the copse of trees—each has a nametag describing its species. Trees are very important in Irish lore and life. They were held in great esteem by the ancient Celts and were thought—then as now—to have healing properties and to possess great wisdom that one could access through ceremonies and meditation at their feet. —EB

Once mass begins at Kylemore Abbey, the front door is locked. Arriving late, we completely ignored the 'Do Not Enter/Staff Only' sign and went around the back. We followed the singing, which led us up a winding staircase, through the priest's door and on to the altar. The priest faltered a moment, while laughing nuns escorted us to seats. After the service, we were chided for being late. I offered that surely someone had done the same thing at least once before us? The reply: "No . . . no. That's never happened before!" —EB

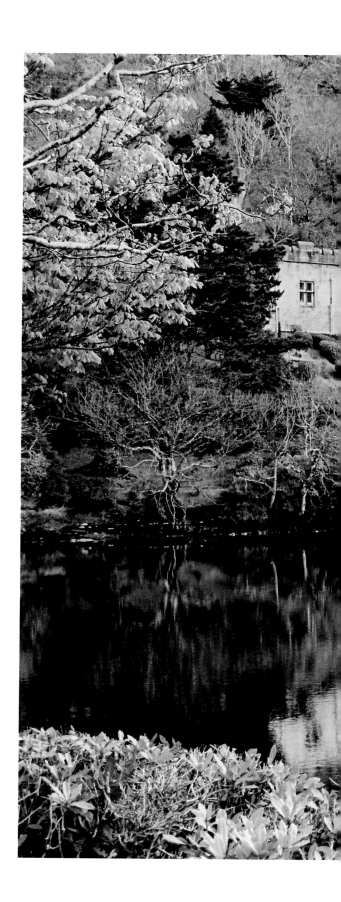

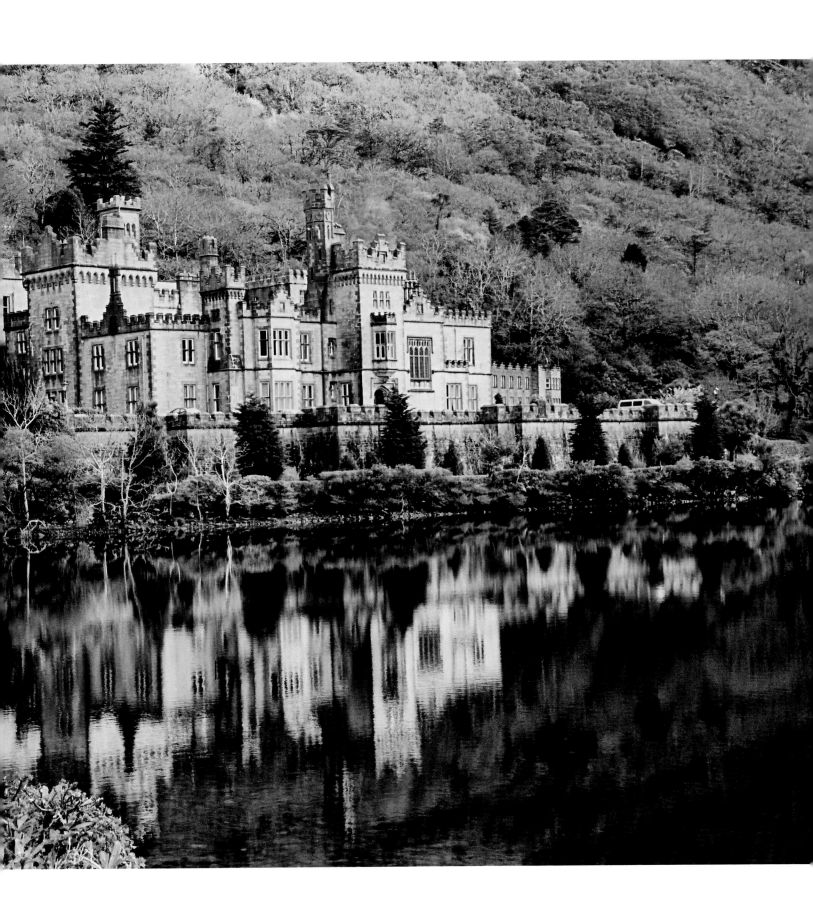

When weather permits, the view across the lake in front of Kylemore Abbey is spectacular. —EB

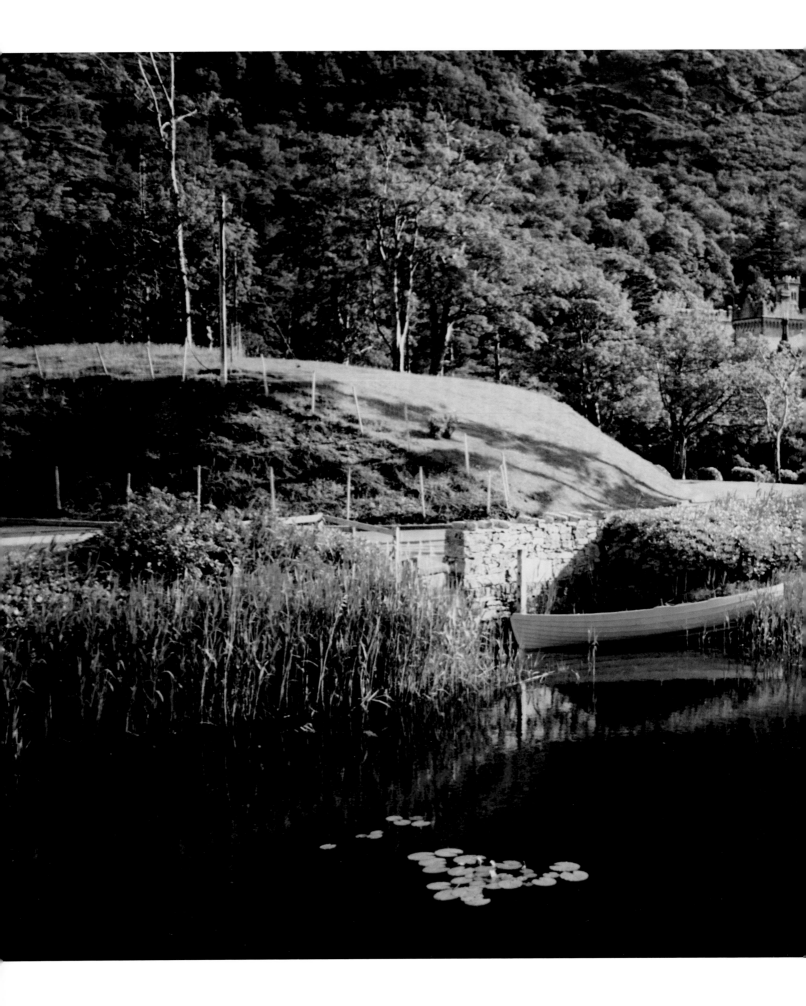

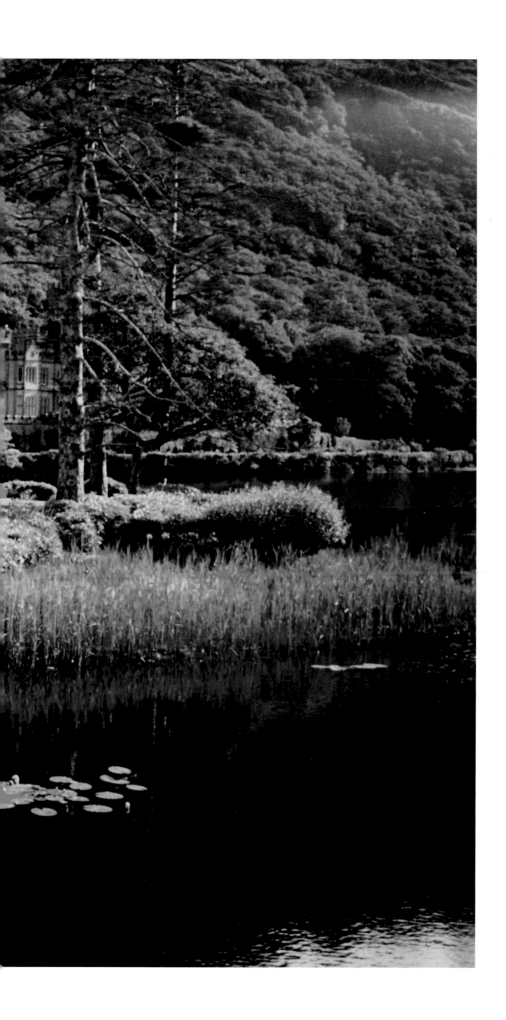

The blue boat nestled in the reeds in front of Kylemore Abbey is one of the most photographed images of this iconic place. There are gorgeous tree-lined trails throughout the property and a gorgeous Victorian walled garden. —EB

In Ireland, our native trees are ash, birch, hazel, oak, rowan (mountain ash), Scots pine, willow, and yew. Many of our place-names come from the names of trees. Antrim, for example, is derived from *aon trim* or elder, Derry or *doire* means oak, Kildare or *cill dara* is "church of the oaks," Mayo (*maigh eo*) is a "plain of the yews," Monaghan or *muineachan* refers to "a place of thicket," and Roscommon or *Ros Comain* means "Saint Comain's Wood." Much of the older woods and forests were ripped up during the sixteenth and seventeenth centuries and exported to Britain to be used in shipbuilding. Even today, only seven percent of our land is wooded, much of it conifer, and only one percent of our trees is native. The destruction of our native species means that much of our wood is now imported.

I like to grow trees, and so every autumn I gather seeds and pot them. When they get to a decent height, I plant them or give them away. Trees are a lovely way to celebrate a birthday, honor the death of a friend, or give as a token of friendship. I have seeds from wherever I have visited: rowans from seeds gathered at Chequers (the British Prime Minister's residence), holly from Hillsborough Castle (the official residence of the secretary of state for Northern Ireland), and redwood from the redwood forest outside San Francisco. The seeds I received from President and Mrs. Obama from trees at the White House, unfortunately, didn't take, but the ones from 10 Downing Street are struggling on.

Trees were sacred and at the center of life for the druids, the pagan priests of the Iron Age, who also believed that trees are a source of great wisdom. The wood of many trees was also considered magical, especially that of the hazel, from whose wood wizards (including Harry Potter and his friends) made their wands. The expression "touch wood" comes from the druids, who warded off evil spirits by touching a piece of wood. So go on, hug a tree—it will do you good. And the tree will be pleased. —GA

Above: A grove of yew trees near Kylemore Abbey.

Opposite: An ancient oak tree by the lake at Kylemore Abbey.

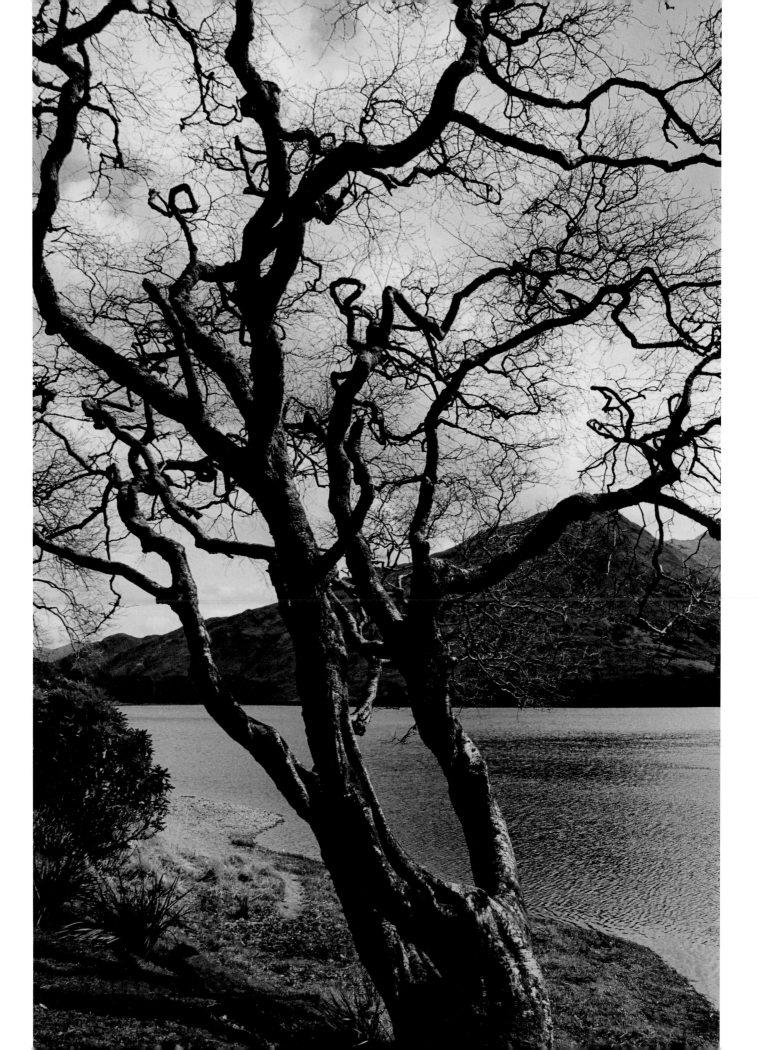

Mayo has its own Neolithic history, and nowhere will you see this more clearly than at
the stunning Céide Fields (above and opposite) in the north of the county, five miles (eight
kilometers) northwest of Ballycastle. Buried beneath bog land on the Atlantic coast, the
Céide Fields (meaning "fields of the flat-topped hill") comprise a huge archaeological site of
dwelling areas, field systems, and megalithic tombs. Approximately 6,000 years old, it is the
most extensive Stone Age monument known in the world—and it was discovered by accident.
During the 1930s, as he cut turf—which has been dried and used as a fuel in Ireland for mil-
lennia—Patrick Caulfield, the local schoolmaster, found piles of stones in a regular formation
beneath it. Seamus Caulfield, his son who had become an archaeologist, carried out his own
investigations and uncovered evidence of cultivated fields and human habitation. He surmised
that climate change or the clearing of trees for farms had led to alterations in the landscape
that rendered the land barren. So the people living there moved, and the bog took over, leaving
the Céide Fields undisturbed for thousands of years. Their chance discovery and the informa-
tion they continue to provide offers a unique insight into the daily lives of the people of Ireland
before the great pyramids of Egypt were built, the great societies of Greece and Persia flour-
ished, and the empires of Rome and China even existed. —GA

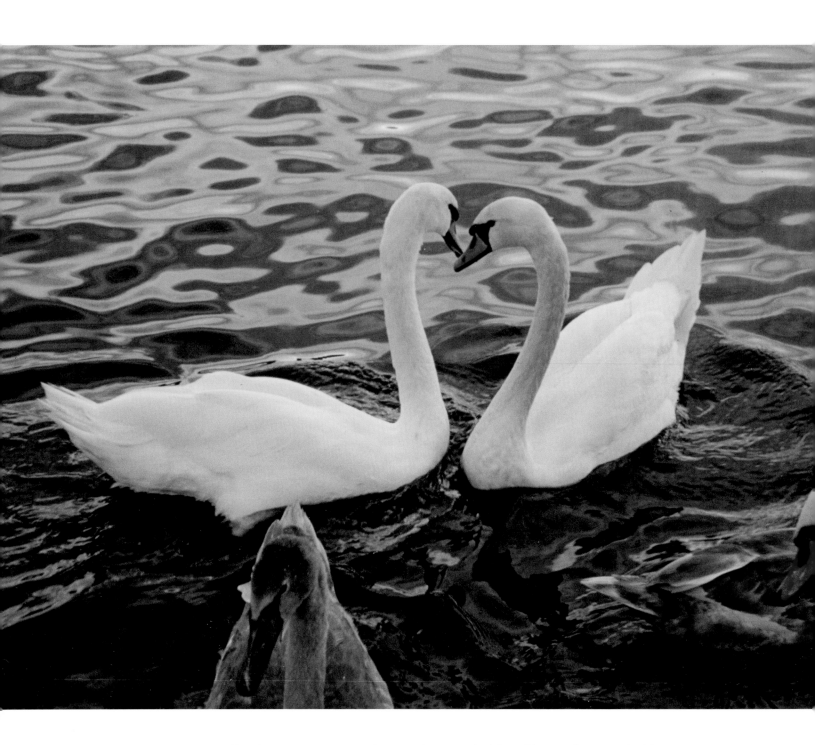

Muted swans congregate and even embrace on the lake at Waterworks, a wonderful green space with a lake, sports facility, and community garden in North Belfast near Cave Hill. During the 1840s, the Belfast Waterworks were established to provide a source of water for the city's residents and factories. In 1897, the site was converted to its present-day use as a special place for waterfowl and recreation. —GA

Afterword

BY GERRY ADAMS

WHEN ELIZABETH BILLUPS AND I first became acquainted and then friends, little did we know that a book on Ireland might emerge. When I was asked to write a short history of Ireland that might complement her photographs, I gladly obliged.

What follows is a brief summary of the complex political history of my native land, the roots of the conflict in the North, and its resolution. It is intended to offer a general overview of how Ireland came to be, politically and socially, during the last several hundred years, especially the last 150, and to provide some context for the photographs. It is a complicated history, not necessarily easy reading, and there are many viewpoints. Mine is that of a native son who has long sought the peaceful unification of one island without borders.

The good news is that today, as a result of the peace process, there is a unique power-sharing system of government in the north of Ireland that supports the creation of a better future and the creation of employment and other opportunities for all its citizens, not just those who are Protestant or British.

As Elizabeth discovered in her exploration of the country, in Ireland the personal is always political. We are very aware of our history, both ancient and contemporary. Reminders are everywhere, from Neolithic sites to medieval castles and monuments commemorating wars, famine, and other tragedies of the past several centuries. But, as she also learned, we Irish are tenacious and light-hearted, with a great sense of justice, but also a great sense of humor and whimsy, two qualities that have carried us through the tough times and beyond.

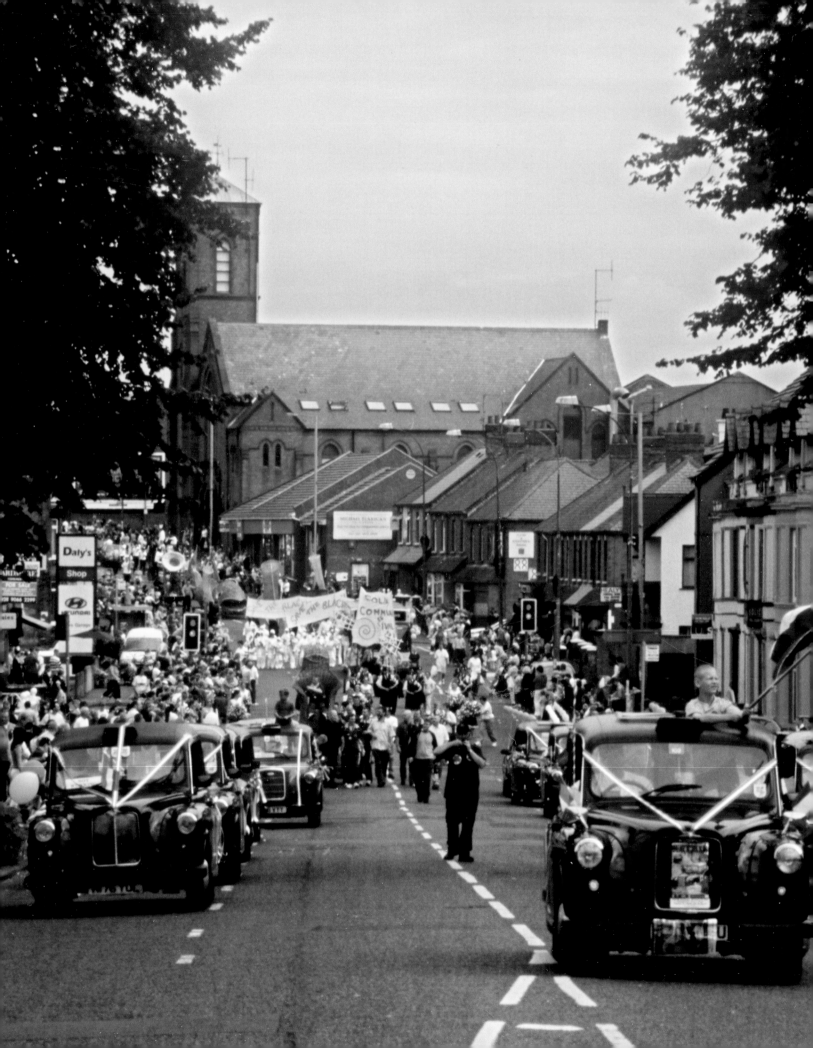

My Ireland:
One Island, No Borders

BY GERRY ADAMS

I was born in October 1948, in Belfast, into an Ireland that was divided. My family had trade union and republican connections and influences going back to the early part of the twentieth century, but I only became politically conscious when, as a teenager in 1964, I witnessed members of the Royal Ulster Constabulary (RUC), the state police, force their way into a Sinn Féin office to remove the Irish national flag—the tricolor—from the storefront window. The result was several days of intense rioting.

In trying to make sense of this and of the decades of conflict and of the peace process, one cannot, in my view, begin to understand the island of Ireland—its people, politics, and society—unless one sets it in the context of the long history of the English occupation, colonization, and partition of the island. Ireland today has been shaped by these events. It is also being transformed by the peace process that emerged out of twenty-five years of war and in which the Irish-American lobby, the United States government, and others played a key role in constructing.

For some, the starting point is the invasion of Ireland in 1169 by Norman feudal knights and lords seeking land, wealth, and power. For others, it's the Flight of the Earls in 1607 in which, following the crushing defeat inflicted on the Irish clan sys-

Opposite: Black taxis take the lead during the *Féile an Phobail* ("Festival of the People" or "Community's Festival") in West Belfast.

175

tem by the army of the first Queen Elizabeth, its leaders—Hugh Ó Neill (1587–1607) of Tyrone and Rory Ó Donnell (1575–1608) of Donegal—fled to Europe with about ninety followers, never to return. Ó Neill and Ó Donnell both died in Rome, and their followers remained in Europe.

As a result, Ulster, the northernmost province of Ireland's four provinces and the last to fall to English rule, was the most heavily colonized. The English distributed the stolen land to farmers, who were mostly from Scotland and who sent most of their yield back to Britain. The settlers thus owed their privileged position to English rule, which guaranteed their loyalty, and so they acted as a garrison population and first line of defense for British interests in Ireland.

The fact that the colonists were members of the emerging Protestant churches while the dispossessed were Catholic led to the introduction of sectarian politics. Unlike other colonial situations, in which color and/or race became the distinctive difference between settler and native, in Ireland it was religion. This became the badge of identification between two sharply divided political positions, with the native population resentful and seeking freedom and the settler community locked into a siege mentality, wanting to retain control of an English colony.

The Cromwellian invasion of Ireland during 1649–1653 along with the defeat of the Catholic King James II at the Battle of the Boyne in 1689 by the Dutch Protestant King William of Orange, who was married to James's daughter, Mary, and his rival for the throne of England, led to even greater appropriation of land by the Protestant English settlers. By 1690, nearly eighty percent of all land in Ireland was held by the colonists, and the island was being run by a Protestant ascendancy class, most of whom belonged to the Church of Ireland, which is part of the Anglican Communion or Church of England. Thus, the Protestants were the majority landowners but only comprised some twenty-five percent of the population.

In order to guarantee their dominance, the Protestants enacted laws that discriminated against the native Irish. Most of these "penal laws" were aimed at crushing Catholicism, but they also stripped the three-quarters of the population who were Catholic of any political or economic power or influence. Catholics were also barred from holding public office, they could neither vote nor become lawyers, and they were prohibited from buying land and denied education. If a Catholic owned a horse worth more than £5, it could be confiscated; £5 was also the price put on the head of a Catholic priest. By 1775, Catholics owned only five percent of the land in Ireland. As a result, the vast majority of Irish people lived as peasants in abject poverty, frequently facing the trials of famine.

The class of English landlords and its agents cruelly exploited this situation to maximize their profits. Here is how one English writer, Arthur Young, described conditions at the time in his 1780 book, *A Tour in Ireland*:

"A landlord in Ireland can scarcely invent an order which a servant, labourer or cotter dares to refuse to execute. Nothing satisfies him but an unlimited submission. Disrespect or anything tending towards sauciness he may punish with his cane or his horsewhip with the most perfect security, a poor man would have his bones broke if he offered to lift a hand in his own defence . . . Landlords of consequence have assured me that many of their cottars would think themselves honoured by having their wives or daughters sent for to the bed of their master; a mark of slavery that proves the oppression under which such people must live."[1]

The penal laws also affected the Presbyterians, who were mainly from Scotland and fully in support of the English occupation. They, too, were discriminated against in employment, particularly government jobs, by the colonial establishment, which was connected with the Church of Ireland.

This was a particular source of grievance and caused many to emigrate to the British colonies in America, where these Scots-Irish played an important role in the independence movement. After the United States achieved its decisive victory at Yorktown, winning its independence from England in 1781, George Washington wrote of them and of the Irish generally:

"When our friendless standards were first unfurled, who were the strangers who first mustered around our staff? And when it reeled in the light, who more brilliantly sustained it than Erin's generous sons? Ireland, thou friend of my country in my country's most friendless days, much injured, much enduring . . . accept this poor tribute from one who esteems thy worth, and mourns thy desolation. May the God of Heaven, in His justice and mercy, grant thee more prosperous fortunes, and in His own time, cause the sun of Freedom to shed its benign radiance on the Emerald Isle."[2]

Indeed, the American War of Independence was one of two events during the late eighteenth century that changed the course of Irish history. The second was the French Revolution of 1789.

When the American colonies declared independence on July 4, 1776, British troops were withdrawn from Ireland to fight abroad. The English crown then established the Irish Volunteers to defend the island against the threat of invasion by the French. With most English soldiers fighting in the American colonies, the English government feared that France, which was supporting the American colonists, would take the opportunity to invade Ireland as a stepping stone to an attack on Britain.

Mostly Protestant, the Irish Volunteers were led by the Protestant aristocrats who ran the Irish Parliament. Yet they, too, chafed under the trade and economic restrictions imposed by the crown to protect English commercial interests, which were not unlike those that so rankled the American colonies. Frustrated, the Volunteers demanded greater independence from Britain. They also sought an end to the penal laws against Catholics, since these laws negatively impacted them as well.

In 1783, the English conceded legislative independence to the Irish Parliament in Dublin but retained administrative power in the hands of the English Lord Lieutenant. Unfortunately, the Irish Parliament was deeply corrupt and failed to deliver for the Volunteers. So there was no significant change in the franchise, and Catholic emancipation was put on the back burner. The Volunteers' movement was gradually stripped of any influence and also of its weapons.

For many, this was a huge disappointment. The success of the American colonists—and of the republican principles of sovereignty, equality, and democracy they espoused—inspired many to adopt a similar political approach, which was further encouraged by the success of the French Revolution. In Belfast, in July 1791, people celebrated the second anniversary of the fall of the Bastille. Thomas Paine's *Rights of Man* (1791) was widely read, and its defense of the French Revolution and arguments in support of democratic rights found many willing supporters. Irish Presbyterians quickly embraced the revolution's principles of *liberté, egalité, et fraternité*—liberty, equality, and fraternity.

That same year, the Society of United Irishmen was established in Belfast, comprised mainly of Protestants, including their co-founder and leader, Wolfe Tone (1763–1798), who argued that the Presbyterians—generally referred to as Dissenters—could not achieve change on their own. His central thesis has remained a cornerstone of Irish Republican philosophy to this day. Tone wrote:

"To subvert the tyranny of our execrable Government, to break the connection with England, the never, failing source of all our political evils, and to assert the independence of my country—these were my objects. To unite the whole people of Ireland, to abolish the memory of all past dissensions, and to substitute the common name of Irishman in place of the denominations of Protestant, Catholic and Dissenter—these were my means."[3]

In 1798, the Society of United Irishmen rose in rebellion against the English. The French—by now having successfully launched their own revolution against their monarchy—landed an army 1,000-strong in County Mayo, but poor communication, betrayal by informers, and overwhelming English forces saw the uprising ruthlessly suppressed. Nevertheless, it laid the foundations for Irish Republicanism in Ireland

and provided a political ideology and demand for independence that shaped Irish history in the coming centuries.

The nineteenth century in Ireland was a turbulent period. It began with the Act of Union of 1800, by which Ireland became part of the United Kingdom of Great Britain and Ireland. The Irish Parliament was scrapped, and Irish Members of Parliament (MPs) were elected to sit in the British Parliament. But conquering Ireland was not enough; the British wanted to destroy any sense of Irishness, including our language, music, and culture. All business had to be conducted in English, and the use of the Irish language was outlawed. For example, one of the penal laws passed in 1695, "An Act to Restrain foreign Education," states in Section 9:

> "Whereas it has been found by experience that tolerating at papists keeping schools or instructing youth in literature is one great reason of many of the natives continuing ignorant of the principles of the true religion, and strangers to the scriptures, and of their neglecting to conform themselves to the laws of this realm, and of their not using the English habit and language, no person of the popish religion shall publicly teach school or instruct youth, or in private houses teach youth, except only the children of the master or mistress of the private house, upon pain of twenty pounds, and prison for three months for every such offence."[4]

As ever, there were Irish men and women who rejected British rule, and there was a succession of abortive rebellions in 1803, 1848, and 1867.

The most devastating event of the nineteenth century and, perhaps, in Irish history was the Great Hunger (in Gaelic, *An Gorta Mór*) of 1845–1849. During the early 1840s, the population of Ireland was more than 8,000,000, of which more than 6,000,000 were tied in a desperate battle with the land to produce enough for their families to live on. Most had less than a half-acre plot of land to cultivate, and they were totally dependent on the potato. The historic failure of the potato crop in 1845, which saw between one-third and one-half of the crop lost due to a blight, led to great hardship and five years of famine and disease in which approximately 1,000,000 died.

The other effect of this disaster was to force people to flee overseas. Abandoning their mostly one-roomed, mud- or turf-walled cabins, with their sod roofs and their small parcels of land, they left on ships (many of which had carried African slaves a few decades earlier) from ports around Ireland and Britain bound for North America.

The *Irish Quarterly* review from the time records the pathetic lines of people on Dublin's quays:

"A procession fraught with most striking and most melancholy interest, wending its painful and mournful way along the whole line of the river, to where the beautiful pile of the Custom House is distinguishable in the far distance, towering among the masts of the shipping.

Melancholy, most melancholy, is the sight to the eye not only of the Dublin citizen or resident, but to the eye of every Irishman who is worthy of being so called and indeed, the spectacle is one of sadness and foreboding. A long continuous procession . . . a mix stream of men, women and children, with their humble baggage, who are hurrying to quit for ever their native land!"[5]

In the years after An Gorta Mór, more than 1,000,000 had left Ireland by 1852. Many hundreds of thousands also emigrated during the remaining half of the nineteenth century until, by 1900, Ireland had lost half its population. In 2013, the combined population of both parts of Ireland is around 6,000,000—still 2,000,000 fewer than the tally before An Gorta Mór. And around 900,000 are foreign-born!

As we look back at this period in Irish history, it is important to understand why so many Irish people distinguish between the use of the word 'famine' and the Gaelic term *"an Gorta Mór."* In a famine, there is no food. In Ireland at the time, there was plenty of food. For example, the quaysides along the River Shannon in Limerick were lined each day with abundant foods, including pork, oats, eggs, sides of ham and beef—all bound for export. One of Limerick's merchants recorded the goods leaving his port from June 1846 to May 1847: 386,909 barrels of oats and 46,288 barrels of wheat.

The reality and irony of this is appalling and was aptly described by George Bernard Shaw in his play, "Man and Superman" (1903), in which the character Hector Malone says:

"Me father died of starvation in Ireland in the Black 47. Maybe you've heard of it?"
To which Violet Robinson, his wife, replies, "The famine?"
"No," says Malone, "the starvation. When a country is full of food and exporting it, there can be no famine. Me father was starved dead; and I was starved out to America in me mother's arms. English rule drove me and mine out of Ireland."[6]

Even as the Irish scattered around the world, it was the 'famine Irish' in the United States who played a significant role in the decades following the Great Hunger in supporting resistance movements against the British in Ireland. The Irish Republican Brotherhood (IRB) was established in 1858. Its goal was to achieve an Irish republic. During the same year, an exiled Irishman, John Ó Mahoney, established the Fenian Brotherhood in the United States. Together, these organizations planned rebellion for

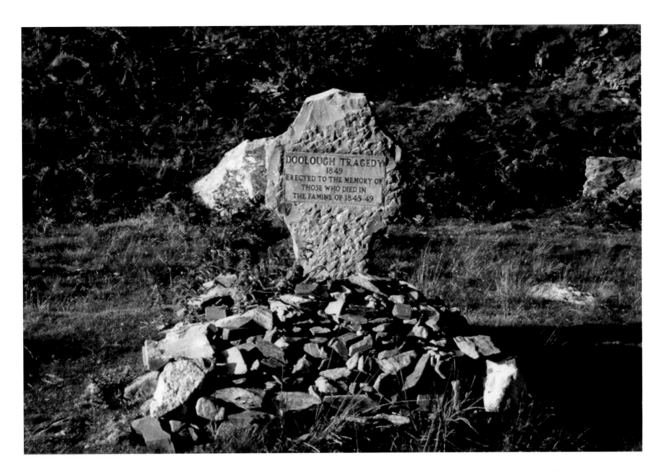

Memorials such as this one in Doolough, County Mayo, dot the Irish landscape to commemorate those who lost their lives during the Great Hunger (*An Gorta Mór*) in 1845–1849. —EB

Irish independence; but, when it came in 1867, their efforts were no more successful than earlier efforts.

Defeat, however, did not see the demise of the IRB. The Fenians, as they were now called, continued to agitate for Irish independence. And both groups, on both sides of the Atlantic, played a key role not only in the Land War of the 1880s, but also in the revival of the Irish language, culture, and sport at the turn of the twentieth century.

The influence of sectarian politics in the northeast of Ireland also grew during the nineteenth century. Belfast mushroomed in size during the Industrial Revolution, its population increasing from around 20,000 in 1800 to 350,000 by 1900. The

base of the city's early growth was the linen industry, which did not threaten English commercial interests, but the mills required machinery, which led to an increase in engineering. By the 1850s, Belfast had also become one of the biggest centers for ship-building in the world.

Members of the business class in Belfast were predominantly Protestant and supported the union with Britain, which they saw as being in their economic interest. Job discrimination based on religion became a means of controlling the growing urban working class. Thus, most skilled and semi-skilled jobs were held by unionists, and, by 1911, only 7.6 percent of shipyard workers were Catholic.

The unionist business and landed aristocracy bitterly opposed several attempts during the late nineteenth century by liberal-led governments in London to introduce home-rule bills for Ireland, which would have devolved into a limited form of self-government. The unionist working class not only was afraid it would reduce access to the British market, but was also convinced that it would lead to "Rome Rule," or more power for the Catholics, which would lead to an end to their privileged status.

In 1905, the political tradition of Fenianism was given new shape with the establishment of Sinn Féin. There was also a radicalization of the working class in Dublin through the work of trade-union leaders like James Connolly (1868–1916). Following two elections in 1910, another Liberal-led government in London found that it needed the support of MPs belonging to the nationalist Irish Parliamentary Party. The Irish demanded another home-rule bill.

Unionist political leaders in the north of Ireland and British Conservatives combined to oppose this measure. They threatened civil war. In September 1911, the Ulster Unionist Council said: "We must be prepared . . . the morning Home Rule passes, ourselves to become responsible for the government of the Protestant province of Ulster."[7] They also established the Ulster Volunteer Force, a largely armed paramilitary force of some 100,000 men. The nationalist response in November 1913 was to establish the Irish Volunteers.

One consequence of the debate on home rule was a proposal to partition Ireland. Some argued for the four northeast counties, which were mostly unionist, to continue to be part of the United Kingdom. Edward Carson, the leader of unionism, wanted all nine counties of Ulster to be excluded from any home-rule legislation.

World events then overtook the debate on Ireland. War was declared between Britain and Germany in August 1914, and Europe went to war. The Home Rule Bill was put on the statute books but with two conditions: it would not come into effect until the end of the war and until the "Ulster" question was resolved.

Meanwhile, the Irish Republican Brotherhood, with the financial support of the U.S.-based *Clann na Gael*, joined forces with a section of the Irish Volunteers and sev-

eral hundred members of the Irish Citizen Army (ICA) to plan a rebellion against the British. The ICA had been created to defend workers during a bitter labor dispute in Dublin in 1913.

On the morning of Easter Sunday, April 24, 1916, Pádraig (Patrick) Pearse (1879–1916) was appointed Commandant-General of the Army of the Irish Republic and President of the Provisional Government. Two hours later, Pearse marched with a small number of comrades to the General Post Office (GPO) in Dublin's Ó Connell Street. The GPO was then occupied, and it became the headquarters for the rebellion. There he read from its steps the "Proclamation of a New Republic." This was a pivotal moment both for Ireland and the British Empire.

At the same time as the GPO was occupied, groups of armed activists then took over other key vantage points in Dublin. For the next six days, this small band of men and women—numbering around 1,500—took on the might of the British Empire.

The rebels were poorly armed, and initial confusion meant that fewer turned out than expected. By the time Pearse surrendered on Saturday, April 29, some 450 people had been killed, including 254 civilians, 116 British soldiers, sixty-four republicans, and sixteen policemen. The center of Dublin was devastated.

More than 3,500 people were also arrested, and almost 2,000 of these were interned in prisons in England and Scotland. The leaders of the rebellion were court-martialled on May 2, and fifteen of them, including Padraig Pearse and James Connolly, were executed by firing squad over the following two weeks. Some months later, a sixteenth leader, Roger Casement (1864–1916), from County Antrim, was hanged in London for trying to import weapons into Ireland.

The executions caused outrage. George Bernard Shaw, the Nobel Prize winner, writer, journalist, and essayist, wrote: "My own view . . . is that the men who were shot in cold blood after their capture or surrender were prisoners of war, and that it was, therefore, entirely incorrect to slaughter them. . . ."[8]

"The Easter Rising" is one of the watershed points in Irish history. It transformed politics and the public mood. This was given expression in the writing of the period. George William Russell (whose pen name was AE) wrote:

"Their dream had left me numb and cold,
But yet my spirit rose in pride,
Refashioning in burnished gold
The Images of those who died,
Or were shut in the penal cell.
Here's to you, Pearse, your dream not mine,
But yet the thought, for this you fell,
Has turned life's water into wine."[9]

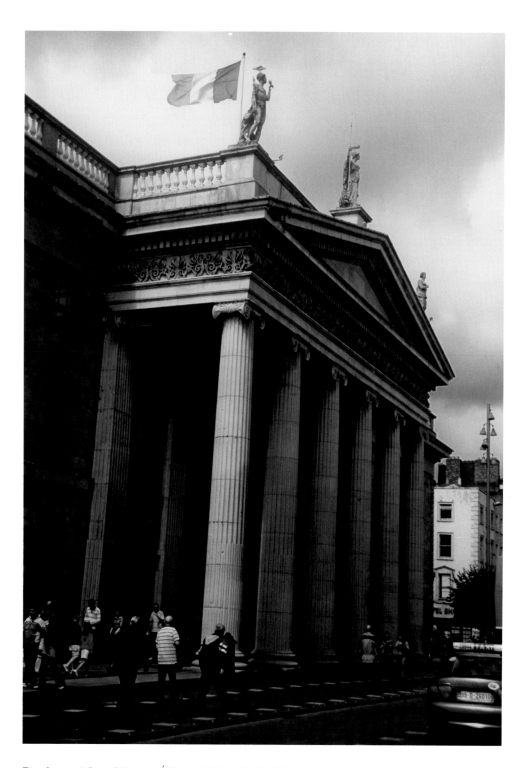

The General Post Office on Ó Connell Street in Dublin served as the headquarters of the Army of the Irish Republic and the place where Pádraig Pearse, Commandant, read the pivotal "Proclamation of a New Republic" on April 24, 1916, during the Easter Rising.

For the Irish, the rebellion was their declaration of an independent republic. But not just any republic. This republic was to be uniquely democratic and determinedly inclusive. Its core values were mapped out in the Proclamation of 1916, which remains today, for me, one of the great documents of history. The Proclamation is the bedrock mission statement of modern Irish Republicanism, a declaration of social and economic intent for a rights-based society in which the people are sovereign. Herewith its key provisions as a freedom charter for the whole island and all the people who live here:

—It guaranteed religious and civil liberty and is avowedly anti-sectarian.

—It promoted equal rights and equal opportunities for all citizens.

—And, at a time when women did not have the vote, it supported universal suffrage.

In the elections that followed World War I, in December 1918, the Irish Parliamentary Party was decimated. It was a landslide victory for Sinn Féin, which took seventy-three of the 105 seats, whereas the Irish Unionist Party took twenty-six seats, almost all in the northeast.

Sinn Féin had pledged during the campaign not to take its seats in the British Parliament but to establish instead a Parliament in Ireland for the Irish people. On January 21, 1919, the first Irish parliament, or *Dáil,* met in the Mansion House in Dublin. Many of those elected, however, were in prison, which sent a clear message to the British government and the world that the Irish people demanded self-determination and freedom. It was also the day in which the first shots were fired at Soloheadbeg, in County Tipperary, where two members of the Royal Irish Constabulary (RIC), an armed police force aligned with the British government, were ambushed and killed. What followed was a bitter guerilla war, known as the Tan (or Black and Tan) War, between the Irish Republican Army and the British forces, with the Irish government and Dáil, outlawed by the British regime, increasingly taking over the running of much of the country.

In the northeast, the Ulster Volunteer Force was revived and a special armed constabulary established by the British government. The Government of Ireland Act, which was passed by the British Parliament in December 1920, called for the partition of the island with six of the northeast counties of Ulster—Antrim, Armagh, Derry, Down, Fermanagh, and Tyrone—excluded, each with its own parliament. The sectarian math was very simple: the two-thirds' unionist majority of the six counties would provide that government with a permanent majority, thus making an independent northern state more viable.

In July 1921, a truce was agreed upon, and, in October, treaty negotiations commenced between the Republican side and the British. Under the threat of 'war within three days' by the British government, the Irish delegation signed an agreement that created an Irish "Free" State in the southern twenty-six counties of Ireland. These would still be part of the British Commonwealth, and their elected representatives would have to swear to "be faithful to H. M. King George V, his heirs, and successors."[10]

The unionist parliament in Belfast was given the right to opt out of the Irish Free State, which meant an acceptance of partition. There was a long and bitter debate in the *Dáil Éireann*, which ratified the treaty by a narrow margin in January 1922. The IRA and Sinn Féin split over this, causing a vicious and cruel civil war in which the republicans were defeated. In the north, there was the worst-yet sectarian violence. The result was two conservative states ruled by two conservative elites. The two states were characterized by economic failure, emigration, backwardness on social issues, inequality, and the failure to protect the most vulnerable of their citizens against economic, religious, and political persecution.

Those who built the southern state turned their backs on the north. It is the product of the counter-revolution that followed the Easter Rising and of a dreadful civil war that tore out the heart at that time of what remained of the generosity of our national spirit.

As the idealism of the aborted revolution waned, a native conservative elite replaced the old English elite, resulting in little real change in the organization of Irish society and no real movement toward social equality based on civil rights. Conservatism ruled, and religion was hijacked by men who enforced narrow moral codes and used the gospel not to empower but to control.

Women, gay, and lesbian citizens were denied equality under the law, and abuses of all kinds, particularly of women and the poor, were tolerated, even encouraged, under the guise of rehabilitation of people, especially women, considered to be of dubious moral character or convicted of petty crimes. Examples of this kind of institutional abuse include the notorious Magdalene Asylums (also known as the Magdalene Laundries), which were essentially sweat shops, and the Bethany Home, a residential facility in Dublin run by evangelical Protestants that housed women who were either pregnant out of wedlock or had been convicted of petty theft, prostitution, and infanticide.

Furthermore, the arts were censored and the Gaelic language undermined and even outlawed. Millions fled to England, the United States, Argentina, and Australia. A lesser people would not have survived.

Although William Butler Yeats's poem, "September 1913," predates the Easter Rising and partition, the following stanzas capture the sense of this betrayal:

"Was it for this the wild geese spread
The grey wing upon every tide;
For this that all that blood was shed,
For this *Edward Fitzgerald* died,
And *Robert Emmet* and *Wolfe Tone*,
All that delirium of the brave?
Romantic Ireland's dead and gone,
It's with O'Leary in the grave."[11]

The northern state became a "Protestant state for a Protestant people," and Unionists set about consolidating their control. Through a series of measures, including the gerrymandering of local electoral boundaries, restrictions on the right to vote, and the imposition of a permanent state of emergency, the unionist regime in Belfast created what was, in effect, an apartheid state. Discrimination was endemic. The northern state was a unionist state, and that meant that unionists got the best jobs—sometimes the only jobs.

The Civil Authorities (Special Powers) Act of April 7, 1922, gave the government the right to outlaw organizations, detain people without charge or trial, impose curfews and restrict movement, prohibit inquests, and order searches and arrests without warrants. If the Minister of Home Affairs felt that some additional power was needed that was not defined by the act, he could make any further regulations he saw fit to authorize the state police to carry out these powers.

The gerrymandering of electoral boundaries stripped the nationalists of any real power or influence. For example, in County Fermanagh, which had a slight nationalist majority, there were thirty-six unionist to seventeen nationalist councilors. And Derry, the North's second-largest city, which had an overwhelming nationalist majority, nonetheless had a unionist majority on the council. Through these and other measures, the Ulster Unionist Party controlled the northern state—the Orange State—for more than forty years.

All members of the unionist government, most unionist politicians and members of the state police, the judiciary, and business class were also members of the Orange Order or another of the so-called Loyal Orders, which were essentially anti-Roman Catholic organizations dedicated to the maintenance of the union of Britain. One prime minister of the North, Sir James Craig (1871–1940), the 1st Viscount Craigavon,

speaking in the parliament in Belfast in 1934, said, "I have always said that I am an Orangeman first and a politician and a member of this parliament afterwards. . . . All I boast is that we are a Protestant Parliament and Protestant state." Two years later, he added: "Orangeism, Protestantism and the loyalist cause are more strongly entrenched than ever and equally so is the Government of Stormont."[12]

During the 1960s, civil rights groups in Northern Ireland such as the Campaign for Social Justice (1964) were involved in civil rights issues and demanding change, but the first tentative steps toward creating a civil rights campaign in the North emerged out of the Republican Wolfe Tone Society. Many of those who participated took as their inspiration the civil rights movement in the United States, but some loyalists expressed their opposition to the demands for change by reforming the Ulster Volunteer Force (UVF). In 1966, two Catholic men and an elderly Protestant woman were the first people to die in the modern era of conflict. They were killed by the UVF.

In January 1967, the Civil Rights Association (CRA) was founded in Belfast. I joined around 100 people from all across the North, who came together to establish an organization to campaign for civil rights. It was the beginning of a long and difficult struggle for basic civil and human rights, including the right to universal suffrage. Its strength was that it was broad-based, and people from across the political spectrum came together to demand basic human and civil rights for nationalists. This included many republicans, socialists, communists, liberals, trade unionists, community activists, and others, including, initially, some unionists.

The CRA demanded one person, one vote; the removal of gerrymandered election boundaries; laws against discrimination by local government; the allocation of housing on a point system; the repeal of the Special Powers Act; and the disbandment of a mostly Protestant militia group known as the B Specials. In 1968, the civil rights campaign took to the streets of Belfast. The state police reacted violently, and the first serious assaults on civil-rights marchers took place.

The unionist government refused to introduce meaningful reform, and loyalist organizations, led by a young, fundamentalist, gospel campaigner named Ian Paisley (b. 1926), objected to any concessions. In March and April 1969, a series of bomb attacks damaged the electricity supply line. The IRA was blamed by the state, but it emerged that the UVF was responsible. The attacks were an attempt to prevent any political reform.

In August of that year, the unionist government allowed a march by the Apprentice Boys, one of the loyal orders, to take place in Derry. Violence broke out, and, for the first time, members of the Royal Ulster Constabulary (RUC), a police force formed in 1922 out of the former RIC, fired CS ("tear") gas into the nationalist Bogside area, commencing what became known as "The Battle of the Bogside." After

several days, the unionist government asked for help from the British government, which deployed members of its army on the streets of Derry on August 14. On that same evening, loyalist gangs attacked Catholic areas in Belfast in the worst sectarian violence seen in almost fifty years. The first to die were killed by loyalist gunmen and the RUC, which fired indiscriminately into Divis Flats, killing a nine-year-old boy and a British soldier home on leave.

The IRA, which at the time was practically non-existent and largely unarmed, took up the defense of the nationalist areas. The North was in turmoil, with the unionist government refusing to countenance any real reform and working-class areas in Belfast sheltering behind barricades.

There was a split among republicans about the best way forward. Some argued for a continuation of gradual internal reform of the Orange state. Others believed that meaningful reform was impossible, that nationalist areas had to be defended and the Orange state destroyed. Eventually, this dispute led to a split within both the IRA and Sinn Féin.

The situation quickly became militarized. In August 1971, the unionist government introduced internment against nationalists, which led to a major escalation of conflict. In January 1972, British troops killed fourteen civil-rights marchers in Derry, and within weeks the British had scrapped the unionist government and taken control of the North.

The following decades saw the playing out of a vicious war. On one side was the IRA, which was generally acknowledged by its opponents as one of the most effective guerrilla armies in the world. In addition, it enjoyed substantial community support. On the other side was the British government along with its state forces and allies among a variety of loyalist para-military organizations. The British used a number of repressive laws and actions in an attempt to defeat republicans and subjugate the nationalist community. These efforts ranged from shoot-to-kill actions and the torture of detainees, to censorship, collusion between British state forces and loyalist death-squads, and the occupation of territory.

It was clear to me and others that this was a political problem that needed a political solution. It was also clear to me that there would be no military victory for either side.

In 1983, I was elected a Member of Parliament for West Belfast. That year, I was also elected President of Sinn Féin. Along with other colleagues, I commenced a process of seeking to engage with our political opponents on the issue of peace. This was hugely difficult, as the British and Irish governments were locked into a strategy of trying to defeat Republicans—and the other political parties were equally determined to marginalize Sinn Féin. After more than ten years and many twists and turns, however, the first IRA cease-fire was called in 1994, and the peace process moved forward.

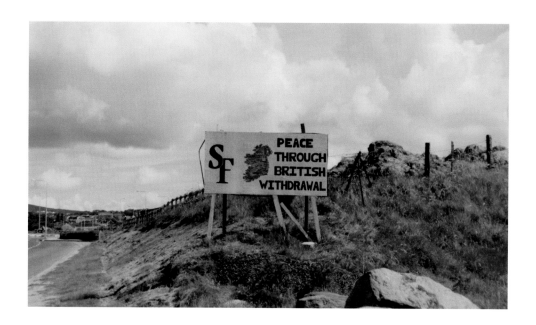

In April 1998, the Irish and British governments and most of the political parties signed the now-historic Good Friday Agreement. Endorsed the following month in referendums by the people of Ireland, the Good Friday Agreement was—and continues to be—the most important political development in Ireland since partition. At its core is the issue of equality. Unlike previous efforts, the agreement was genuinely comprehensive and inclusive, addressing a broad range of issues previously ignored. It dealt with constitutional, institutional, as well as political matters and put in place a mechanism to hold a border poll to address the issue of partition. It also set up political structures to provide for the sharing of power while including checks and balances to prevent a recurrence of past political abuses.

The Good Friday Agreement achieved remarkable progress in the areas of policing and justice, demilitarization and arms, discrimination and sectarianism, equality and human rights, and in validating the common usage of Gaelic, the Irish language. It was accompanied by a sense of great hope. Most important, the agreement provided, for the first time, a peaceful and democratic process to facilitate change, usher in equality, and achieve the new Irish Republic that Irish republicans sought to create. There have continued to be challenges, but, with hard work and compromise, many difficulties have been resolved.

In 2005, the IRA formally ended its armed campaign and stood down its structures. It has gone. And Sinn Féin has grown in strength, in 2013 holding five ministerial positions in the North's Executive or Cabinet, including the position of Deputy First Minister. Under the terms of the Good Friday Agreement, the positions of First

Minister and Deputy First Minister have equal power and are responsible for managing the work of the executive.

Sinn Féin is now the largest nationalist party in Northern Ireland. Having resigned as MP for West Belfast, I stood in the general election of 2011 for the Louth constituency in the South and was elected, along with our biggest team of *Teachta Dálaí* (members of the Irish Parliament) since partition. And, in 2007, the unimaginable—some would say the unbelievable—occurred when DUP leader Ian Paisley and Sinn Féin's Martin McGuinness (b. 1950) took up their positions as First and Deputy First Ministers in the North's power-sharing government. And, more recently, Sinn Féin commenced a campaign for a border poll to be held after the next elections to the Assembly in the North of Ireland and to the Dáil.

We have all come a long way from the dark days of partition. Although significant progress has been made, there is still work to be done, and we cannot take the peace process for granted. It requires constant attention. But we can proceed knowing that the overwhelming majority of citizens want it to work. I believe that, if we remain fixed on this course, we will achieve a free, independent and united Ireland, a new Republic.

Wolfe Tone, regarded as the father of Irish republicanism, caught the sense and spirit of this new republic more than 200 years ago, when he wrote of "a cordial union among all the people of Ireland, to maintain that balance which is essential to the preservation of our liberties and the extension of our commerce."[13] Today's Republicans are for:

> —A Republic where neither gender or race, age or disability, sexual
> orientation or class, location, creed, or skin color can be used to deny
> citizens their full rights and entitlements, and where the right to a job and
> a home, to a decent standard of education and health, and to equality for
> the Irish language is enshrined in our Constitution.

> —A Republic that builds reconciliation between Orange and Green
> and that is democratic and inclusive, based on equality, freedom, and
> social solidarity.

> —A Republic that shares its wealth more equitably, looks after its aged and
> its young, provides full rights for people with disabilities, liberates women,
> and delivers the highest standard of public services.

These rights and promises are enshrined in the Proclamation of 1916 and in the Democratic Programme of the First Dáil on January 19, 1919. We now have the opportunity to re-imagine Ireland, an Ireland where conflict and violence are in the past, an Ireland that reflects our genius and diversity, our dignity and our strengths: one island, without borders.

Notes

1. Arthur Young, *A Tour in Ireland: With General Observations on the Present State of That Kingdom: Made in the Years 1776, 1777, and 1778 and Brought Down to the End of 1779,* Vol. 1. (Print on demand by Ulan Press, 2012), p. 96.

2. George Washington, The Writings of George Washington, John H. Rhodehamel, ed. (New York: Library of America, 1997), *passim.*

3. R. Barry O'Brien, ed., *The Autobiography of Theobald Wolfe Tone,* Vol. 1 (London, UK: T. F. Unwin, 1893), *passim.*

4. Education Act 1695, Act of Irish Parliament (7 will.3 c.4). www.library.law.umn.edu.

5. Edward Laxton, *The Famine Ships: The Irish Exodus to America, 1846–51* (New York: Henry Holt and Co., 1997), 10.

6. George Bernard Shaw, *Man and Superman* (London, UK: Penguin Classics, 2001), 150. For a contemporary American view of An Gorta Mór and historical amnesia, see Timothy Egan, "Paul Ryan's Irish Amnesia," *The New York Times* (March 16, 2014): SR3.

7. Ian Colvin, *The Life of Lord Carson,* Vol. 2 (London, UK: Victor Gollancz, 1934), 77 and 79.

8. George Bernard Shaw, as quoted in *The Daily News of London* (May 10, 1916): *passim.*

9. From 'To the memory of some I knew who are dead and who loved Ireland,' in Owen Dudley Edwards and Fergus Pyle, eds., *1916: The Easter Rising* (London, UK: MacGibbon & Kee Ltd., 1968), 220.

10. N. I. Parliamentary Debates (Hansard) House of Commons, Vol. 16, Cols 1091, 1095.

11. William Butler Yeats, "September 1913," ed. Richard J. Finneran, *The Collected Poems of W. B. Yeats* (Hertfordshire, UK: Wordsworth Poetry Library, 1996), 86.

12. www.alphahistory.com/northernireland/northern-ireland/quotations.

13. This was the first of three resolutions agreed at the first meeting of the Society of United Irishmen in Belfast on October 14, 1791. www.yourirish.com. *passim.*

Acknowledgments

Thank you, Gerry Adams, for encouraging me to do this book and for bringing your wisdom, humor, and inimitable voice to it. I appreciate that you stayed with it for all these years, my friend. Thanks, Richard McAuley, for your friendship and for all your assistance with the details that made this book possible. I am immeasurably grateful to the entire Martin McAuley family, for their help, support, and friendship and for allowing their home to be my Belfast home. Thanks to all my friends at Conway Mill for their support, and to all the wonderful people in Ireland whom I have met over the years, for welcoming me so warmly with your laughter and loving spirit.

Thanks to my creative team, Joanna Hurley, David Skolkin, and George Thompson, for their belief in this book and for bringing it into the world. Their help with details great and small was invaluable, including meticulous research on place names and locations. Very special thanks to Joanna, for believing in the vision of the book and for her remarkable persistence in bringing it to fruition. Without her care and guidance, it would not have happened. And thanks to Thomas Parks at Orion Studios, for his assistence with the pre-press scans.

Thanks to all my family and friends for their support and love, especially Jo, Lamar, Guy, Walter, Christa, Lynne, Doris, Maureen, Scott, Susan, Margie, Johnny T., Christine, Suzanne, Van, Corinna, Colin, Laurie, Dr. Mark, and many more too numerous to mention.

To Dave, thank you for everything.

About the Authors

ELIZABETH BILLUPS is a Santa Fe-based photographer, author, environmental activist, and philanthropist. Her photography documents her extensive travel and interaction with people outside of the United States and has been exhibited in both the U.S. and Ireland. She is currently on Nuclear Watch New Mexico's steering committee and the Guiding Council for Alliance for the Earth. She is a co-founder of Apsara Global Arts, a company that supports women in Cambodia who have lost limbs to land mines and now makes exquisite silk scarves that are sold worldwide. She has worked for many years with the American Indian Movement and also the International Indian Treaty Council. In her work with John Trudell of AIM, she assisted him in the production of his poetry spoken over the music of the legendary guitarist Jesse Ed Davis. The result, *Aka Graffitti Man*, was hailed by Bob Dylan in *Rolling Stone* as 1987's best album of the year.

GERRY ADAMS has been president of Sinn Féin, the largest all-Ireland party, since 1983. He served as a member of Parliament for West Belfast from 1983 to 1992 and from 1997 to 2011. Since 2011 he has been the *Teachta Dála* or representative to the Irish Parliament, the Dáil, for Louth. Heralded as "a gifted writer" by *The New York Times*, he is the author of a volume of fiction, *The Street and Other Stories* (Warnock Books, 1992), and several volumes of nonfiction, including *The New Ireland: A Vision for the Future* (The O'Brien Press, 2005) and *A Farther Shore: Ireland's Long Road to Peace,* which was published to wide acclaim by Random House in 2003. He is a native of Belfast.

ABOUT THE BOOK

Ireland: One Island, No Borders was brought to publication in an edition of 1,500 hardcover copies. The text was set in Bembo with Berthold Walbaum display, the paper is Lumisilk, 150 gsm, and the book was professionally printed and bound in Canada by Friesen Press.

Publisher: George F. Thompson
Project Manager and Editor: Joanna Hurley, of HurleyMedia, L.L.C.
Editorial Assistant: Mikki Soroczak
Copyeditor: Purna Makaram
Proofreader: Mary Wachs
Book Design and Production: David Skolkin

George F. Thompson Publishing, L.L.C.
217 Oak Ridge Circle
Staunton, VA 24401-3511 U.S.A.
www.gftbooks.com

22 21 20 19 18 17 16 15 14 1 2 3 4 5

The Library of Congress Preassigned Control Number is 2014932406.
ISBN: 978-1-938086-14-4

Page 1: In a country full of rainbows, here is one over Cork City, Munster.

Page 2: The cliffs of Moher, County Clare, Munster.

Page 3: A statue of Archangel Michael in Glasnevin Cemetery, Dublin.